Prayers on Fire FOR Women

365 Days of Praying the Psalms

**Brian Simmons
& Candice Simmons**

BroadStreet
PUBLISHING

BroadStreet Publishing® Group, LLC
Savage, Minnesota, USA
BroadStreetPublishing.com

Prayers on Fire for Women: 365 Days of Praying the Psalms
Copyright © 2025 Brian Simmons
Written by Brian and Candice Simmons with Sara Perry.

9781424568864 (faux leather)
9781424568871 (ebook)

All rights reserved. No part of this book may be reproduced in any form,
except for brief quotations in printed reviews, without permission in
writing from the publisher.

Unless otherwise indicated, all Scripture quotations are from The Passion
Translation®. Copyright © 2017, 2018, 2020 by Passion & Fire Ministries,
Inc. Used by permission. All rights reserved. ThePassionTranslation.com.

Cover and interior by Garborg Design Works | garborgdesign.com

Printed in China

25 26 27 28 29 5 4 3 2 1

Prayers on Fire for Women is dedicated
to the wonderful women of God who nurture children,
both natural and spiritual.

January

Heartfelt Praise

You can pass through his open gates with the password of praise.
Come right into his presence with thanksgiving. Come bring your
thank offering to him and affectionately bless his beautiful name!

Psalm 100:4

Creator, I come right into your presence with praise. There are so many reasons to give you thanks. I offer you my heart, my attention, and my love right here and now in this very place. As I do, I know you meet me. You usher me into the courts of your kingdom by your presence. You fill me with joy as I offer you my wholehearted thanks. Like a good father knows his daughter, you always know just what I need to hear in every moment. I depend on you to fill me up with your life-giving love each and every day.

Thank you for loving me so well. I belong to you, Lord. As your Word says, you are our Creator, and we are the people of your pleasure (v. 3). Oh that I would know the depths of your delight over me today! Reveal your heart as I focus my attention on you. Thank you, Lord, for loving me to life over and over again.

What are you grateful for today? Nothing is too small. Use it as
fuel for your praise and go right into the presence of your King.

Relief at Last

His massive arms are wrapped around you, protecting you.
You can run under his covering of majesty and hide.
His arms of faithfulness are a shield keeping you from harm.

Psalm 91:4

Almighty God, you are the one I run to in my trouble. You are the one I depend on when my life feels as if it's turning upside down. It doesn't matter how big or small my problems are; you welcome me with open arms. There is nothing too difficult for you. You cover me with your grace every time I run to you. Relieve me of my fear as I lean into your arms of faithfulness. Fill me with your perfect peace as I depend on you. Be my defense and my advocate. I rely on you, God!

When I feel the burden of others' expectations weighing me down, I will not try to shoulder them alone. I will bring you all I am carrying. Lift the burdens that are not mine to bear and ease the pain I have endured. I hide myself in you, for you are the one who gives me peace, a reason to hope, and a love that redeems even that which seems irreparable. I rest in you today.

What do you need God's protection from? Run into his arms and find your rest in his presence.

My Source of Life

Deep within me are these lovesick longings, desires and daydreams of living in union with you. When I'm near you, my heart and my soul will sing and worship with my joyful songs of you, my true source and spring of life!

Psalm 84:2

Father God, my soul bursts with longing for you. The hunger of my heart leads me to your presence. You hold the words of life my soul craves; where else would I go? My heart spills over with songs of grateful praise. I cannot begin to thank you for the overwhelming goodness of your love. You revive my soul, and you satisfy my thirst with the living waters of your presence. You have been so good to me, and I trust that you will continue to be.

Your friendship means the world to me. You are closer to me than even my closest confidant in this world. As I draw close to you, my true source and spring of life, meet me with the power of your love once again. I long for more of you!

What song stirs in your heart when you turn your attention to the Lord? Serenade him today.

Great Advocate

*You have stood up for my cause
and vindicated me when I needed you the most.
From your righteous throne you have given me justice.*

Psalm 9:4

God, I trust you to come through for me in the time of my great need. When I am completely powerless to change my situation, you are a faithful help and a strong presence. Do what only you can do, Father. I don't want to waste away in worry. Strengthen my faith as I remain anchored in you, my living hope. You are righteous and true, and you will not fail to bring beauty from the ashes of my life.

Show me, oh Lord, when I need to change my heart or my approach and when I simply need to hold my ground and wait on you. You are faithful regardless. I know you will not accuse the innocent. Build me up in your wisdom and give me strength as I lean on you. Protect me, guide me, and reveal the truth so others may see, know, and drop their weapons. Thank you!

What are you trusting God to come through with? Give him your worries and wait on him.

Overflowing Gladness

We laughed and laughed and overflowed with gladness.
We were left shouting for joy and singing your praise.
All the nations saw it and joined in, saying,
"The Lord has done great miracles for them!"

Psalm 126:2

Lord, you are the miracle maker. You do great and wonderful things, and when you do, we are overcome with joy, washed with relief, and filled with gladness. When you move in mercy, we are left shouting for joy. As I think about the ways you have transformed my life in your limitless love, I cannot help but sing your praise today. I won't get caught up in the unknowns of the future when I slow down to focus on your goodness to me, both in my history and in the present.

Your presence is filled with delight. Joy not only fills my heart but also flows through my body, making me smile and lifting the weight of worry off my shoulders. You are so good! Thank you for the miracles of your restoration and redemptive power. I am in awe of you.

When was the last time you "laughed and laughed"? Do something today that brings you real joy.

Conquered by Love

Even when your path takes me through the valley of deepest darkness, fear will never conquer me, for you already have! Your authority is my strength and my peace. The comfort of your love takes away my fear. I'll never be lonely, for you are near.

Psalm 23:4

YAHWEH, you are my shepherd and my best friend. I trust you to guide me through the twists and turns of this life. I know that this path isn't easy, and it is not always clear. I need your leadership, especially when I walk through deep, dark valleys of suffering. Your presence carries perfect peace, and I know that is my portion. Overcome me with the light of your love and relieve the fear that threatens to drain me of all my energy.

I trust that you know what you are doing every step of the way. You see the obstacles I can't, and you guide me with goodness. Your comfort is close, and your love overwhelms my fear. I am never without your presence. I'm never without your friendship. I'm never without you. Thank you.

When life is painful, where do you turn for guidance and comfort?

My Savior

I will sing my song of joy to you, YAHWEH,
for in all of this you have strengthened my soul.
My enemies say that I have no Savior,
but I know that I have one in you!

Psalm 13:6

YAHWEH, my heart bursts with joy at the thought of all you have done for me! You have strengthened my soul, and you have protected my life. You have been so very wonderful to me, and I know you aren't finished working out the miracles of your mercy in my life. Even when others doubt your goodness toward me, I don't doubt for a second. They may not be able to see the power of your presence with me, but I am the one who experiences it.

I will offer you my song of joy today for all that you are to me. You are a constant comfort and faithful companion. You are my healer and my holy help. You are always with me, and I can't get away from your love. What good news that is! You are a breath of fresh air whenever the world's air grows stale. You are my confidence and my hope. All my treasures are rooted and found in you.

What has God done for you lately?

Pleasant Paths

Your pleasant path leads me to pleasant places.
I'm overwhelmed by the privileges that come with following you!
Psalm 16:6

Good Shepherd, I am so thankful for the steady hand of your leadership in my life. You don't lead me astray; I know your pleasant path leads me to pleasant places. The boundaries of your great love hem me in, behind and before. You have surrounded me with the power of your presence, and I am never alone. I don't take for granted the goodness of your faithful kindness toward me. I stand undone and in awe as I think of all the ways that you have provided for me.

Open my eyes even more and tune my attention to the fingerprints of your mercy in my life as I recount your faithfulness. What pleasant paths you have laid for me! What peace I have found in you. I know you will continue to guide me in loyal love as I trust you. "You are my prize, my pleasure, and my portion. You hold my destiny and its timing in your hands" (v. 5).

How has God revealed his faithfulness to you in your lifetime?
Ask the Holy Spirit to remind you.

Let It Go

Now listen, daughter, pay attention,
and forget about your past.

Psalm 45:10

Lord, when the shame of my past overwhelms me, let me remember the kindness of your heart, and help me to give myself as much compassion as you offer me in your forgiveness. I don't want the mistakes of yesterday to hold me back. I'm so glad you don't require perfection from me. Help me to forsake my feelings of guilt. How could I beat myself up over things you've already forgiven me for? Wash me afresh in the overwhelming warmth of your love and remind me of who I am, of who you say I am.

I choose to listen to your voice today. I am paying attention. I let go of the need to change the past. I put it all in your hands and give you my focus. Thank you for the power of your redemption that takes broken dreams and failed attempts and makes something beautiful out of them. I let go of the desire to control what you do, and instead, I trust you to do better than I can even imagine. I love you.

Is there something from your past that you are struggling to let go of? Try turning your full attention to the Lord and what he has to say to you today.

Follow Him

I hear the Lord saying, "I will stay close to you, instructing and guiding you along the pathway for your life. I will advise you along the way and lead you forth with my eyes as your guide. So don't make it difficult; don't be stubborn when I take you where you've not been before. Don't make me tug you and pull you along. Just come with me!"

Psalm 32:8–9

Thank you, Lord, for promising to stay close to me, guiding me along the pathway of my life. I'm overwhelmed with gratitude for your persistent presence in my life. I don't want to stubbornly follow you, dragging my feet along the way. I trust that no matter where you lead, you are guiding me in your goodness. Even in the fog of confusion and the dark of night, I trust your constant guidance. You always have clarity. You always know what you are doing.

Oh Lord, as I yield to your leadership today, I remember how kind, how strong, and how capable you are. There is no one like you. I willingly follow your lead, Holy Spirit, for you are trustworthy and true.

Do you trust God's guidance in your life? If there is an area that you have been hesitating to release to him, take that step toward fuller trust today.

First Responder

He has not despised my cries of deep despair.
He's my first responder to my sufferings, and when I was in pain,
he was there all the time and heard the cries of the afflicted.

Psalm 22:24

Loving Father, you do not delay when your children cry out for help. Lord, you see my need today. You know my heart. I don't hesitate to come to you with my worries, my pain, and my burdens. You lift high my head, liberating me from the shackles of shame. Thank you for being the first responder to my sufferings. Why would I suffer in silence when you are ready and willing to help me? I choose to give you every burden today, no matter how trivial it may seem to others. I know you do not downplay my pain.

I rejoice in your presence, and I take comfort in your peace. Draw even nearer as I come close to you, Spirit. I need you more than I can say. Lord, do not neglect the cries of the desperate around me either. Be their first responder and their champion defender. Bring healing, restoration, and freedom. Thank you.

What point of pain can you invite God into today?

Forgiven

I finally admitted to you all my sins, refusing to hide them any longer. I said, "My life-giving God, I will openly acknowledge my evil actions." And you forgave me! All at once the guilt of my sin washed away and all my pain disappeared!

Psalm 32:5

Father, thank you for the power of your forgiveness. It washes away my guilt, and I am free to follow in the light of your love with my head lifted high. I don't take your mercy for granted. It is life to me. What relief, joy, and liberation I find in your mercy-kindness. What purpose, peace, and hope I find in openhearted surrender before you.

Just as you freely forgive my sins when I bring them to you in honesty and repentance, I want to extend that same mercy to others in my life. Even when others are unwilling to admit their failures and faults, may I err on the side of your mercy that releases the need for seeking payback. Your ways are better than the ways of this world, and I choose to follow you on the radical path of your laid-down love.

Is there something you have been hiding from the Lord? Or is there someone in your life that you can forgive? Follow the loving lead of your Savior.

Unfailing Trust

*He alone is my safe place. His wraparound presence always
protects me as my champion defender. There's no risk of failure
with God! So why would I let worry paralyze me, even when
troubles multiply around me?*

Psalm 62:6

God, I can't pretend that fear never comes knocking on the
door of my heart. I could choose to carry many worries today,
but that's not how I want to live. I want to trust your faithfulness
more than my lack of control. I choose to turn my attention to
your very real and very near presence. You are my safe place.
Wrap your presence around me and fill me with your perva-
sive peace. There is no comfort like the comfort of your love.

Though I may fail a thousand times, you never do. When
your plans look different from my expectations, may I adapt
and align to your kingdom ways instead of trying to force your
hand. Holy Spirit, give me the vision of your perspective today
and lift the burden of the unknowns I cannot foresee. I trust
you more than I trust my own understanding.

*If there were no risk of failure, what would you put your time
and energy toward today?*

Quiet Retreat

*You're my place of quiet retreat, and your wraparound presence
becomes my shield as I wrap myself in your Word!*

Psalm 119:114

Spirit, I have come to love the quiet retreat I find in you. When I sit in silence, I do not seek to fill it with noise, for I have found beauty in the stillness. With your presence as my quiet retreat, I can find rest at any time. I find respite for my soul when you meet me, even when I cannot escape the noise of life. You quiet the chaos of my own mind, bringing clarity and peace. As I read your Word, fill my heart with the goodness of your truth. Like a feast for the soul, satisfy me with the nourishment of your living Word.

When the din of the world just won't let up, quiet the noise with your Word. Cut through the commotion with the clarity of your voice that brings peace, love, joy, and hope. Be my shield, especially as I go through this day. I depend on you, my God, my guide, and my defender.

How much quiet do you find in your life? Where can you create pockets of silence for your soul?

Revive Us

*Revive us, O God! Let your beaming face shine upon us with the
sunrise rays of glory; then nothing will be able to stop us.*

Psalm 80:3

Glorious God, when you shine upon us, we become reflections of your glory. Your love-light makes us bloom and thrive under the rays of your beauty. Living openly before you leads to honor, strength, and joy. Your presence brings so much peace, and your love creates endless delight.

This world is far from perfect, but I don't want to live as one who feels doomed by the fear that runs rampant. Though there are many troubles in this life, I know I will overcome them by your resurrection power alive in me. Revive me, Lord! I need a fresh encounter with your grace. I long for fresh revelation of your nature to wake me up to the wonder of who you are. Let your beaming face shine upon me today as I look to you. You are my victor and the one I willingly give my life to.

*Is there an area of your life that feels hopeless, stagnant, or in
need of healing? Ask the Lord to revive you and invite him to
do that work as you surrender to him.*

With Every Part

With my whole heart, with my whole life, and with my innermost being, I bow in wonder and love before you, the holy God!

Psalm 103:1

Wonderful Father, with all my heart, my whole life, and my innermost being, I praise you. You are so worthy of my attention, my love, and my honor. You have it today. With every part of me, I celebrate your wonderful love. You are better to me than anyone I have ever known. You are better than a good father, for you are the perfect Father. You always know what I need, how to provide, and just what to say at any given moment. Your miracles of kindness I cannot count, but I will not forget the power of your mercy in my life.

With my mind, I crown you King over my thoughts. With my heart, I surrender the most vulnerable places to your tender and trustworthy care. With my body, I offer you my strength and my weakness. Be glorified in my life, in my choices and relationships, in my workplace and in my home. With every part of my being and life, I honor you. I stand in awe and love before you, my holy Father.

Is there any part of your life that you have resisted offering to God?

Devoted in Love

You have heard my sweet resolutions to love and serve you,
for I am your beloved. And you have given me an inheritance
of rich treasures, which you give to all your devoted lovers.
Psalm 61:5

Oh God, I am undone at the thought that you have chosen me as your own. I am your beloved daughter, and you are my good Father. I am your willing partner, and you are my close friend. There is no good that you withhold from those who put their trust in you. I choose to serve you because you are worthy. Even more than that, you are trustworthy. You are always reliable. You are forever faithful. You never ever fail.

I am your devoted one, Lord, for you have been so good to me. I cannot ignore the overwhelming goodness of your faithfulness, even when I have failed to follow through. You cover my weakness with the power of your gracious strength, and you restore what I thought was forever lost in the power of your redemption. Truly, there is no love like yours. I will spend my life loving you, for you are the source of all goodness, all peace, all delight, and all love.

How have you experienced the richness of God's love lately?

A Father's Help

Give us a father's help when we face our enemies.
For to trust in any man is an empty hope.
Psalm 60:11

Father, you are not only the place I go when I have nowhere else to turn but also the first place I go. You are the first line of defense, the first place I run to when I am in trouble. You have the wisdom, strength, and resources I require. Your help is better than my own feeble attempts to fix things. I don't want to rely on my limited learning when I already know that you know better. You know best. I trust in you more than in my own abilities. All wisdom is yours. You give me clarity for my confusion, and you offer peace for the fear I feel.

Help me to never place my full trust in any person. Though trustworthy people are a gift, I know that no one sees perfectly, knows all, or can follow through with unblemished motives. Only you can do that. I trust you to put the right people in my path, but I also trust that when I cannot find any help, you are more than enough. Thank you.

In what area do you need your Father's help today?

When I'm Afraid

In the day that I'm afraid, I lay all my fears before you and trust in you with all my heart. What harm could a man bring to me? With God on my side, I will not be afraid of what comes.

Psalm 56:3–4

Good God, I know that I cannot live undisturbed by turmoil and pain. I cannot escape the suffering that happens with loss, with disruptions, and with unforeseen tragedies. When I'm afraid, God, I lay my fears before you. I won't carry them like burdens. It is not my job to fix the lives of those around me. I can't carry the weight of responsibility for others' choices even when I want to. Help me to first let go of what is not mine to carry and then give you my own very personal fears.

I know I don't have to fear what comes, no matter the outcome, with you on my side. Oh God, I want to be found on your side. Help me to remain aligned in your love, choosing to partner with your mercy, to uphold your justice, and to walk humbly before you all the days of my life. I trust you with my whole heart.

When you feel the prongs of fear tightening around your heart, what brings peace, space, and clarity?

Promise of Joy

Gaze upon him, join your life with his, and joy will come.
Your faces will glisten with glory.
You'll never wear that shame-face again.

Psalm 34:5

Lord, I take time to gaze upon you today. I know that no moment in your presence is wasted. You are the giver of life, the restorer of souls, and you are my living hope. I long for a breakthrough of joy in my life today. It starts—it *always* starts—in your presence. As I turn my attention to your very present love, I cannot help but be overcome with awe. Pour over me like a waterfall. Wash away my weariness and revive me in hope.

There is no part of my life that I close off from you. You have access to it all. I have joined my life to yours, and I trust that joy will come. No problem is too big for you to solve, and there is no obstacle that you cannot overcome. I choose to look to you, raise my gaze above the details of my struggles, and simply follow you step by step. Your faithfulness will not let up, and I will experience breakthrough once again.

In what area do you need the Lord to break through for you?

Don't Give Up

Here's what I've learned through it all: Don't give up; don't be impatient; be entwined as one with the Lord. Be brave and courageous, and never lose hope. Yes, keep on waiting—for he will never disappoint you!

Psalm 27:14

Lord, I need your strength to meet me today. May your gracious hand hold me and let me see into your merciful heart. I know that your timing is different from mine, but that does not make it wrong. The longer I live, the more I see how little I know. And oh, how wonderful that is! You know best, always. Nothing is a mystery to you, not even the human heart. Not even me.

You make me courageous, Lord. Your faithful love carries me through hard seasons and gives me the strength and wisdom to put one foot in front of the other when I cannot see where I am going. When my heart is entwined with yours, I am full of peace. I am able to patiently wait on you. I won't lose hope as my heart remains interlocked with your love. I trust that you will not disappoint, no, never!

Is there something you have been impatiently waiting on? Are you ready to give up hope? Renew your hope in the power of God's strength and trust him.

Healing Answers

Yes! YAHWEH my healer has heard all my pleading
and has taken hold of my prayers and answered them all.
Psalm 6:9

YAHWEH, you are my healer. Body, heart, and soul, your love is a salve that makes me whole. You do not pick and choose which prayers to hear. You hear them all. What love is this that overwhelms my troubles with peace? You have solutions I don't even know to ask for. I will not stop turning to you for help, for you hold my healing in your hands.

Lord, I offer you the tenderness of my wounds today. I cannot ignore the pain I am in. Healer, heal me. Soothe me with the balm of your kindness and align all that is out of joint with the power of your truth. There is no better standard than yours. I give you the questions of my heart, the ones I have wrestled with. Speak into them and bring clear vision, freedom of movement, and peace to my heart. Thank you.

What prayers has God answered for you? Consider keeping a journal of prayers so you can also record when God answers them.

Choosing Gratitude

I will give my thanks to you, YAHWEH,
for you make everything right in the end.
I will sing my highest praise to the God of the Highest Place!
Psalm 7:17

Father, you make everything right in the end. Before the end gets here, I choose to trust you, and I build that trust through gratitude. When I am in the middle of a journey that has lost the excitement I had at the beginning, but it's still too far from the end to see the light, I have only to keep persevering and doing the work. I know that this is true in my journey of faith too. Thank you for ways to connect with you that turn the mundane into powerful opportunities for worship.

There are so many reasons to be thankful today. I am thankful for this day, for the roof over my head, and for the food that fills my belly. I am thankful for the relationships in my life. I am thankful for the glimmers of beauty I find in the world around me. As I turn my heart toward gratitude, open my eyes to the wonderful gifts you have put all around me.

Do you have a practice of gratitude in your life? At the end of every day this week, write down three things you are thankful for that day.

Peaceful Sleep

*Now I'll lie down and sleep like a baby—then I'll awake in safety,
for you surround me with your glory.*

Psalm 3:5

Savior, when sleep evades me, I turn my thoughts to you. There is so much that could keep me up at night in worry, but I want to rest in the power of your love. Your peace is a gift, and I don't take it for granted. As the psalmist experienced your help and empowering presence and was able to rest well after crying out to you, I, too, expectantly wait for your presence to settle my mind and heart.

I want to rest so fully in your peace, God, that I can sleep through storms, confident of your faithfulness. Jesus slept in the belly of a boat in a fierce gale because of your peace. Lord, even when the loud chaos of this world doesn't let up, will you quiet my heart and mind so that I can sleep in that same assurance? You are the one who keeps me safe. I won't be afraid, for you are my Savior. I trust you.

How can you promote God's peace in your mind and heart before you go to bed?

Not Even Once

I will forever praise this God who didn't close his heart
when I prayed and never said no when I asked him for help.
He never once refused to show me his tender love.

Psalm 66:20

Faithful One, your love is too much to comprehend. Its limits no one can reach. Its power no one can overcome. You are indescribably generous in mercy and benevolent in kindness. Your love cannot be depleted. Thank you for access to the endless resources of your mercy, grace, hope, joy, and peace. Your arms are open and waiting to embrace me with the tenderness of your affection every time I come to you. What a wonderful Father you are!

I will forever praise you for your goodness. The kindness of your heart is beyond anything I have ever known. Help me to stay openhearted and generous in love, just as you are. I want to walk in the ways of your gracious mercy and compassion for as long as I live, giving you praise and reflecting the light of your glory all the days of my life.

When did God amaze you with his faithfulness? How did you thank him?

More Mercy, More Grace

*We look to you, our God, with passionate longing to please you
and discover more of your mercy and grace.*

Psalm 123:2

Loving Lord, I come before you with my heart wide open and
hands stretched high to worship you today. You are worthy
of my adoration and praise. You are overflowing in kindness,
and I can't help but run to you with the expectation of meet-
ing your goodness. Thank you for always pouring out more
of your presence on my life. I long to discover more of your
mercy and grace. Overwhelm my senses with the wonderful
peace of your presence.

You know the obstacles I face, and you promise to be with
me. Lord, show me your mercy. Lord, show me your grace in
tangible ways that encourage my heart in hope and my lips in
praise. I love you, I trust you, and I hold on to you today.

*Have you gone to God for more of his mercy and grace lately?
Have you asked for a fresh portion of strength, wisdom, and
peace for all that you face?*

Come as You Are

*He responds to the prayer of the poor and broken
and will not despise the cry of the homeless.*
Psalm 102:17

Lord, thank you for the reminder that vulnerability is the only way to grow closer to you. Pride presents a façade, but humility is the ability to recognize and present things the way that they are. I resist the pull to put on a mask and pretend that my struggles are not real. I don't have to be anything but real with you. I can't thank you enough for that. Help me to remember that everyone is welcome in your kingdom, no matter how beaten down or vulnerable they are. May I give the love that I so freely receive and be a reflection of your justice, your peace, and your kindness.

I leave the shoulds, the woulds, and the coulds behind and come to you as I am. You know just what I need in every moment, and right now is no different. Meet me with the power of your presence and guide me with your wisdom. Provide by your gracious mercy, and give me your strength in my weakness. I need you so, God.

Have you taken time to really look at what is in your heart these days? Come to God with all that you carry, all that you are, and all you need.

New Song for a New Day

Go ahead—sing your new song to the Lord!
Let everyone in every language sing him a new song.

Psalm 96:1

I don't want to hold myself over on yesterday's bread when you offer me a fresh portion today. Just as your manna was sent from heaven to feed your people in the desert every morning, so I will look to you for the fresh bread of your presence each day. What do you have for me today? In the same way, I will offer you a new song. I don't want to give you what I have already offered. I want to offer you something I've never given you before.

I love that you don't care about the tone of my voice or the quality of my song. Every song I sing to you is a delight because you are my good Father, and I am your beloved daughter. I will not hold back from you. Thank you for the gift of a new day, for a fresh opportunity to encounter you. I love you, and I take hold of this moment. Here is my song, Lord. May it bless your heart.

When was the last time you made up a song? No matter how simple, how short, or how it comes out, sing straight from your heart to your Father's heart today.

Don't Stop Sharing

Don't stop! Keep on singing! Make his name famous! Tell everyone every day how wonderful he is. Give them the good news of our great Savior. Take the message of his glory and miracles to every nation. Tell them about all the amazing things he has done.

Psalm 96:2–3

God of my victory, fill me with the persistent hope of your presence. I won't stop worshiping you. I will persevere in praise. May I never stop telling people of your undeniable goodness, for you are my glorious Savior and my close friend. You speak, and storms are silenced. You move, and the winds and waves die down. You look, and every heart is laid bare before you. There is no one like you.

Lord, as I sit in your presence today, wash over me with the living waters of your love. Refresh my heart in hope and refine my vision with your wisdom. I will think about how wonderful you are, and as I do, I know I will find new reasons to praise you. I will find a nugget of miraculous mercy to share with others. Open my eyes, Lord, even as I open my lips to sing your praise.

What amazing things has God done for you?

Heart Open

The source of your pleasure is not in my performance or the sacrifices I might offer to you. The fountain of your pleasure is found in the sacrifice of my shattered heart before you. You will not despise my tenderness as I bow down humbly at your feet.

Psalm 51:16–17

Father, I bow humbly at your feet. I lay aside every excuse that keeps me from you. I offer you my heart even when it feels shattered. You will not despise my broken heart. I offer it tenderly to you, for I know your touch is gentle and your power strong enough to bind it up. I'm relieved to know I don't have to dress myself up to come to you. You don't measure my worth by what I can do for you. How liberating it is to know that! Though I do my best, I know that your love does not depend on my performance. Thank you!

Here is my heart, open before you. I am yours. Meet me here, heal my wounds, and refresh my weary soul. I am yours.

How does knowing that God's love isn't dependent on your performance make you feel? Ask him to show you the depths of his love in new measure today.

Written in the Stars

God's splendor is a tale that is told, written in the stars.
Space itself speaks his story through the marvels of the heavens.
His truth is on tour in the starry vault of the sky,
showing his skill in creation's craftsmanship.

Psalm 19:1

When I look at the night sky, dark yet full of bright, shining stars, I cannot help but slow down in wonder. How is it that you created the entire universe, more than we even know is in existence, and still you know me by name? I am awestruck. I am overwhelmed. I am full of lavish love, persistent peace, and jubilant joy. I am yours, and you are mine. What a wonder!

God, reveal your majesty even more thoroughly to me through the details of this world, through nature, through scientific discoveries, and through the marvel of this wide and wonderful planet. I want to know you more. What a joy it is to discover more reasons to delight in your creativity as I learn more about this world you created. I don't want to be just a bystander of your goodness in creation. I also want to be a caretaker and a partner with your purposes. Your truth is written in the stars, and it's written upon my heart. Oh, the mystery!

How does nature move you closer to God?

February

Words of Life

YAHWEH's Word is perfect in every way;
how it revives our souls!
YAHWEH's laws lead us to truth,
and his ways change the simple into wise.

Psalm 19:7

Lord, yours is the truth that sets the captive free and gives joy to the weary. Your words of life are like a song that moves me. I can't help but dance! You revive my heart, you restore my soul, and you give me a hope for the future. When I cannot see more than a couple steps ahead, let me turn the ground where I stand into a dance floor, spinning around in praise. Your Word says that you visibly delight over your people, rejoicing over us with gladness (Zephaniah 3:17). When you move in mercy, I do the same.

I need your guidance, Lord, and I trust you to faithfully lead me. Your ways lead to truth, and you give revelation and understanding to those without it as they seek you. I won't stop following you, for you are life and breath and peace, perfect in every way.

What do you do when you feel stuck? Perhaps try moving with joy right where you are and see what that does.

Tucked into His Presence

YAHWEH himself will watch over you;
he's always at your side to shelter you safely in his presence.
He's protecting you from all danger both day and night.

Psalm 121:5–6

At times, I cannot escape the weight of this life. Lord, when the burdens of heartbreak close in, surround me with your protective peace and your healing presence. Guard me, Father, and continually watch over me as you promise in your Word. You never slumber nor sleep, so I can let my guard down under your watchful care.

YAHWEH, you are my refuge. When I walk through danger and darkness, you keep me close. You tuck me into your side and cover me with the mercy of your presence. I am safe here. Settle my heart as I lean in to hear your heartbeat. I trust you to watch over me. Here I can find my rest even when the world doesn't settle around me.

When you are afraid, have you ever tried picturing yourself tucked into God's side, hidden by the covering of his cloak? Try it when you are overwhelmed today and see if that helps settle your heart.

Only Him

Every evening I will explain my need to him. Every morning I will move my soul toward him. Every waking hour I will worship only him, and he will hear and respond to my cry.

Psalm 55:17

Faithful Father, I cannot begin to express my gratitude for your presence in my life. I don't ever have to stay away from you, not when I'm in a bad mood, or incredibly sad, or just plain bone-tired. I take the psalmist's lead and explain my need to you every evening. I move my soul toward you with each new morning. When I open my eyes each day, may my heart reach out for you before I do anything else. Every moment throughout my day is an opportunity to worship you.

I open the lines of communication with you as I seek you in the morning, and I keep them open throughout the day as I turn my attention toward you again and again. You are my help, my confidence, and my closest friend. I love you!

How can you keep your heart engaged with the Lord throughout the day?

Heart Desires

*May Yahweh give you every desire of your heart
and carry out your every plan as you go to battle.*

Psalm 20:4

Lord, I have surrendered my heart to you. I trust you to lead me through this life with loving-kindness. I depend on you to provide for my daily needs and to comfort my heart when it is grieving. You are not a far-off figure to me. You are close, dependable, and very real. Open my eyes to see how you are weaving the thread of your mercy through my life. I don't want to just wait on your hand. I also want to see the power of your heart moving in and through me.

Thank you for taking notice of the things I care about. They are not trivial to you. Lord, I trust you with the deep-seated desires that have labored long but have not yet been birthed in my life. You are the giver of good gifts, and I trust your timing. Carry out your purposes in my life as I partner with you. I am yours, and I am delighted by the astonishing power of your love as it moves in me.

What plans are you fighting for that you need to entrust to God?

Right on Time

When I had nothing, desperate and defeated,
I cried out to the Lord and he heard me,
bringing his miracle-deliverance when I needed it most.

Psalm 34:6

Mighty Deliverer, I won't stop crying out to you in my desperation. I won't be discouraged by my circumstances, for they only lead me to you. You are a sure help in time of need, and you never disappoint. You bring miracle-deliverance when I need it most, and I know I can count on you today. Settle my soul in your confident peace as I wait on you.

Countless times throughout the Psalms, the writer felt his desperation, and it led him to you, Father. I don't have to be ashamed when I feel overwhelmed by this life or this world. No, I won't pretend to have it all together when I am grasping at straws. And still, I trust in you, Mighty God. You will not fail. You'll send a father's help right when I need it. And oh, Lord, I need it!

How has God delivered you from your fears in the past? How can that help you trust him more today?

As Long as It Takes

I am standing in absolute stillness, silent before the one I love,
waiting as long as it takes for him to rescue me.
Only God is my Savior, and he will not fail me.

Psalm 62:5

Father, you know the fast-paced world we live in. You know how quickly news spreads and trends move. I can't keep up with it, but my body and mind are primed to move fast. Teach me to slow down in your presence and wait on you. I know I can't rush your hand. I can't rush your timing. Yet you will not fail to show up. Your ways are wiser, and your timing is impeccable, even though it's different from my own.

I choose to practice simplicity and to slow down my nervous system by disconnecting from the ever-on-demand presence of technology. I don't want to be a slave to my impulses, and I know that choosing to wait in absolute stillness before you gives you the space to speak, to move, and readies my heart to listen and receive. As long as it takes, may I dwell in your peace and wait on you.

How can you incorporate pauses into your day—stillness
and intentional waiting—instead of mindlessly engaging with
everything the world throws at you today?

Lovesick

O God of my life, I'm lovesick for you in this weary wilderness. I thirst with the deepest longings to love you more, with cravings in my heart that can't be described. Such yearning grips my soul for you, my God!

Psalm 63:1

God of my life, my heart longs for you. As the deer pants for the water on a hot summer day, so my soul thirsts for you. I have tasted and seen your goodness, but it has been just that—simply a taste. I long to know you more today, more than I did yesterday and all the days before. I have known you in the joys of this life, and I have known your comfort in my grief. Meet me today, right where I am. Cover me with your kindness and refresh my soul in the life-giving waters of your pure love. I am lovesick for you.

Yours is not an unreachable love. It is accessible. It is mine. And I pour my love right back on you. You have my heart. It is yours—I am yours—today and forever.

What generous act of love can you offer God today? Be both extravagant and creative with it. He loves your love.

Overflowing Compassion

Lord, don't hold back your love or withhold your tender mercies from me. Keep me in your truth and let your compassion overflow to me no matter what I face.

Psalm 40:11

Merciful Father, I need a fresh dose of your love today. Remind me of the limitlessness of your mercy that breathes kindness into my lungs and courage into my weary soul. No matter what I face, I can get through it with the strength of your compassionate truth steadfastly holding me. Relieve my fears with the power of your presence, God.

I have given so much thought to my worries, but now I want to focus my attention on your faithfulness. You will continue to guide me in the light of your glory. You will defend me; you will clear the path so my steps will not falter. You will lovingly lead me as I look to you. Oh, I look to you today, my Savior and my God.

What has your attention been consumed by? Turn your attention to the Lord and fill up on his lavish love. He pours it over you even now.

Sanctuary of His Presence

God of Heaven's Armies, you find so much beauty in your people!
They're like lovely sanctuaries of your presence.

Psalm 84:1

Holy Spirit, thank you for making your home in those who look to Christ for their salvation. Thank you for making your home in me. Your Word says that your people "have become God's inner sanctuary and...the Spirit of God makes his permanent home" in us (1 Corinthians 3:16). It is a mystery that I cannot fully understand; the Creator of everything in this world, God of heaven's armies, makes his home in me. Thank you.

Fill my heart, my soul, and my spirit with the fruit of your kingdom ways. Let the redemption life you impart shine through my life as I continually yield to your leadership. I choose to follow you, for I am your beloved, and you are mine. You are better to me than I have ever been to myself. Lord, my heart is your home.

How does your life reflect the indwelling of the Spirit? Are there areas of your heart that you have kept closed off to him? Open up and let the light of his love shine in.

In Your Hands

Yahweh, you alone are my inheritance.
You are my prize, my pleasure, and my portion.
You hold my destiny and its timing in your hands.

Psalm 16:5

Oh God, you are my portion, and that portion is plentiful. You are a never-ending spring of life to my soul. You wake me up from my sleepy state and give me vision to see how you're working in this world. How your mercy moves in mighty ways! You are a miracle maker. You are a reliable Savior. You are more than I could ever ask for, and you are mine.

When I get sidetracked and lose my way, bring me back to your path with the kindness of your correction. You are my inheritance, so let me keep my eyes fixed on you. You are worth more than all the wealth this world holds. You are better than the company of the powerful. You are my deepest desire and the keeper of my heart. I trust you with my destiny and all that entails. I trust you with the timing, for you are never late. I trust you; my life is in your hands.

How can you actively trust God's timing today?

Rock of Rescue

YAHWEH, you're the bedrock beneath my feet, my faith-fortress, my wonderful deliverer, my God, my rock of rescue where none can reach me. You're the shield around me, the mighty power that saves me, and my high place.

Psalm 18:2

Mighty God, when my feet are planted in the soil of your love, the roots of faith grow deep and wide, strengthening my innermost being. You are the one I build my life upon. In seasons of ease, with sun shining bright and breezes floating pleasantly through, I bind my heart and life to your purposes. I celebrate your nearness and your goodness to me. In harsh seasons, I remain yielded to your grace and mercy. You are the bedrock beneath my feet. You are my wonderful deliverer. You are my rock of rescue, and I trust you.

When my faith is being tested, may I run into your heart and hide there. No matter what happens in this life, I know that you are good. You are faithful. You are true. I hide myself in you, my shield and my fortress. May I always be found in you, no matter the season.

What do you do when you need help? Does it include running to God?

He's Done It Before

He made a highway going right through the Red Sea as the Hebrews passed through on dry ground, exploding with joyous excitement over the miracles of God.

Psalm 66:6

My Deliverer, you are faithful to lead us, even when we come up against impossible odds. When you led the Israelites out of their captivity in Egypt, it was no simple escape. They stood at the waters of the Red Sea. They were cornered. Where could they go? But you, oh God, provided a way where there was none. Through Moses, you split the Red Sea in two so they could walk across a dry path. What a miracle!

When I come up against impossible odds in my own life, I know that I can trust you to make a way. As long as I am following you, I have no reason to fear. You will do what needs to be done, even when that means something completely unexpected. I trust you, my God. You have delivered many before, and I trust you will make a highway where there is none and when there are no other options. How wonderful you are!

Is there an area where you have reached an end and you don't know how to proceed? Pray for a miracle of God's mercy to show you the way today.

Holy, Holy, Holy

It's here in your presence, in your sanctuary, where I learn more of your ways, for holiness is revealed in everything you do. Lord, you're the one and only, the great and glorious God!

Psalm 77:13

Holy One, I come to you first. I come to you hungry to know you today. Here in your presence is where I learn your ways, your wisdom, and who I am called to be. I don't want to go searching for answers in the world when you hold all true wisdom in your heart. I don't have to travel to the ends of the earth to find you. I don't even have to go to the end of my street. Here, right here in this place, is where you meet me. Your presence overwhelms my senses, and I am undone before you. You are holy, the one and only holy God.

I stand before you in awe today. I bow low in your presence, humbling my heart before you. You have the answers I seek, and you know the way that leads to life everlasting. Speak, Lord, into the innermost places of my being. I am listening.

Where do you need the input of wisdom, answers, or truth today? Go to God first and invite him to speak to you throughout your day.

Promise Keeper

He satisfies all who love and trust him,
and he keeps every promise he makes.

Psalm 111:5

Father, you don't speak and then take back your words. You measure each word as you speak it, and you extend kindness with every promise. I know I can depend on your faithfulness to follow through on all that you say you'll do. Strengthen my heart in courage and build up my faith in confidence of your goodness. Regardless of my own faith, I know that you will be faithful to fulfill your promise. Even so, I want to grow in deeper trust. That is why I must know you more, beautiful Lord.

Satisfy my soul today with the kiss of your kindness upon my life. Speak to my heart as I listen for your voice. Lead me in love as I follow the truth of your ways. Encourage my hope as I see you moving in the details of this world. You are faithful, you are good, and you always will be.

Do you struggle to believe God will follow through on his promises? Get to know his nature more today and invite him to open your eyes to his kindness already at work in your life.

Tender Generosity

Even if darkness overtakes them, sunrise-brilliance will come
bursting through because they are gracious to others,
so tender and true.

Psalm 112:4

Light of the World, you shine, and darkness flees. You speak, and my fears are relieved. You move, and I am overwhelmed by your kindness. Today, Lord, meet me with this overflowing kindness. I know you have not changed even when my feelings do. I trust you.

I will not neglect your Word when life gets hard. When times are tough, you remain the same. So I will follow you on the path of laid-down love that serves others. I will continue to follow your lead in generosity. May I be gracious, holding to the truth, and be kind to the oppressed, the distressed, and those who are beaten down but not yet destroyed. Your love is tender, and I have known its power. I won't hold back this tender love from anyone who needs it today. No matter how dark this day, your truth remains. Your sunrise-brilliance will come bursting through again; I am sure of it.

How can you move in gracious generosity toward others today?

My Confidence

We can never look to men for help; no matter who they are, they can't save us, for even our great leaders fail and fall. They too are just mortals who will one day die. At death the spirits of all depart and their bodies return to dust.

Psalm 146:3–4

Father, keep me from the disappointment of putting my confidence in people more than in you. Every person fails when it comes to perfection. Many of the powerful who promise relief to our souls work only to please themselves. I know that people will let me down, so keep me grounded in the faithfulness of your truth. You will never fail. You won't change. You are not driven by an agenda. You are full of unfailing love that reaches the depths and the heights, stretching out to every heart.

Lord, you are my true hope. You will not go back on your promises, and your love will never let up. Although many great men and women fail and fall, you never do. You are my confidence, God, and I will put my hope fully in you.

Do a heart check today. Whom do you have confidence in? Is it more than the confidence you have in God? Does it leave room for their mistakes and blind spots?

Beloved Child

*The same way a loving father feels toward his children—that's but
a sample of your tender feelings toward us, your beloved children,
who live in awe of you.*

Psalm 103:13

Loving Father, I want to know your heart more today. Reveal
the plans and purposes you have for me and remind me of the
affection you feel toward me. You are my tender Father, and
I am your beloved daughter. You do not punish me for simply
being who I am. You know me better than anyone else does.
You created me. You formed me while I was in my mother's
womb, and you delighted in how you made me. May I experi-
ence your delight over me today.

Speak to me as a father speaks to his daughter, tenderly
and truly. I don't want to be distracted by the to-dos to which I
constantly look to earn your favor. I don't have to earn a thing
when it comes to your love. You give it freely, without condi-
tion. Thank you. Love me to life in your presence and fill me
with the confident assurance that you are pleased with me.
How I love you!

Do you know God as a tender Father?

Daily Bread

You provide sweet wine to gladden hearts.
You give us daily bread to sustain life,
giving us glowing health for our bodies.
Psalm 104:15

Sustainer, you are the one who feeds my heart with the nourishment it needs every day. You are my daily bread, my perfect portion, and my living hope. You refresh my soul and revive my faith. Just as a nourishing meal gives strength to the body, so your living Word gives energy to my soul. I come to your table today. I don't have to circle it, looking for crumbs. You have already laid out a feast, and all I have to do is take and eat it. What satisfaction is already available as I partake of the food of your presence!

Thank you for a fresh portion each new day. I don't have to survive on yesterday's food. You have daily bread to offer, just what I need for the day. Feed me, Father. I trust your provision, your wisdom, and your beautiful ways.

Do you go to God for daily nourishment? Each morning this week, spend time in his Word and presence. He always has just what you need, a "right now" word to satisfy.

Real for Me

Lord, listen to my heart's cry, for I know your love is real for me;
breathe life into me again by the revelation of your justice.
Psalm 119:149

Lord, I don't want to rely on the experience of others in your name to feed my deepest needs. I need you. Make your love real to me. I know it is present, it is true, and it is for me. I don't want to deal in hypotheticals when it comes to you. Your mercy is not just for others; it is for me too. My heart cries out to you today. Breathe life into me again. And again! As often as I ask, will you fill me?

I long to know you as a close and dear friend. I need your justice. I must know your heart. Show me the places in my own heart where I keep you at a distance. I invite you into my deep need. I invite you into my vulnerability. God of my salvation, be real to me. Reveal yourself in practical, real-world ways to me today.

How have you known God's love to be real for you? Press in
to know him more; there's always more to experience and
discover.

Faithful Help

I was desperate for you to help me in my struggles, and you did!
So come and deliver me now.

Psalm 120:1–2

God, I'm so grateful that I can come to you at all times, in every way, unashamed and laid bare before you. It doesn't matter how many times I ask for help; I can ask for more. When I was desperate for your help, you came through for me. Whenever I need you, you are there. Why would I stop coming to you when you promise to come to my aid whenever I call out to you?

Lord, I want to grow in wisdom. This is true. But there are still things outside of my control that I can't handle on my own. Thank you for your strength. Thank you for your miracles of mercy. Thank you for your persistent presence in my life. Thank you for your help. I won't stop relying on you, for you are the God who meets my deepest needs and helps me in my struggles.

How has God helped you in your struggles? What do you need God's help with right now?

Everyone Everywhere

You answer our prayers with amazing wonders and with awe-inspiring displays of power. You are the righteous God who helps us like a father. Everyone everywhere looks to you, for you are the confidence of all the earth, even to the farthest islands of the sea.

Psalm 65:5

Righteous God, you are the hope of the nations, and the peace the world longs for is found in you. Why would I look somewhere else for help today? I offer you the bold prayers of my heart, and I expectantly wait upon your faithful hand of help. You are the God who helps his children, and I am your daughter. I rely on you.

You offer an open invitation into your presence to taste and see your goodness. I won't waste my time on futile pursuits, the stuff of distraction and numbing. You are the source of life itself, and every good and perfect gift comes straight from your hand. I come to you, my heart wide open and my hands ready to receive your gracious provision. Thank you.

Do you believe that God is for everyone everywhere? As you encounter people from different walks of life, remember that God loves them fully.

So Many Reasons

There are so many reasons to describe God as wonderful!
So many reasons to praise him with unlimited praise!
Psalm 48:1

Wonderful One, when I stop to consider how you have met me with mercy time and again, I cannot help but praise you. I have so many reasons to thank you, so many reasons to stand in awe before you. As I take time to remember how you have provided for me, how you have healed me, how you have led me in love, may the overflow of my heart be like a sweet fragrance before you. Open my eyes to things I had forgotten about, and I will pour out my love even more.

Even as I look at the natural world around me, I see so many reasons to praise you. The way the sun dances on the snow, the way the ocean both humbles me and reminds me of how great you are, the night sky full of stars that reflect your glory—so many reminders of your greatness surround me. I will not hold back my praise today. You are worthy of it in every moment of every single day.

What reasons can you find today to describe God as wonderful?

Waiting on His Breakthrough

Then he broke through and transformed all my wailing into a whirling dance of ecstatic praise! He has torn the veil and lifted from me the sad heaviness of mourning. He wrapped me in the glory-garments of gladness.

Psalm 30:11

Lord, when I find myself in a season of waiting, help me to keep my eyes fixed on you. I know you will come through for me. Breakthrough is on its way, and I know you won't fail to meet me with your loving-kindness in overwhelming ways. You are the one who turns my mourning into dancing and lifts me from the sad heaviness of grief. Even though sorrow lasts for a night season, I know that dawn is coming and, with it, joy!

Even in seasons of sadness, you bring glimmers of hope, of delight, and of peace. I rely on you in the good times and in the extremely hard times. I have seen you come through for me before, and I trust that you will do it again.

When you are in a time of grief or overwhelming sadness, what brings relief?

Grace Granter

*Whenever I was in distress, you enlarged me. I'm being squeezed
again—I need your kindness right away! Grant me your grace, hear
my prayer, and set me free!*

Psalm 4:1

God, when I am being squeezed by the trials of life, I need your
grace. I need your kindness right away. Grant me the power of
your grace every moment I look to you. I don't want to waste
away under burdens too heavy to bear. You are the bearer of
my burdens, so will you lift them today? I choose to take the
yoke of your love, for it is light and brings so much relief.

I know I cannot keep distressing circumstances at bay. Life
will hand them to me whether I want them or not. When I am
being pressed on every side, I need your grace to empower
me in soul, spirit, and body. You are my protector, my guide,
and my source of life. You are what I need, Lord, in any and
every circumstance. Grant me your grace today, hear my
prayer, and set me free.

*What life-giving relationships offer you space when you feel
the pressures of life bearing down on you?*

Wait for Him

Quiet your heart in his presence and wait patiently for YAHWEH.
And don't think for a moment that the wicked, in their prosperity,
are better off than you.

Psalm 37:7

YAHWEH, I quiet my heart right now. All the swirling thoughts, the nagging worries, and the pull of what needs to be done can wait. I lay them before you and trust that you will lift what is not mine to carry, and you will offer me only what I can do by your strength and through your Spirit. Show me what my assignment is for the day. What do you want me to focus on?

Before I move on with my day, I take time in your presence. I don't want to be in a rush. Even as I step into the tasks of my day, I invite you to go with me. I keep my heart open to your leadership and my mind available to your wisdom. Even as my body moves, my soul still waits on you. You are glorious; why would I take my gaze off you? I trust you with my heart, my plans, my relationships, and my life.

How can you actively wait on God throughout your day?

Life-Giving Counsel

The way you counsel me makes me praise you more,
for your whispers in the night give me wisdom,
showing me what to do next.

Psalm 16:7

Father, when I wake up in the middle of the night, my mind full of thoughts I can't settle, whisper your wisdom into my heart. Fill my dreams, my thoughts, my plans with your mercy. Show me the way I should go. Help me let go of the things I cannot change. Give me compassion for myself as well as for those around me. Your counsel is life-giving. How kind and gracious you are! How acute and specific is your wisdom! When I don't know what to do, you help me. Most of all, you teach me how to be like you through your incomparably good nature.

I need your input, Lord. I need your direction. I submit my plans to you, and I trust you to guide me, even as I take steps forward. When I need to pivot, redirect me. When I need to stay flexible, open my eyes to other options. You are so reliable in wisdom and full of kind guidance.

Do you need God to speak whispers of wisdom into your plans?

Day and Night

*He rises on one horizon, completing his circuit on the other,
warming lives and lands with his heat.*

Psalm 19:6

Creator, you are not relegated to one place on this earth. You are everywhere, with all who cry out to you. Whether I stay or go, no matter where I am in this world, you go with me. This is almost too much to comprehend. I give little thought to whether there will be oxygen to breathe when I travel the world; I just expect it to be true. May I come to expect your presence in the same way. In my workplace, in my travels, or alone in my room, there you are. With every breath, I am reminded of how near your presence is. And so you are with all your beloved children.

As I draw my attention back to my breath throughout the day, may I be compelled to pray for those around the world waiting for your help. Reveal yourself to them as their mighty Savior. Be near in comfort to those who mourn. Be glorified in the celebrations of your sons and daughters. Day and night, rise up and warm the lives of those you love.

Have you ever used a cue to help with prayer? Use your breath as a reminder to pray and that God is with you.

Rays of Revelation

*Pour into me the brightness of your daybreak! Pour into me your
rays of revelation-truth! Let them comfort and gently lead me onto
the shining path, showing the way into your burning presence,
into your many sanctuaries of holiness.*

Psalm 43:3

Holy One, there is so much wisdom in your presence. Your
glory shines, and it lights up the darkest night. As I spend time
with you today, pour into me the brightness of your daybreak.
Like the earth comes alive in the light of dawn, so make my
inner world come alive as you shine on me. I long for the reve-
lation light of your truth. Here I am. I lift my eyes to you.

The warmth of your revelation thaws the cold edges of
my heart. It brings warmth and comfort. I cannot help but be
relieved by the bright light that breaks through the dark night
of the soul, through the fog of confusion, through the wilder-
ness overwrought with the weeds of this world. Shine on me,
and I will see where I need to go to follow you on the shining
path. Thank you.

What revelations of God have given you vision and hope?

He Makes Things Right

He was so kind, so gracious to me.
Because of his passion toward me,
he made everything right and he restored me.

Psalm 116:5

Kind Father, I've never known a love like yours, so gracious and patient. You are gentle with me, like the best mothers are with their children. You see the areas of pain in my life, and you don't leave me to suffer in them. You meet me there, right in the middle of my pain, and you make everything right. You restore what is broken, and you redeem what seemed forever lost. You are the miraculous one who rights my wrongs and revives my life.

Thank you for the power of your persistent presence in my life. You have done more good for me than anyone else. You have revealed the lengths of your love by pursuing me even in my wandering. There is nothing that you won't do for those you love. There is no problem I face that you can't make right. I trust you, my God.

What has God made right in your life? What restoration are you waiting for?

Powerful Refuge

*God, you're such a safe and powerful place to find refuge!
You're a proven help in time of trouble—more than enough
and always available whenever I need you.*

Psalm 46:1

Rock of Ages, you are the one I run to when the world seems to be spinning out of control. You are my firm foundation, the solid rock that never moves. You are the faithful one who delivers his people time and time again. Thank you for the hope I find in you. You are a powerful place of refuge. You never run out of resources. Today, again, Lord, I run to hide myself in your presence. You are always more than enough and always available.

I don't want to be overwhelmed by worry or distracted by fear. Lord, I need the peace of your presence to set me right and to settle the chaos. I trust you more than I do my own senses. I trust you more than I trust my closest friends. I trust you, Lord. Meet me with the abundance of your grace and pull me in close to hear your heart once again.

*Does your soul find rest in God's presence? Take him your
worries today and leave your cares with him.*

He Holds Eternity

One thousand years pass before your eyes like yesterday that quickly faded away, like a night's sleep soon forgotten.

Psalm 90:4

Constant One, when I feel the crunch of time, remind me that you are not rushed or worried. May I find peace in your presence; there is space to relax, to move slower, and to unwind in you. You are the Eternal One, and you are not limited by time frames. You are not hemmed in by challenging circumstances. I will trust you with my days, with my troubles, and with my heart. You are my great confidence. As your Word says, "My life, my every moment, my destiny—it's all in your hands" (Psalm 31:15). I can rely on you every moment of every day without fail, for you are there through it all.

Lord, I don't just trust you with my life, but I also trust you with my soul. When the light of my life dims and I enter the expanse of eternity with those who have gone before, I trust that I will meet you there. You hold my destiny in your hands, and that includes the destiny of my soul. I am yours, and in you, I find true rest, both now and forever.

Does trusting God offer you peace about the future?

Rescued and Redeemed

Into your hands I now entrust my spirit.
O Lord, the God of faithfulness,
you have rescued and redeemed me.

Psalm 31:5

Jesus, before you entrusted your spirit to the Father's hands upon the cross, David had already put those words to melody as a song of poetic praise to his heavenly Father. I don't take for granted the help I have found in you. You are my confident hope, my advocate, and my defender. You rescue and redeem me, and you do it over and over again. You are the God of my restoration, the healer of my body and soul. I love you more than I can say. Why would I not entrust my spirit to you?

As long as I have breath, I will sing the praises of my Savior. You guide me and keep me close to your heart as I follow your ways. I will never stop thanking you for your faithfulness. I offer you my wholehearted trust again today, holding nothing back from you. You are loyal in love and faithful in kindness. Thank you for all that you have done, are doing, and have yet to do.

How has God rescued you? Spend time thinking about the specific scenarios and give him thanks for each one.

Present Peace

Every godly one receives even more than what they ask for.
For you hear what their hearts really long for,
and you bring them your saving strength.

Psalm 145:19

Father, you are better than good to me. You are generous in all you do, offering even more than I know to ask for. You overwhelm my need with the abundance of your resources. You meet me with the overflow of your present peace and your limitless love. You speak, and my heart sings. You move, and my fears dissipate in the wonder of your miracle-working mercy.

Thank you for reading the truth of my heart, the longings I cannot put into words. I lay my heart before you like an open book. I invite you to write your truth upon the pages of my life. I am yours, Father. I am your daughter, and it astounds me the way that you delight in me. Watch over me, guide me, and lead me into your love with every dawn. Tuck me in with your peace each night. I trust in you.

How have you seen God's generosity in your life? Make a list, and when you need encouragement or a fresh dose of hope, come back to it.

All That We Need

The oppressed get justice with you.
The hungry are satisfied with you.
Prisoners find their freedom with you.

Psalm 146:7

Lord Jesus, you are the liberator of the imprisoned, the advocate of the oppressed, and the satisfier of the hungry. All that we need, all that we long for, all the comfort, relief, and generosity we could ever dream of is found in you. Lifter of my burdens, do what only you can do today. I don't have much to offer except an open heart when my resources are depleted. There is so much pain in this world. It is too much to bear without the hope of your help, God.

You are our true help. When nothing else works, you are the miracle deliverer. When the strongest among us falls, you are not tripped up at all. You remain steadfast in loyal love, and you bring restoration to situations that seem completely hopeless. I know that you are the answers I am looking for, Lord. Rise up and move in mercy and in truth. Open my eyes to your miraculous presence with me even now. I need you.

When your faith is tested, how do you keep hold of audacious hope?

God of the Breakthrough

Our hero, come and rescue us! O God of the breakthrough, for the glory of your name, come and help us! Forgive and restore us; heal us and cover us in your love.

Psalm 79:9

Glorious God, you are the hope of the hopeless. In you, there is always promise for breakthrough, for nothing is impossible with you. You led your people out of their captivity and through the bed of the Red Sea with walls of water on either side. You led them through the desert with a cloud by day and a pillar of fire by night. You gave them manna from heaven to feed their bellies, and water gushed from a rock to satisfy their thirst. You are a miracle maker with creative solutions for every problem we face.

Instead of trying to problem solve on my own today, I look to you. Especially in the areas where I see no possibility of goodness, I depend on your wisdom and your power to move. You are the God of the breakthrough. You are the God of *my* breakthrough, and I rely on you.

What do you need God's help with today? In what area are you relying on him for breakthrough?

Inside and Out

You know all about us, inside and out.
You are mindful that we're made from dust.

Psalm 103:14

Creator, when I grow tired of having to explain myself to others, I know that I can let my guard down with you. You know it all. You know me through and through. Nothing in my heart is a mystery to you, even the things that I can't understand about myself. When I am confused and disappointed, speak your words of life over me. Remind me again that you fully see me, know me, and love me. I long for the relief of your kindness toward me even now.

With your compassion as my guide, help me to extend compassion to myself. I don't want to hold myself to an unrealistic expectation, especially one that I would never put on someone else. You are the only perfect one. May my soul find rest in your loving gaze today, refreshing me from the inside out. I love you.

When you are disappointed in yourself, do you go to God and ask him to speak his words of life over you? He is not disappointed in you.

Never Overlooked

You've kept track of all my wandering and my weeping.
You've stored my many tears in your bottle—not one will be lost.
For they are all recorded in your book of remembrance.

Psalm 56:8

Faithful Father, I am so far from perfect. This life is so far from perfect. There are heartbreaks and tragedies that I just cannot avoid. Lord, where there is pain in my heart, life, and the world, come in close with the comforting peace of your presence. I know that you don't overlook a thing; it all matters to you. When I am overwhelmed with grief, your love overwhelms me even more. Thank you for the limitless mercy of your heart that you never hide or hoard. You are so generous in kindness and compassion. Your love is not weak; it is the strongest force on this planet.

I'm so glad that I never have to fake the state of my heart with you. You accept me in my weakness, in my sorrow, and in my doubt. I bring it all before you. Meet me with your miraculous mercy and encourage my heart in the knowledge that you see, you know, and you will never look away.

Do you bring God the pain, the heartbreak, and the suffering
you experience?

Above All Else

*Surrender your anxiety. Be still and realize that I am God.
I am God above all the nations, and I am exalted
throughout the whole earth.*

Psalm 46:10

Lord, in a world that is always giving me more reasons to worry, I cannot pretend that I never struggle with anxiety. And you don't ask me to pretend. Your Word reminds me to give you all my anxiety because you tenderly care for me (1 Peter 5:7). When I feel anxiety about a situation, I can offer it to you in prayer, trusting that you hear me and will help me. God, thank you for the ways that you faithfully meet me with the power of your peace. You bring clarity to my confusion, peace to my chaos, and hope to my weary heart. You are never worried about a thing, and I don't want to be either.

I will saturate my life in prayer starting today. As every worry pops up, I will bring it to prayer and hand it over to you. I won't stop asking for your intervention, for your wise solutions, or for more of your love in my life. I quiet myself in your presence now before I do anything else. You are the God who reigns above everything and everyone.

How can you keep your heart connected to God throughout your day?

Secret Place

Lord, you are my secret hiding place, protecting me from these troubles, surrounding me with songs of gladness! Your joyous shouts of rescue release my breakthrough.

Psalm 32:7

Great God, I run to hide in you when the world is overwhelming. But the truth is that I want to hide myself in you even when all is calm too. Your presence is like a hidden spring. It refreshes my soul. It is like a secret paradise that I cannot get enough of. You protect me from the troubles of this life; truly, they melt away when I sink into the spring of your love, your peace, and your joy. All that I need is found in you, in the encounter that happens in that secret place within my soul where your Spirit pours into me.

Wash over me, Lord, and I will sing the songs of gladness that you surround me with. You are the God of my breakthrough, and I trust you. The more time I spend in your life-giving presence, the more confident I become of your goodness.

Do you have a "secret hiding place" you go to with the Lord? It could be a place you imagine or a physical place of rest. Spend time with him there today.

One Glorious Thing

Here's the one thing I crave from YAHWEH, the one thing I seek above all else: I want to live with him every moment in his house, beholding the marvelous beauty of YAHWEH, filled with awe, delighting in his glory and grace. I want to contemplate in his temple.

Psalm 27:4

Beautiful One, even when I come to you with a long list of requests, I can honestly say that it all comes down to this: I want to be near you. I want to know you. I want to be loved to life in your presence every day. You are better than anyone I have ever known. Your love is not based on conditions, and your wisdom isn't something I can earn. Whenever I come to you, you receive me with open arms. What a wonderful God you are! What a perfect Father! What a dependable friend! You truly are better than I can ever comprehend.

This one thing I crave, God: to live with you every moment. I know that your Spirit makes itself at home in me, so this isn't a pipe dream. Fill me with awe as I turn my attention toward you. Light up my heart as you shine on me. I delight in you.

What draws you to God time and again?

Renew My Hope

YAHWEH, you have heard the desires of the humble and seen their hopes. You will hear their cries and encourage their hearts.

Psalm 10:17

YAHWEH, thank you for the encouragement you offer through your presence. Thank you for your life-giving words that renew my hope and refresh my soul. You are the one who relieves my fears, who breaks through the dark night of the soul, and who provides for all that I need. You are reliable and strong. You are faithful and true. You never give up on me, and I won't give up waiting on you. Meet me with the power of your presence and encourage my heart in hope as you speak to me today.

I won't hold back my desires from you, for you see my hopes. You know my deepest longings, and I can trust you with them. You won't ever hold them against me. You are reliable in love, and you always lift my spirits when I am discouraged. Here I am, Lord. Lift my spirits again.

What do you need encouragement over today? Even if you cannot think of a specific area, ask God to build your hope as he encounters you with his love today.

Tested and True

Every word YAHWEH speaks is sure and reliable.
His truth is tested, found to be flawless, and ever faithful.
It's as pure as silver refined seven times in a crucible of clay.

Psalm 12:6

Lord, you are not just a truth-teller; you are the way, the truth, and the life. You are the foundation of all that is right. Your Word says that you never lie. You have no reason to manipulate us with anything. You are always true. You are the standard, and everything is laid bare before you. As I hold my questions up to the light of your truth, shine on them and reveal your lasting wisdom. Where there is confusion, bring clarity. Where there is doubt, bring confidence.

Every word you speak is reliable. Every promise you make is a sure thing. I can always count on you to follow through on your word. I'm beyond grateful that you are faithful. May I follow your example and be a woman of my word. I want your light to shine brightly through my yielded life. Be glorified in me, Lord.

What promises of God are you holding tightly to today? What promises of your own do you need to follow through on?

A Devoted Caregiver

Lord, you delivered me safely from my mother's womb.
You are the one who cared for me ever since I was a baby.

Psalm 22:9

Faithful One, you are the keeper of my soul, and you hold me close in your arms. You care for me like a devoted mother, like a tender father. You provide for me, but you also shower me with love. What a powerful picture of affection I find in you as my devoted caregiver. You are not my boss; you are not a taskmaster. You are the Father, and I am your beloved daughter. Thank you.

I trust that you will not let me go and you won't abandon me. Even as I grow older, you care for me still. You offer your wisdom, your affection, and your guidance whenever I need it. You don't hold back your love even for a moment. Revive my heart in the fellowship of your presence today. I lean into your heart with my own.

Do you know God as a loving caregiver? Consider the most loving parental figure you know. God is even more gracious, tender, and attentive to you than they are.

Arise with Gratitude

*At each and every sunrise we will be thanking you for your
kindness and your love. As the sun sets and all through the night,
we will keep proclaiming, "You are so faithful!"*

Psalm 92:2

Lord, each morning is a new opportunity to see your goodness and to thank you for it. Just as the sunrise is a cue for a new day, may I rise with gratitude in my heart and on my lips. Even when I wake up with worry, I can redirect my heart in hope by drawing my attention toward what is true, what is beautiful, and what is graciously enough in the moment. You are always enough. You are always near. Your kindness never wanes. I am forever grateful for your presence.

I know that as I set my heart on you, I will see your faithfulness shine through my life. You provide for your children, you pour out your love upon us, and you never leave us. Each evening, give me eyes to see how faithful you are to me, and I will turn my heart to you each morning with gratitude and an open heart of praise.

*Do you have a practice of gratitude in your life? Set your heart
with gratitude in the morning and consider God's faithfulness
each evening.*

Keeping Your Heart Sensitive

This is what I've learned through it all: All believers should confess their sins to God; do it every time God has uncovered you in the time of exposing. For if you do this, when sudden storms of life overwhelm, you'll be kept safe.

Psalm 32:6

Loving Father, I don't want my heart to grow cold and unyielding. I want to stay malleable in your love. When I am confronted with parts of myself that are not in line with your nature, help me to humble myself before you and others. I want to grow in wisdom, and I know that takes intentionality. It is your kindness that melts my heart and leads me to repentance. How could I turn away from such understanding and compassion?

I will not excuse compromise in my life. No, I want to live freely and openly before you, so I choose to confess my sins every time you uncover them. Thank you for the opportunity to experience your redemption, your restoration, and your mercy every time I repent.

How willingly do you receive correction? How quick are you to admit when you are wrong?

Shelter of Hope

He's the hope that holds me and the stronghold to shelter me,
the only God for me, and my great confidence.

Psalm 91:2

My Father, you are the hope that holds me, wrapping around me like a great big bear hug. I confess that I need such hope to carry and shelter me today. When my world is spinning, you are the one who steadies me. When the storms of life whip around me, your arms are the shelter that keeps me safe and warm. You are my living hope.

Though my confidence in others may wane as their faults come shining through, you remain my great confidence. You are unchangeable, and that is the best news my heart could receive. Though I have doubted your goodness from time to time, you remain steadfast in mercy-kindness. You overwhelm my doubt with the reality of your powerful love. Don't stop revealing your beautifully faithful nature to me. Show me your heart, even as you pull me in close.

What kind of hope holds you today?

Pursuing the Truth

Help me turn my eyes away from illusions so that I pursue only
that which is true; drench my soul with life as I walk in your paths.
Psalm 119:37

Loving Lord, direct my eyes to your truth and light up my mind with your unchanging love. So many distractions vie for my attention. I don't want to get caught up in conspiracies or what-ifs. I want to be grounded in the truth of your mercy, the grace of your presence, and moved by the kindness of your heart. You are light, and life, and truth, so I look to you.

Jesus, your example is beautiful and profound. You didn't distance yourself from people facing real and overwhelming problems. You met them in it. You showered them with love, showed them a better way, and healed their diseases. You are the one who raises the dead to life, and you haven't stopped moving in wonder-working ways through your Spirit. I follow after you, Lord Jesus, and I spend time in the Word to fill up on your wisdom. Guide me and direct me, first with my attention so that I can turn my eyes away from illusions and fix them on what is true.

What illusions have distracted you from the message of Christ?

Glorious Freedom

Go ahead—let everyone know it! Tell the world how he broke through and delivered you from the power of darkness and has gathered us together from all over the world. He has set us free to be his very own!

Psalm 107:2–3

Mighty Deliverer, no problem is too big for you to handle. No darkness is so great that you don't light it up with your presence. You are the God of the impossible, setting wrong things right, moving mountains, and healing hearts. How I love you! God, you see the areas of my life where I am a work in progress. You call me daughter, and you lovingly guide me through the twists and turns that I cannot see around.

There isn't a nation where your Spirit is absent. There isn't a people that you don't already hold in your heart. You love us, you gather us to yourself, and you set us free as your very own. What a beautiful Father you are to the nations! I am humbled to be a part of your diverse family that knows no borders.

What are the limits you have put on God that he wants to break through?

Steady On

Keep hoping, keep trusting, and keep waiting on the Lord,
for he is tenderhearted, kind, and forgiving.
He has a thousand ways to set you free!

Psalm 130:7

Constant One, thank you for the power of persistence that keeps me close to you. Even when I have no energy to push through boundaries, I continue to trust you and take each step as it comes. I will keep hoping today. I will keep trusting your faithfulness, especially in the liminal spaces between promise and breakthrough. I will keep waiting on you, for I know you will show up.

I'm relieved by the truth that you are not limited in ways to set me free. You know all possible routes and destinations. You see every possibility. I yield to your wisdom and ask for your best, Lord. In the meantime, I will hope, trust, and wait for you. Drench my heart with your tender love and speak to me with your kindness. Thank you for your generous forgiveness every time I stumble and fall. I keep coming back to you, my Savior and my God.

What small step can help you to hold on to hope and keep trusting the Lord today?

Persistent Love

I will never, no never, lift my faithful love from off their lives.
My kindness will prevail and I will never disown them.

Psalm 89:33

God of my hope, I am mesmerized by your faithful love. You never give up on your children, and you'll never give up on me. Your kindness is persistent in my life. I cannot begin to thank you for all the goodness you have shown me, for all the kindness you have sown into my life. You are wonderful, and my heart expands in awe before you as I consider the ways you have satisfied my needs in your mercy.

I will take your lead and persist in love for you today. I will pour out my heart as I hold on to the hope that I have not seen the last of your goodness. Meet me again as I seek your face. Pull me in close to your heart. Let the truth of your faithful love that will never leave or let up seep deep inside the cracks of my heart today. I am yours, and I am listening for your voice, even if it comes in a whisper. Awaken me again to the joys of your presence.

Do you believe that you can never lose God's love?

Spilling Over

God, our hearts spill over with praise to you!
We overflow with thanks, for your name is the "Near One."
All we want to talk about is your wonderful works!

Psalm 75:1

Near One, I am in awe of your presence that comes in close, blanketing me in your powerful peace, your lavish love, and drenching me in your delight. My lips cannot stay silent, for my heart overflows with love for you. Thank you for never giving up on me. Even on my darkest days, you have remained constant and close in comfort. You never leave me, and you never will. Thank you for the promise of your companionship, your strength, and your help.

I am spilling over with praise today. When I think of the ways you have overwhelmed my fears with the practical provision of your wonderful works, I am flooded with gratitude. Thank you for providing for my needs. Thank you for alleviating my fears. Thank you for your strength, your comfort, and your peace in the waiting. You are the Near One, and you will always be.

How has God's nearness transformed your heart, your perspective, or your life? Take time to consider the fruit of God's presence in your life.

Purposeful Grace

If God's grace doesn't help the builders, they will labor in vain to build a house. If God's mercy doesn't protect the city, all the sentries will circle it in vain.

Psalm 127:1

Great God, I don't want to labor in vain in any pursuit. Though I can do a lot to stay busy, busyness is not the point. I want to partner with your purposes, revealing your lavish love, your compelling compassion, your marvelous mercy, in all that I put my hands to. I don't want to go about my days, weeks, or years with mindless work that is missing the power of your grace and mercy. Thank you for your partnership. I invite you into the work of my mind and hands, and I ask you to put your power behind it. And where I need to pivot, guide me by your Spirit. I trust your leadership.

I rely on your grace to empower my efforts. I depend on your mercy to protect my home, my relationships, and my heart. You are stronger, wiser, and more diligent than the most skilled people I know. Why would I leave you out of anything?

Is there any area of your life into which you have yet to invite God?

Soothed and Contented

I am humbled and quieted in your presence.
Like a contented child who rests on its mother's lap,
I'm your resting child and my soul is content in you.

Psalm 131:2

Lord my God, some days I feel like a helpless child in need of her mother. When I do not know how to soothe myself, I long for the soothing of your presence. Gather me into your arms, speak to me with gentle words, and regulate my heart and body with the peace and strength of your own. I trust you to care for me. You know better than I ever could just what I need in every moment. Satisfy my heart with the abundance of your love.

As I walk through this day, I keep open the connection of my heart to yours. When I feel overwhelmed, rush in close as soon as I turn my inner attention to you. Some days I need your protective care more than others, but each day you honor just what I need. I am grateful that I need never stay away from you. You are a help in all sorts of ways, not the least of which is caring for and soothing me in your presence.

How would you help soothe a child who is hurt? God wants to care for you in the same way.

Unoffendable Peace

There is such a great peace and well-being that comes to the lovers of your Word, and they will never be offended.

Psalm 119:165

Prince of Peace, when I fill up on the bread of your Word, my soul is satisfied. You nourish me with the life-giving waters of your Spirit. Your presence carries a pervasive peace that soothes my worries and builds my confident trust in who you are. I won't neglect spending time with you each day. I take the time to listen for your voice and to grow in the wisdom of your Word. Just as my body needs energy from food, so my soul needs the nourishment of your living Word.

Lord, I want to be unoffendable. Even when others try to hurt me, may I be so rooted and grounded in your love that I let it trickle off like rain on a windowpane. Your peace is like a protective shield for my heart. As I sit in your presence even now, build up that buffer of peace within me so that I can walk through my day with generous grace in every interaction. Thank you.

How does spending time in God's Word and in his presence set the tone for your day?

Collective Blessings

God himself will fill you with more. Blessings upon blessings will be heaped upon you and upon your children from the maker of heaven and earth, the very God who made you!

Psalm 115:14–15

Creator, you are the true source of all that we need. You are my source. I don't take this for granted today. I come to you with an open heart, ready to be filled. What a glorious mystery that you, the maker of heaven and earth, make your home in the hearts of your people. You fill me with more of yourself. I have tasted and seen your goodness through the blessings of your nature and your helping hand. There is an abundance of blessing in the collective of your people.

Lord, open my eyes to see the wonders of your love at work in my life, in the lives of my family and friends, and in communities around the world. You are working, and I know you won't stop. Thank you for all that you have done, for all that you are doing, and for all that you will continue to do. You are wonderful.

Have you spent time counting your blessings lately? Look outside your own life to those around you and thank God for the blessings you find.

How He Does It

Look! Here he comes! The Lord and judge of all the earth!
He's coming to make things right and to do it fair and square.
And everyone will see that he does all things well!

Psalm 98:9

Righteous One, I know that you are the way, the truth, and the life. You do not compromise, even when everyone around me seems to. You aren't impressed by smooth talking or charming deception. You are not won over by wealth or power. You see everything and everyone as they truly are. I trust that you will make things right and do it with justice and mercy. I don't have to take justice into my own hands or seek revenge; in fact, if I try, I will be no better than those who hurt and oppress others. Help me to partner with you and to stand in your love no matter what.

Lord, I lift you high as King over my heart. You are my defender and my shield. You are my advocate and my liberator. My hope is in you, not in the leaders or nations of this world. I know that you do things well, so I will live my life yielded to the law of your love. I know you are worth it.

Do you trust God to make things right in the end?

Gentle and Patient

Lord, your nurturing love is tender and gentle. You are slow to get angry yet so swift to show your faithful love. You are full of abounding grace and truth.

Psalm 86:15

Gentle Lord, your love is not weak. Kindness and tenderness are strengths. May I never overlook the power of a loving gesture. I'm so grateful that you are slow to anger. At times, I am too quick to jump to conclusions about others. I don't want a temper that is out of my control. Help me to lean into your grace and admit to those in my life when I have missed the mark. I want to be full of grace for them when they do the same.

Your patience is astounding. Though you are slow in judgment and anger, you are quick in compassion and tender love. You are faithful to meet me with the mercy of your heart every time I come to you, even when I am kicking and screaming. Just as a good parent deals with their child's unregulated emotions with compassion, so you do the same with me. Thank you.

Do you know the gentleness and kindness of God's love?

Miracles of Healing

O Lord, my healing God,
I cried out for a miracle and you healed me!

Psalm 30:2

Lord, I need your healing. You see the wounds in my body and soul, and you are the one who knows just what I need. Like a healing salve, pour your presence over the vulnerable places of my heart and life and bind up my wounds. I cry out for a miracle today.

Restore me, Lord. You see the areas of brokenness that need a touch from you. Jesus, you are the healer. You are my healer, and I am reaching out for you. When I think about the ways you have healed others, it encourages my heart in hope. I don't want to live hanging by the thread of others' testimonies. Move in me, meet me, and overwhelm my body, mind, heart, and soul with your powerful peace. Knit together what has come undone in me and make me new in you. Miracle maker, do what you do best and restore my energy and soul.

What needs healing in your body, heart, mind, or life?

Divine Help

The Lord God has become my divine helper.
He leans into my heart and lays his hands upon me!

Psalm 54:4

Lord God, you are my divine help. I rely on your strength more than I rely on anyone else. When all is well in my world, when my health is strong and my mind clear, there is not much I think to ask you for. But when I am feeling the depth of my need, I call out to you with the desperation of a child. Lord, lay your hand upon me and settle my soul with your peace. Lean into my heart with your love and expand my understanding of who you are. I trust that you won't let me down, not today and not ever.

You are the God who made bread fall from heaven. You are the God who shut the mouths of lions when Daniel was thrown into their den. You are the God who made a path through the Red Sea. You are the God who healed the sick and who raised Lazarus from the grave. You are the God of miracles, the God of present help, and the Good Shepherd who leads his children out of harm's way. You are my God, and I trust you.

What do you need God's help with?

Arise with Praise

Arise, my soul, and sing his praises! I will awaken the dawn with my worship, greeting the daybreak with my songs of light.

Psalm 108:2

Son of Righteousness, with the dawning of the day, my heart awakens with love for you. Pour over my heart the way sunlight cascades over the earth, lighting up the shadows. I will greet the day with praise, for you are the giver of life and you have given me another day to know and love you. This is yet another opportunity to experience the joys of this beautiful life. I will look for reasons to praise you. I will look for the goodness that is already around me. What an abundance of blessings there are to offer you my grateful praise.

Oh my heart, light up with praise. Your God has not abandoned you. He is here with present peace. He is overflowing in love that soaks into the soil of your heart, into every crack and crevice. He is with you, and he is for you. Give him praise today.

When you look at the landscape of your life, where does the light reveal God's goodness to you?

April

In My Weakness

Lord, in my place of weakness and need, won't you turn your heart toward me and hurry to help me? For you are my Savior, and I'm always in your thoughts. So don't delay to deliver me now, for you are my God.

Psalm 70:5

Lord, turn your heart toward me today. Empower me with your grace, for I am weak. Meet my need, for I cannot do it on my own. Thank you for always being available and accessible. You are my closest friend, my holy help. You are my Savior, and I depend upon you. I need you to meet me in the place of my weakness. I know you will handle me with care. You are a skilled heart surgeon, and your hand does not shake. Do what only you can do and love me to life from the inside out once again.

I don't pretend to have it all together today. What a vain thing to do. No, you are my safe space, and you are trustworthy. I don't hide the vulnerable places of my heart or my life from you. Welcome in. Hurry to help, Lord, for I need you more than I can say.

When you let your guard down, what is there that the Lord can minister to?

Unending Portion

You become my delicious feast even when my enemies dare to
fight. You anoint me with the fragrance of your Holy Spirit;
you give me all I can drink of you until my cup overflows.

Psalm 23:5

Father, I feast at the abundance of your table. You are my unending portion every single day. The power of your Spirit is alive and well and moving in me. Fill me up to overflow with the grace and mercy of your presence. When I am hungry, you offer me the bread of your Word. When my soul is thirsty, you quench it with the living waters of your pure presence. There is always more than enough in you.

No matter what comes up today, whether conflict or chaos, I find all I need in you. I run into your heart with abandon, knowing you are the place of my peace, the generous grace that I desire, and the wisdom I need to navigate this world. Guide me, Spirit, for I am yielded to your leadership. Thank you.

What is your heart, mind, or soul hungry for today? What do
you need from God's presence? Take and eat, for he offers you
all that he is.

Perfect Consideration

*The Lord looks over us from where he rules in heaven. Gazing
into every heart from his lofty dwelling place, he observes all the
peoples of the earth. The Creator of our hearts considers and
examines everything we do.*

Psalm 33:13–15

Lord, I know that only you see perfectly. I am limited to the
little I already understand, but oh, how I long to learn more of
your ways today. Thank you for the opportunity to grow in wis-
dom each and every day. I humble my heart before you and
willingly align myself to your ways as you reveal them. I know
that I will fail sometimes, and you aren't scared of my failures.
Help me to take each as a lesson and to stay humble before
you and others. I trust your leadership more than the pull of
my own opinions, for you are perfect in all your ways.

Gaze into my heart today and shine on the parts that need
compassion, direction, and healing. I trust you as my God and
my healer, my Savior and my confidant. I'm so glad you see
our hearts clearly. I yield to your guidance today. Lead me in
your love, Lord.

*Are you quick to judge the actions of another without
knowing their heart?*

Live Charitably

*Life is good for the one who is generous and charitable,
conducting affairs with honesty and truth.*

Psalm 112:5

Generous Father, there isn't a resource that you keep to yourself. You share your kingdom, your love, and your grace with all your children. Thank you for the beautiful example of your benevolent love shown through the life, death, and resurrection of your Son. I want to walk in the light of integrity with nothing to hide from you or anyone else. May your love keep me on the shining path. Help me to choose honesty even when it is hard. Help me to promote the truth, especially when conspiracies and deception are the more popular thoughts, even among your people.

As for me, I choose to live as one who is generous and charitable, not holding back from doing good when I have the ability to do so. I will remain honest and truthful in my work and in my relationships. I will admit when I am wrong, and I will do better when I know better. Thank you for the power of peace in a life that is surrendered to you.

Of the attributes described in today's verse, which do you need help with?

Everlasting Victory

*Some find their strength in their weapons and wisdom, but my
miracle-deliverance can never be won by men. Our boast is in
YAHWEH our God, who makes us strong and gives us victory!*

Psalm 20:7

Lord, I know that victories won by sheer strength of will or
muscle do not last. But your victory, oh Lord, is forever and
final. Your miracle-deliverance cannot be denied. I have expe-
rienced success by earning it with my achievements and hard
work, and I am grateful for it. But it means nothing to me in
comparison to the victory I experience in you when I have
nothing to offer but my meager faith. You are my deliverer.

When I am discouraged, I lift my eyes from the world and
its ways, and I remember who you are. Many scheme and suc-
ceed, at least for a little while, but I know that won't last. I wait
for you, and in my waiting, I trust that you will empower me in
grace, faith, patience, and compassion. You are my great God,
and I know with you is the victory I am longing for.

*Is there an area in your life where you need a fresh dash of
hope and a reminder of God's power?*

Nature's Cues

The God of gods, the mighty Lord himself, has spoken! He shouts out over all the people of the earth in every brilliant sunrise and every beautiful sunset, saying, "Listen to me!"
Psalm 50:1

Mighty God, open my eyes to see you in the landscape of this world. When I see the sun rising in the east, speak to my heart of the power of your love. When I watch it setting in the west, expand my awareness of the beauty of your heart. As I notice the trees, the budding flowers, and the bees buzzing around them, speak to me of the redemption of new life. Remind me of the cycles of my own life as I see them reflected in the seasons of the earth. There is so much to discover about you in the way that your creation works.

I open my heart to listen to you each day, offering you my prayers and praise but also quieting myself before you. As I slow down and calm myself in nature, increase my awareness of your presence. Speak to me and teach me through the details of your handiwork. How I hunger to know you more!

How much time do you spend in nature?

The Fruit of His Goodness

From your kindness you send the rain to water the mountains from the upper rooms of your palace. Your goodness brings forth fruit for all to enjoy.

Psalm 104:13

Kind God, thank you for sharing your goodness with us. The fruit of your kindness is sweet to the taste and satisfying to the soul. May your fruit bear more fruit in my life. I cannot escape the power of your Spirit that produces basketfuls of your holy traits in this world and in my life. Wherever there is joy that overflows, peace that subdues, and patience that endures, there you are at work. Where there is kindness in action, a life full of goodness, and faith that prevails, you are there too. Where there is gentleness of heart and strength of spirit, the fruit of your presence is there.

I long for that kindness, the fruit of your character, to be evident in my life, not just in bits and pieces but in abundance. I submit my heart to you, and I follow in your ways, cultivating the love, joy, peace, patience, kindness, goodness, faith, gentleness, and self-control that you provide. Your ways are always the best.

What fruit of the Spirit can you cultivate in your heart and life today?

Spill It

*I spill out my heart to you and tell you all my troubles. For when
I was desperate, overwhelmed, and about to give up, you were
the only one there to help. You gave me a way of escape from the
hidden traps of my enemies.*

Psalm 142:2–3

I have had close friends, and I have known the sting of betrayal,
but you, oh Lord, are my closest confidant. You never break
my trust, and I am forever grateful for your loyal love. I spill my
heart to you today, remembering that there is always an open
door to your presence. You don't silence or belittle me. I don't
have to vie for your attention. You are my help at all times and
in every circumstance. Why would I keep anything from you?

I will share both the joys and the aches of my heart with
you, Lord, for you are trustworthy. You are close. You are kind.
You are also incomparably wise, and you offer the best advice
when I need it. You have solutions to my biggest quandaries.
What an amazing friend you are!

Do you talk to the Lord like you do to a dear friend?

Be Still

Chaos once challenged you. The raging waves lifted themselves over and over, high above the ocean's depths, letting out their mighty roar! Yet at the sound of your voice they were all stilled by your might.

Psalm 93:3–4

God, you are the calmer of every storm, so I'm asking you today to calm the storm inside of me. When my mind is racing, soothe it with the truth of your Word. When my heart is full of chaos and anxiety, still the churning with the sound of your voice. Bring peace to my inner world, even if the world around me remains a mess.

There is no chaos that you can't calm. There isn't a tempest that you can't quiet with one word. Just as Jesus calmed a storm with the words, "Hush! Be still" (Mark 4:39), so when you speak peace to my heart, it comes to rest. I join with your voice and learn to copy your actions, promoting peace where there is chaos, quiet where there is unrest, and unity where there is division. Be still.

How has God's peace calmed an area of your life? Do you know how to bring peace to stormy situations?

No Matter What

Your godly ones will thank you no matter what happens.
For they choose and cherish your presence above everything else!

Psalm 140:13

Worthy One, I don't need a big reason to thank you today. I find reasons to thank you in the smallest details. Thank you for the breath in my lungs. Thank you for the pops of color in the blooming flowers. Thank you for the rain that waters the earth. Thank you for the lessons I have learned from failures and mistakes. Thank you for your presence that is with me through the highs and lows of this life, through the calm times and the tumultuous ones. You are more precious to me than the comforts of this life.

No matter how this day unfolds, I choose to give thanks to you for the beauty that remains. I choose to hold up to you in gratitude that which is true. Even the hardest days hold pockets of peace. There are glimmers of hope. Gratitude is always brimming from a heart that looks for the fingerprints of your mercy in the details of this world.

What are you grateful for today? Choose to spend time in God's presence, thanking him for who he is.

Honorable Humility

When one of your godly ones corrects me or one of your faithful ones rebukes me, I will accept it like an honor I cannot refuse. It will be as healing medicine that I swallow without an offended heart. Even if they are mistaken, I will continue to pray.

Psalm 141:5

Jesus, when I look at your life and how humbly you lived, I cannot excuse the pride in my heart. I don't want to be cold or closed off to correction. I know that as long as I live, I will still be learning. When I truly accept this, I can experience the relief of giving up the appearance of perfection. We are all learning. We are all growing. With this in mind, I can accept correction like an honor I cannot refuse. Even if others are mistaken in their estimation of me, I can pray and consider their perspective.

May my heart remain open and malleable. May I never think that I am above reproach. Even as I walk in the integrity of your ways, I know that there is always room to grow. Keep my heart open in curiosity and compassion. Thank you.

How do you receive correction and constructive criticism?

Deep Calls to Deep

My deep need calls out to the deep kindness of your love.
Your waterfall of weeping sent waves of sorrow over my soul,
carrying me away, cascading over me like a thundering cataract.

Psalm 42:7

When I feel the depth of my need, I call out to your over-flowing love. Your kindness goes to the depths and beyond, overwhelming my need with the abundance of your heart. No need is greater than what you have to offer. I am overcome with gratitude at the thought.

When the deepest parts of my soul cry out to your Spirit, you rush over me with the power of your love. When I don't have the words, you read the yearnings of my heart. I don't have to have the words to speak in order to experience the ministering healing of your Spirit. You read my heart, you know the deepest longings of my soul, and you answer the cries that have no language. Wash over me with the kindness of your love yet again as I live before your gaze. I am yours.

Have you ever experienced the ministry of the Spirit in your heart without the words to explain it?

Liberating Love

Farther than from a sunrise to a sunset—
that's how far you've removed our guilt from us.
Psalm 103:12

Father, if I were to stand in the flat desert and watch the sun rise and the path it takes throughout the day to get to the place where it sets, I might get a glimpse of your great mercy. It takes time for the sun to move across the sky, but it takes no time at all for you to remove the guilt of my sins. When I confess my shame before you and offer you my humble heart, you remove the weight of it. Just as the sun cannot both rise and set in the same place, neither can the guilt of my sin remain in my heart when you have already removed it.

You are my great freedom. I have room to move, to dance, to live, to breathe, to sing, to mess up and get back up again, to feast, to rejoice, and so much more in the liberty of your love. I won't hold myself back when you paid so much to set me free. What you have already removed is gone. May I not take back the burden of old guilt when you have already said I am forgiven and free.

Is there guilt you have yet to let go?

Passionate Pursuit

Even the strong and the wealthy grow weak and hungry, but those who passionately pursue the Lord will never lack any good thing.

Psalm 34:10

Lord, I know that as I give my energy to pursuing you, you will fill me with all that I need. Even the strong and wealthy grow weak and hungry, but you replenish those who put their trust in you. I refuse to worry about tomorrow, knowing you will help me deal with every challenge and obstacle as it arises. I don't have to jump ahead into the unknowns of tomorrow when you give me the strategy to face what is mine to handle here and now.

I fix my eyes on you, Jesus, and make you the passionate pursuit of my heart today. I want to know you more, to honor you with the way I live and relate to others. May your love be the thing that shines brightest in my surrendered ways. You are wonderful, and you are worth my interest and my time.

How can you passionately pursue God today? What time, energy, and focus can you give him?

Creativity Birthed

He breathed words and worlds were birthed. "Let there be,"
and there it was—springing forth the moment he spoke,
no sooner said than done!

Psalm 33:9

Creator, inspiration is like a breath of life to my mind. You breathe, and you create worlds. You whisper, and suddenly something new appears that never existed before. I ask you to do that in me today, Lord. You are the author of creativity, and I depend on your Spirit for inspiration. I partner with your heart and rely on your innovation to inform what I put into the world.

Thank you for making me in your image, a creative being breathed into existence by the Creator of everything. I delight in the opportunity to create something new out of the materials I have on hand. Whether it's weaving words to create a new story, building notes upon one another to create a new melody, or using yarn to form a pattern, there is something so beautiful in creating. Breathe your breath into my mind, heart, and hands and help me create something lovely today.

What creative pursuit do you need fresh inspiration for today?

Flourish and Bloom

He will be standing firm like a flourishing tree planted by God's design, deeply rooted by the brooks of bliss, bearing fruit in every season of life. He is never dry, never fainting, ever blessed, ever prosperous.

Psalm 1:3

I am your daughter. When I am rooted in your affection, Father, following your instruction and growing up under your wise guidance, I will flourish and bloom, just as I am meant to. My life is yielded to your loving care. You are my safe space and my refreshing fountain. You pour your life into me, and I come alive. Just as a tree planted by pure, plentiful waters flourishes in every season, so will I.

Thank you for the bounty of your presence that offers all the nutrients I need to grow strong in faith. Your love feeds the tender root system of my heart. As I reach for you, I find you meeting me with abundance. Thank you, Father. May my life give off the aroma of your mercy-kindness as I follow your ways, Jesus.

What is feeding the roots of your life—your mind, heart, and body? Look at the fruit of your life for a clearer understanding.

Fall like Fire

*At each and every sunrise you will hear my voice as I prepare my
sacrifice of prayer to you. Every morning I lay out the pieces of my
life on the altar and wait for your fire to fall upon my heart.*

Psalm 5:3

Spirit of God, I know the importance of turning my heart
toward you each day. I won't neglect the fellowship you offer.
I won't ignore the importance of your power in my life. Today
I will lay out the pieces of my life before you. I hold nothing
back. As I do, I wait for the fire of your presence to fall upon
my heart. Don't delay.

Without you, I am weak. Without your power, I am just
an ordinary vessel. I know you don't despise my frailty or my
commonness. When your fire touches my heart, you light up
my life with the supernatural power of your mercy. It is you
who lifts me from the ashes of despair and disappointment. It
is you who sets my feet on the solid foundation of your love.
It is you who never fails. I won't stop offering my sacrifice of
prayer and praise each day.

*How often does prayer feel like a sacrifice? If it costs you
something today, know that the Lord will honor it with the fire
of his presence.*

Worship Warfare

When you appear, I worship you while my enemies run in retreat.
They stumble and perish before your presence.

Psalm 9:3

Mighty One, I don't want to be someone who wastes my effort on useless goals, missing out on the opportunity you offer me to submit my heart, my body, and my life to you. It is not my job to put other people in their place. No, I set my heart on you, my Savior and my God. I will worship you for all that you are, for that is my place of warfare. Worshiping you in spirit and in truth is the way I fight my battles.

I don't want to be so focused on others that I forget that you are my defender. You are the one who takes care of me. As Jesus exemplified, violence is not the way of your kingdom. Pursuing peace is the way of your lavish love. Help me to remember that when I am tempted to curse those who hurt me. Help me to turn my attention to the astounding power of your love and worship you. I want to stand upon your mercy and partner with your purposes, and I know that means keeping you central at all times.

How does worship change your heart and focus?

Unshakable

YAHWEH is never shaken—he is still found in his temple of holiness, reigning as King YAHWEH over all. He closely watches and examines everything man does. With a glance, his eyes examine every heart, for his heavenly rule will prevail over all.

Psalm 11:4

YAHWEH, as I set my heart upon your faithfulness today, remind my soul of your loyal love that never changes and align my heart with the power of who you are. You see what everyone else overlooks. You don't miss a thing. Instead of telling you how I think you should move today, I surrender my heart before you. I trust that you know what is best, and I rest in the confidence of your unfailing nature.

You have not changed. You have not grown sleepy or weary. You are not annoyed with our failures. You are patient in love, and you are persistent in kindness. What a mystery it is that you can love us so unflinchingly, even when we misrepresent you. God, I stand upon the foundation of your love and ask that you would light up my heart with the glory of your presence. Show me how I can best partner with you, walking in the light of your mercy today.

Do you need a reminder of God's faithful nature today? Ask the Spirit to reveal it to you in deeper ways.

Living in the Light

Yahweh, who dares to dwell with you?
Who presumes the privilege of being close to you,
living next to you in your shining place of glory?

Psalm 15:1

Lord, I dare to long for you as a child longs for the embrace of their parents. I thirst for you the same way an animal finds a stream after running through the wilderness. With one focus, I must have you. I must quench the thirst that arises in my soul. I will not be satisfied until I do. Wrap around me with the power of your presence and draw me close to your heart.

Thank you for the power of your Word that provides confidence to those seeking to dwell with you, living in the light of your glory. I will take the rest of Psalm 15 seriously, living in the integrity of your ways. With nothing to hide and with love as the source of living water that satisfies and strengthens, my choices will reflect your goodness. Where I need to humble myself and change, I depend on your kindness and grace to empower me to do just that. Your ways are the best ways. I will live in your light, and I will not be ashamed.

Do you wonder what it takes to have the confidence today's verse speaks of? Read the rest of Psalm 15.

Glorious Inheritance

*The humble of heart will inherit every promise
and enjoy abundant peace.*

Psalm 37:11

Wonderful Father, I am overwhelmed at the thought of your tender affection toward me today. You are not just a Father; you are a good one. The best, in fact. In this world, there are no perfect people. But you are perfect. You don't harm those you love, not even for a moment. You always know just what to say and offer the wisdom I need in every moment. You see me clearly, my heart, my intentions, my hopes, my flaws—all of it. And you love me fully.

I won't waste my time singing my own praises, for I have found true belonging and hope in you. You make me better than I am on my own. You offer me the life-giving waters of your love that meets me in my weakness and helps me in my need. I know that your pervasive peace is a promise that you will keep. Surround me in your powerful peace as I humble my heart before you today.

Have you humbled your heart before God today? Simply put it in perspective, offering it to him and remaining curious about what he reveals. There is no shame in his wisdom or his love. There is so much peace.

Read My Tears

Lord, listen to all my tender cries. Read my every tear, like liquid words that plead for your help. I feel all alone at times, like a stranger to you, passing through this life just like all those before me.

Psalm 39:12

Comforter, some days I can't stop the tears from falling. On days when my sorrow is great, read my tears like liquid words. I'm so grateful I don't have to put my overwhelming emotions into language that seems too limiting for them. You read my emotions and see them for what they are, for what they reveal, and for what they need. You don't need me to explain them to you, which is a relief because sometimes I cannot even explain my feelings to myself.

Spirit, when I feel alone in my pain, come in close. Even closer than the skin on my bones, rest your peace upon my heart and wrap around my nervous system like a blanket. When it all seems meaningless, help me to rest in your presence and trust that it will pass. I need you, oh Spirit of God. Be near.

How has God met you in your overwhelming sadness?

Joy in His Presence

You crown the earth with the fruits of your goodness.
Wherever you go, the tracks of your chariot wheels drip with oil.
Psalm 65:11

Glorious Lord, when you are near, everything changes. My perspective, my heart, my body, my life come alive in the power of your presence. Your love is like oil dripping down and soaking through. Oil doesn't evaporate the way water does. It stays. It leaves its mark. It seeps down, and it nourishes from the inside out.

Just as you crown the earth with fruits of your goodness, I know you do the same in my life. Open my eyes to see the mark of your mercy. Give me vision to see the oil stains of your goodness in the world around me. May I hunt for your kindness like I would for treasure. Turn my attention to where your love is already at work within my life and overwhelm me with the joy of your presence once again. I am in love with you and the way you work.

What fruit of God's goodness can you find in your life today? Where do you see the signs of his mercy in the world around you?

Powerful Partnership

O Lord our God, let your sweet beauty rest upon us.
Come work with us, and then our works will endure;
you will give us success in all we do.

Psalm 90:17

My God, you are beautiful in all your ways. You have no hidden motives in your heart. You don't lie in wait to ruin or ravage. You sow mercy-miracles into all you touch. You move in peace, in love, in joy, in hope, and in power. You are full of truth and justice. You are overflowing in kindness and in generous grace. There isn't one good thing that did not begin with you.

I don't want to work to make my own name great. As I sow love into my work, into my relationships, and into my dreams for the future, I trust that you will be glorified. Come work with me, with us, with your people, and then the work we do will endure. True success is found in you, so I don't hesitate to welcome you into the work of my hands. May the way I do business honor you, Lord.

Have you invited God into your work? Do you choose to walk in the integrity of his wisdom in all that you do?

Overcome by Awe

Everything I am will praise and bless the Lord! O Lord, my God, your greatness takes my breath away, overwhelming me by your majesty, beauty, and splendor!

Psalm 104:1

Lord, with everything I am, I praise you today. I offer you the sacrifice of my praise even when it takes some inner work to develop an attitude of praise. I don't want to withhold a thing from you, for I know that you are worthy. Lord, don't let me keep this knowledge isolated in my mind. Let it sink down deep into my heart. I want to be overcome by awe in your presence today.

I know that your splendor is on display for all to see. When I go into nature, clues to the beauty of your being surround me. Take my breath away as I look with eyes ready to encounter your goodness. Capture my attention, Lord, for I want to see you as you are—wonderful, powerful, and true. Open my eyes to your beauty and captivate my heart today with the truth of who you are.

How can you cultivate awe in your life today? Try taking a nature walk, paying attention to whatever grabs your attention, and then taking your time with it.

Bring Us Back

It was like a dream come true when you freed us from our bondage and brought us back to Zion!

Psalm 126:1

Mighty Deliverer, I have known what it is to desperately cry out for your help and wait upon your hand of mercy to meet me. I can think of times in my life when you have freed me from my fears and liberated me in the relief of your provision. Remind me of the power of your faithfulness that has not let up. You have delivered me before, and I trust that you will do it again.

Bring me back to the place of trust and rest. Revive my heart in hope again. You have not given up on your promises, so I won't either. You will come through at just the right time, delivering me from my fears and setting my feet on the solid rock of your loyal love. I won't be afraid today, for you are near. You take care of me, and this trial I face will be like one more dream come true as you provide for all that I need.

What do you need God's liberating love to deliver you from?

Hope-Filled Waiting

*Your forgiving love is what makes you so wonderful. No wonder
you are loved and worshiped! This is why I wait upon you,
expecting your breakthrough, for your Word brings me hope.*

Psalm 130:4–5

Faithful Father, you are so quick to forgive. You don't hold
a grudge when I humble myself before you, for you separate
my sin from who I am. Thank you. You don't hold my mistakes
against me, and I am overwhelmed with gratitude that your
love is so powerfully liberating. I won't stay away from you
today. I won't hang back in doubt of whether you will meet me
with mercy this time. I know that you will.

I bring you my full attention today. I give you the intentions
of my heart too. You see it all anyway. I know that I don't need
to hide any part of myself from you. Oh Lord, as I wait upon
you, my heart is filled with hope. Your promises will not fail,
and your presence won't either. Overwhelm my senses with
the power of your presence today.

Is there anything you have been hesitating to bring before God?

Kind in Every Way

Lord, you are so good to me, so kind in every way and ready to forgive, for your grace-fountain keeps overflowing, drenching all your devoted lovers who pray to you.

Psalm 86:5

Gracious God, I cannot thank you enough for the kindness of your heart. You are so good to me! Whenever I come to you, you meet me with overflowing grace. You fill me with your miraculous mercy, and I am completely satisfied in you. Your grace flows into every area of my life. There's no place that is off-limits to you.

Your kindness is real, not just a theory. It is much more than a good thought toward me. You exude kindness in everything you do for me, in every way you move. If something isn't kind, then it doesn't come from you—it is missing a key characteristic of who you are. The fruit of your Spirit reveals the source. I trust that what you do is always filled with benevolence. If I am not kind, I step out of alignment with your kingdom ways. I understand that kindness is not the same thing as agreeing about everything. It does not mean that justice is absent. Even your justice is laced with kindness.

In what ways or areas do you question God's kindness, either toward you or others?

Easy to Please

Let everyone thank God, for he is good, and he is easy to please!
His tender love for us continues on forever!

Psalm 136:1

Father, I have known people who are hard to satisfy, but you are not one of them. Your Word says that you are *easy to please*. Like good parents are delighted in their children, taking interest in their hobbies and relishing their company, so you are with me. I don't have to be perfect to please you. In fact, you never expect perfection from me. What a relief!

You have my wholehearted trust, Father. I know that I can depend on you in every season of the soul. In times of ease and in times of trial, you are good. You know just what I need in every moment, and you provide for me. Your love is not theoretical or small. It can't be lost or lessened. It is always overflowing, always gentle, and always near. Wash over me and renew my heart in hope as I look to you today. You are my good Father, and I cling to you.

What weight can you let go of today, knowing that God is, in fact, easy to please?

Quick Courage

At the very moment I called out to you, you answered me!
You strengthened me deep within my soul and breathed fresh
courage into me.

Psalm 138:3

Faithful God, when I cry out for your help, answer me quickly. You have done it before, and I trust you to do it again. Even when my circumstances don't change, you transform my soul with strength and breathe fresh courage into my heart. You are ready to move on my behalf as soon as I call out to you. You have been watching and waiting, ready for the signal. You don't miss a beat, and for that, I am undone in gratitude.

Some situations cannot wait for your help to arrive, and you know exactly what my heart needs in every moment. I trust that you will fill me with the courage I need to face what I cannot escape. Provide a way where I see none, and most of all, keep me connected to you. Lead me, and I will follow in wholehearted trust and surrender. You are God of my courage.

Can you think of a time when you started to ask for help and help was already there? How has God's Spirit strengthened your heart in courage?

May

Lifted Up

Lord, you will keep us safe, out of the reach of the wicked. Even though they strut and prowl, tolerating and celebrating what is worthless and vile, you will still lift up those who are yours!

Psalm 12:7–8

When I am overwhelmed by the world and the dangers around me, wash over me with the power of your love, oh Lord. Lift me up above the fray, above the chaos of this world, and set me safely in your presence. I know this will sometimes look no different from the outside, but from the place of my soul seated in your throne room, I can see more clearly. I am safe with you. No one can steal me from your presence.

I trust you to keep me close to your heart even as I draw near to you today. You are the God of peace, my joyful Savior, the hope of the hopeless, and the defender of the defenseless. I will not be intimidated by those who have no regard for your goodness. I lean into your love and rest in your presence.

What do you need God to lift you out of today?

Never Too Early or Too Late

This forever-song I sing of the gentle love of God! Young and old alike will hear about your faithful, steadfast love—never failing!
Psalm 89:1

Savior, your love is more powerful than the weapons of men, and it is gentler than the light touch of a mother soothing her child. It is strong, sufficient, and wonderful. I won't stop singing about the wonders of this love. Thank you for fresh mercies every morning. You never withhold your kindness from those who seek you. It doesn't matter how many times I've come to you, whether incessantly or rarely. You always overwhelm me with the strength of your love when I do.

This faithful love never fails. It hasn't given up on me. Though I may feel as if I've wasted so much time relying on my own abilities, I know it's never too late to draw from the spring of your life available in me. I won't stay away or put off for another day what you offer freely today—the abundance of your love that fills me up and satisfies my soul.

Do you doubt the fullness of God's love for you?

Songs for the Night Seasons

I remembered the worship songs I used to sing in the night seasons, and my heart began to fill again with thoughts of you. So my spirit went out once more in search of you.

Psalm 77:6

Father, I remember the hard days when I would press into your presence. There, I found strength to continue. I found fullness of fellowship that empowered my heart in courage and my body in strength. I take time to remember how you met me in the hard seasons of life. You were ever so close, my friend, my comforter, and my confidant.

I send my spirit out in search of you, as this psalm describes, looking for the power of your love that met me in my darkest days. I know that you are still near even when all is calm and well in my world. You never abandon your children, and I am your daughter. You don't and you won't abandon me. Thank you! Flood my heart with thoughts of you as I recall your marvelous mercy as it has met me through the years.

Do you know songs or Bible verses that got you through a difficult period in your life? Play or read one today and let your heart reach out again to the God of your help.

Driven by Desperation

Oh, Lord God, answer my prayers! I need to see your tender
kindness, your grace, your compassion, and your constant love...
In this deep distress, come and answer my prayer.

Psalm 69:16–17

When I feel my need so desperately, Lord, I cannot limit my prayers to mere words. I need your tender kindness today. I rely on your grace to overwhelm my weakness. When I am frozen in place and at a loss for what to do, I turn my heart toward you. Meet me with your compassion. Revive my heart and sharpen my mind with your peace-inducing love. Desperation may drive me to you, but you overwhelm my deep need with the abundance of your resources. Thank you.

Lord, do not delay when I am distressed. I need the grounding of your presence to bring peace. I need the touch of your love to steady me. Lord, let me see through the higher perspective of your vision so that my heart can rest in confidence that you are not at a loss. I depend on you.

What helps you to settle your soul when you are feeling desperate?

Peace as a Practice

*Keep turning your back on every sin, and make "peace"
your life motto. Practice being at peace with everyone.*

Psalm 34:14

Prince of Peace, I know that if I want to be like you, I have to take your peace seriously. You never condone or encourage violence, hatred, or vengeance. Your Word instructs that we should be pursuers of peace at every turn. Help me to stay grounded in this truth and to not be seduced by the temptation to get even with someone who hurts me. I will practice peace, even and especially when it is unpopular to do so.

Jesus, you are the example I follow. When one of your followers resorted to violence to defend you, you told him to put his sword away, and you healed the man who was injured—one of the very ones who had come to arrest you (Luke 22:49–51). I want the courage, the compassion, and the peace of your love to motivate me in all I do. So I will follow you, turning my back on compromise and chaos and wholeheartedly living out your shalom.

*Do you practice living from a place of wholehearted peace?
How can you do that more often?*

Persevere in Hope

I waited and waited and waited some more,
patiently, knowing God would come through for me.
Then, at last, he bent down and listened to my cry.

Psalm 40:1

Faithful One, when you do not answer my prayers right away, I will not give up hope. I know waiting will be necessary at times. Some trials are not so simple to turn around, but that doesn't mean that you aren't working under the surface. I will wait as long as it takes, persisting in hope with the help of your Spirit.

And when my heart falters in belief, I trust that you won't let me go. Your faithfulness is not dependent on my faith. Even so, I will still wait for you. I will not give up hope, even if it hangs on by a thread. Hold on to me with the strength of your love, gripping me with your grace. Don't let up, Lord, even when I am tempted to. I believe that I will see your goodness yet and again in the land of life eternal (Psalm 27:13). I hold on to you. I hold on to hope.

When the wait grows long, what helps keep you connected to and growing in hope?

Paradise of Protection

*Lord, you are a paradise of protection to me. You lift me high
above the fray. None of my foes can touch me when I'm held
firmly in your wraparound presence!*

Psalm 61:3

Father, when I cannot stand the chaos or conflict anymore, lift
me high above the fray. Surround me with your wraparound
presence, securing me tightly in your grip. Become to me like
a paradise of protection, relieving me of the pain that exists
in the chaos with the powerful peace of your presence. Hem
me in, set me in the center of your love. Be my shield and my
defense, especially when there is nothing else to protect me.

I am tired, Lord. I am tired of the fight, of the incessant con-
flict. I need you to step in on my behalf and do what only you
can do. I need you to lift me out of the depths of depression
and darkness that threaten my health and my mind. You are
the one I rely on, Lord. You are the one I need, and you are
more than enough for me.

*Do you know the relief of God's wraparound presence in your
life? What do you need God to protect you from?*

Momentary Beauty

*Our days are so few, and our momentary beauty
so swiftly fades away!*
Psalm 103:15

Creator, the world is full of wonders, of beauty that blooms and then fades. Though flowers only bloom for a little while, their beauty is significant. The poignancy of their fragrance brings joy. Their value is not found in the length of their life but in the impact they have in that time. They don't work to be valued. They simply are; they bloom under the light of the sun and the watering of their roots. It doesn't take much for them to blossom and grow.

Lord, thank you that I am a bloom that brings you delight, no matter how short or long that life is. May I live with the same abandon that flowers do, opening to the rays of your light, my roots growing strong in the living waters of your presence. Though this life is but a few years really, it is beautiful, nonetheless. May I bloom and know that my very being is valuable and brings delight to your heart.

When you consider the beauty of flowers, how does it make you think about your own beauty?

Loyal Love

Lord, keep pouring out your unfailing love on those who are near you. Release more of your blessings to those who are loyal to you.

Psalm 36:10

God, I know you never stop pouring out your love on those who are close to you. There is no shortage in your presence. There is no risk of running out. You don't ration your love, for there is no need. I want to love you unabashedly, Lord, with my whole life. When I wander from your ways, I will come back to you as soon as I realize it. I will not abandon your love, for it is the source of life, everything I need and could ever want.

As I live surrendered before you, I ask you to release more of your blessings upon my life. Don't hold back your goodness from me. I know you won't. You are full of gracious kindness that shows up in all sorts of ways. You won't stop blessing me with your presence. Oh, how wonderful you are!

What and whom are you loyal to? Does God's love make that list?

Chosen Family

*My innermost circle will only be those who I know are pure and
godly. They will be the only ones I allow to minister to me.*

Psalm 101:6

God, I'm so grateful for good friends. They are like the family
I choose. Help me to choose my circle wisely, especially those
I will be closest to. I know the quality of their character and the
quality of these relationships will influence me in many ways. I
will not bare the most vulnerable places of my heart and life to
just anyone. They must be trustworthy, proven friends who are
loyal to your love, who promote peace, and who are people
of their word.

May I choose people with integrity for my closest circle,
women full of honesty, compassion, and grace. When I can
trust their character, I know I can trust their advice. Thank you
for these kinds of friends. You are good at connecting your
people, so help me trust you with my friendships as much as I
trust you with every other area of my life. I'm grateful for your
gracious hand of help.

*Who are the people in your innermost circle? Are they
trustworthy and true? Are they people you want to be like?*

Grace to Hold Back

God, give me grace to guard my lips
from speaking what is wrong.

Psalm 141:3

Gracious One, I am so grateful to be liberated in your love and to have the freedom to live brightly for you. I know, still, there are times to remain quiet, especially when my words are not laced with your loving-kindness. Give me grace to listen rather than jump in with hurried opinions that I may regret. I don't want to be a person who cuts others down with her words. I want to be a builder and encourager, a truth-teller, and a grace-giver.

Out of the heart, the mouth overflows. That is what your Word says in Matthew 12:34. What is in my thoughts will also be revealed through my words. Help me to fill my thoughts "with heavenly realities, and not with the distractions of the natural realm" (Colossians 3:2). I need your grace to empower me, not only in soul strength but also in self-restraint. Thank you for your present help.

Are you aware of the impact of your words? Take time to think before you speak today, especially when you are prone to saying something harsh.

On Display for All to See

God, everyone sees your goodness,
for your tender love is blended into everything you do.

Psalm 145:9

There isn't a thing that you do that is absent of your loyal love. Your goodness is plain to see; it is on display in the mercy you offer. Open my eyes to see your goodness, God, and remind me that it is not only in the places where I am accustomed to looking for you. You move in all sorts of ways, in all kinds of places, and your love cannot be denied.

As I go through this day with open eyes and an open heart, reveal to me the fingerprints of your mercy in this world. At the grocery store, in my workplace, in a conversation with friends, in the natural world, show me your goodness all around. You are so good, Lord, and my heart is encouraged in hope as I encounter your kindness in places where I hadn't noticed it before.

Do you expect God's goodness to meet you in the world?
Or is it reserved for specific times and places in your mind?
Go into this day with open eyes and thank God for every
movement of mercy you find.

Preserved

God always blesses those who are kind to the poor and helpless. They're the first ones God helps when they find themselves in any trouble. The Lord will preserve and protect them.

Psalm 41:1–2

Savior, you are not impressed by power or strength, and I love that about you. No one can buy your favor or manipulate your mercy. You are close to the brokenhearted. You are near to the distressed. You advocate for the poor and helpless, and you ask your people to partner with you and do the same. I will not neglect the impulse of your love to show kindness to all people, especially those who are down on their luck.

You are the God who preserves and protects those who cry out to you. You don't bend to the whims of the powerful; you rush in close to comfort those who have been oppressed. May I be found in you, walking in your ways, Jesus. You are humble, and so I choose to humble myself again before you. I will be kind and generous just as you are kind and generous.

How do you treat the poor and helpless you encounter?

Tracked Down by Love

Why would I fear the future? Only goodness and tender love pursue me all the days of my life. Then afterward, when my life is through, I'll return to your glorious presence to be forever with you!

Psalm 23:6

Wonderful One, with you as my guide, my protector, and my Savior, I have nothing to fear. Even when my path winds through the shadow of grief and suffering, I know that your goodness and tender love pursue me still. You will not let up on meeting me with mercy. You won't stop sowing seeds of blessing in the soil of my suffering. When I look back, I will see a garden of glory along the path where I felt such sadness.

I have nothing to fear in the future, for you have already gone before me. You know what is coming, and in the end, I will return to your presence and dwell in your glory forever. That is the most hopeful promise of all. Thank you for your persistent peace, your overwhelming love, and the deeply rooted joy that you have sown into my life. I love you.

Where have you seen God's goodness and love track you down? Let it fuel your hope for the future.

A Clean Heart

Keep creating in me a clean heart.
Fill me with pure thoughts and holy desires,
ready to please you.

Psalm 51:10

Father, you are my Creator, you are my help in times of trouble, and you are my closest friend. I can always depend on you. You have begun the beautiful work of heart-mending already. I ask today that you will continue to create in me a clean heart, one that is full of light, love, and hope. Purify my intentions in your mercy. Align my values with the values of your kingdom. Expose any hidden sin or shame that needs correction. I trust you.

Your thoughts are healing, they are good, and they are encouraging. Your living Word pierces to the very core of my being, where soul and spirit meet. Reveal the true thoughts of my heart and transform them in your love by the power of your Spirit. I cannot thank you enough for the deep healing you bring.

What is the substance of your thoughts, the fruit of them
in this season of your life? Submit them to God and follow
the wisdom of his ways by taking your thoughts captive and
holding them up to the light of God's heart.

Once and for All

God said to me once and for all,
"All the strength and power you need flows from me!"
Psalm 62:11

Mighty God, I spend so much of my time trying to be better in my body, heart, mind, and soul, and at the end of the day, I don't want to lose the most important thing of all: dependence on your grace. I know that it is not wrong to do my best to grow and learn in the knowledge this world provides, but that can't be where it begins and ends. Help me to avoid being distracted by all the to-dos. Let me live with the power of your compassion, the strength of your grace, and the delight of your joy as my constant source.

The tools of this world will only get me so far; they all have their limits. But you, oh Lord, do not. You are always overflowing in strength and limitless in love. No one can earn your healing. No one can measure your mercy. I'm so grateful. Once and for all, I remember that all the strength and power I need flows from you.

Where is your greatest confidence—in your own ability to do all things well or in God's ability? Lean on his grace and trust him with what you cannot control today.

Compass of His Wisdom

Help us to remember that our days are numbered, and help us to interpret our lives correctly. Set your wisdom deeply in our hearts so that we may accept your correction.

Psalm 90:12

I don't want to waste my days by forgetting how fleeting this life is. Thank you for the power of purpose that transforms even the most mundane days into places of peace. May I be compelled by your compassion and guided by your wisdom in all that I do. I don't have to live a large life to live a satisfying and meaningful one. Your presence, your fellowship, Spirit of God, is what gives intention and gravity to every moment.

Thank you for your grace that meets me in each moment. Even now, I wait upon you. I need the compass of your wisdom to direct me throughout my days. You are my true north, showing me the way to go. When I go off-course, correct me with the magnetism of your truth. You never fail, and I yield to your leadership.

Have you been living on cruise control? Or do you take time to ground yourself in the present wisdom and peace of God each and every day?

Time to Trust

*O people of God, your time has come to quietly trust,
waiting upon the Lord now and forever.*

Psalm 131:3

Lord, your Word says that today is the day of salvation. Today is all that I have. It's all that I can interact with, so I won't neglect the power I receive when I set my heart upon you in trust. I choose to wait for you. You are the source of all that I need. You have the wisdom I long for and the direction I am waiting for. You have peace that settles chaos. You have love that covers all my faults and flaws. You are the delight of my heart, and I turn to you today with my full attention.

When nothing seems to change from day to day, I will still quietly wait for you. I know that you are at work in the details I cannot see. You are working all things together in your mercy and for the good of your children. I won't waste away with worry, for you are trustworthy, faithful, and true. And you are with me, in the action and in the waiting.

*How can you actively wait upon God today and trust him?
What need to control can you let go of today?*

Wonders of His Word

Open my eyes to see the miracle-wonders hidden in Scripture.
Psalm 119:18

Jesus, you are the Living Word. You were there in the beginning, before anything in heaven or on earth was created. You spoke, and the world was formed. You speak today, and you create life where there was none. I won't neglect your Word, for there is so much wisdom, encouragement, and hope hidden in it. Miracle-wonders are spread throughout. Your nature shines through, and I am in awe of who you are. May I not be distracted by the unanswered questions of my mind and heart, but instead, fill me with the wonders of your love and how it has played out through history.

Open my eyes as I read your Word today and give me revelation of the miracle-wonders I have missed before. There is always something new and wonderful to discover in you, so I thank you in advance for the power of your living Word as it ministers to and astounds me today.

What hidden gems of truth has God revealed to you through his Word?

Confident Hope

Lord, never forget the promises you've made to me,
for they are my hope and confidence.

Psalm 119:49

Faithful One, flood my heart with the peace of your presence as I turn my focus to you today. I long for a fresh filling of your love, for greater revelation of your goodness as it meets me in the practicalities of my life, and for the confidence of your kindness that never leaves or lets up. I hold on to the hope of your faithfulness. I remember the promises you've made me, and they remain my hope and confidence, for you are loyal to your Word, always faithfully following through on your promises.

When the waiting grows long, encourage my heart in the power of your presence. Direct my thoughts to your faithful love that overwhelms me each and every day. Help me to ground myself in the day I have, to not overlook the peace I can find here, even in the waiting. There is so much beauty all around. While I wait on you to come through in specific ways, I delight in what is already mine today.

Have you given up hope in any area where God has given you a promise? Lean into his love and ask him to encourage your heart today.

Embrace the Little

It is much better to have little combined with much of God than to have the fabulous wealth of the wicked and nothing else.
Psalm 37:16

Generous Father, I don't want to waste my time comparing the little I have to the abundance of what others have. Jealousy is not a fruit of your Spirit, and envy is a bitter distraction. Help me to be truly grateful for what is mine and overwhelmingly thankful for the abundance you supply in my lack. You won't let me down. I know that wealth brings its own troubles. I don't trust in glamorous prosperity or the powers of this world. I trust in you.

When my heart becomes distracted by all that I don't have, bring me back to the present, the gift of the now. I will not take for granted the beauty that is already available in my life. In some ways, I am living a dream that I prayed for in the past. What a humbling realization! Thank you for all that you offer me. You are astoundingly good, and I am grateful for this little life that is mine, infused by your gracious and loving presence.

Instead of comparing your life to others, can you find what you are thankful for in your own life? Be intentionally grateful for what you have today.

Generous and Ready Help

No matter where I am, even when I'm far from home, I will cry out to you for a father's help. When I'm feeble and overwhelmed by life, guide me into your glory, where I am safe and sheltered.

Psalm 61:2

Gracious Father, I will never stop depending on you. You are the one I look to first and most when I need assistance. No matter where I am, whether I am close or far from home, you are a ready help in the time of my need. When I am overwhelmed by life, lead me into the shelter of your presence where I am safe and secure.

You know exactly what I need today, and you know just how to help me. Lord, I rely on you to meet me with your generous grace and mercy. Guide me into your glory. Show me the steps to take out of the mess I find myself in. You are good, and I know you won't ignore my cries for help. Thank you, Father.

What do you need your Father's help with today?

Secure Hearts

*They will not live in fear or dread of what may come,
for their hearts are firm, ever secure in their faith.*

Psalm 112:7

You are the God of my refuge and a great rescuer. You do not leave me to flounder in fear; no, you overwhelm me with the confidence of your love every time I turn to you. Secure my heart to yours with the power of your mercy. Hold me fast with the anchor of hope. No matter what is happening today, no matter the threats going around, I don't have to live under dread. Even when conflict breaks out, you are faithful.

May my heart be so rooted and established in your loyal love that the clashes of this world don't make my faith waver. You are unchangeable and true. You always come through. I trust your wisdom and ways, and I choose to follow you on the path of your laid-down love no matter what. Please cover me in your mercy and empower me with your grace as I follow your lead, dear Jesus.

When you think about the future, do you have hope? Lay your fears before God and ask him to fill you with the strength of his faithful love.

Path of Deliverance

Yes, the Lord keeps raining down blessing after blessing...
For deliverance goes before him, preparing a path for his steps.
Psalm 85:12–13

God of my hope, you are not only a faithful Father, but you are also my deliverer. You are the God who delivered his people out of their captivity. You are the God who reliably helps those who call on you. You are the God who put on flesh and bones and showed us what your love truly looks like in Jesus. You are the God who liberates us in mercy and breaks the power of death in your resurrection life. You are the one who goes before me, preparing the path of freedom for me to walk in. Thank you.

When I am overcome by life, I will remember that you are the Lord who keeps raining down blessing after blessing. You never stop. You are lavish in loving-kindness and overflowing in generous joy. You lead me on paths of peace, and you restore my soul. I won't stop trusting you. I will follow you every step I take.

Can you see the steps that God has prepared for you to take today?

Joy Restored

Restore joy to your loving servant once again,
for all I am is yours, O God.

Psalm 86:4

God, all I am is yours. I belong to you. I have known sorrow, and I have known peace, but I won't deny that I need a fresh restoration of joy in my heart. I long for your deep delight to overshadow my heart, loving me to life in your presence all over again. Bring me to an open space where I can rest and move and dance. Bring me into the glorious light of your presence, and shine on me.

This life has so many cycles, and I know I can't escape them. I also have so many reasons to be grateful, and I won't ignore them. You are the God of my restoration, leading me higher in healing with every turn around the sun. You haven't given up on me, and I have not given up on you. Meet me with the power of your mercy today, filling up the spaces of my heart, my mind, and my life with your wonderful grace.

Is there an area of your life that needs a restoration of joy?

Watching and Waiting

The eyes of the Lord are upon even the weakest worshipers who love him—those who wait in hope and expectation for the strong, steady love of God.

Psalm 33:18

Oh Lord, even the weakest ones find overcoming strength in you. You don't look away from your children, and I trust that means you're watching me today. I don't have to have my life together for you to be willing to help me. You are my hope. You are my joy. You're my expectation; God, you're my delight. Even when all I have to offer is my "yes," that's enough for you to move in quickly with mercy. Your steady love reaches me right where I stand. You're watching, even as I'm waiting on you. What hope fills my heart as I realize your eyes are on me!

There is no weakness that you cannot fill with your power. There's no challenge you can't overcome. What is difficult for me is easy for you, and I rely on your grace to help me through. In my strength, I will testify to your goodness. In my weakness, I wait for you to breathe your life in me. I lift my eyes and meet your gaze today. Have your way.

Do you judge what you have to offer God today? He doesn't.

Celebrate His Goodness

Celebrate the goodness of God! He shows this kindness to everyone who is his. Go ahead—shout for joy, all you upright ones who want to please him!

Psalm 32:11

Wonderful One, there is always reason to celebrate your goodness. I won't hesitate to look for your kindness and freely offer you my gratitude as I find it. You are at work in the world, and you are at work in my heart and life. There isn't anywhere that your love is absent. What a miracle that is! There is hope in you at all times and in all ways. How marvelous you are, my Lord!

I am yours, and I am a recipient of your kindness. Open the eyes of my heart to understand just how thoroughly you move in my life with your love. As I think about your goodness, my heart is overwhelmed with gratitude. What joy fills my soul! You are my God, and you are worthy of all the praise. You are so wonderful to me.

What kindness and goodness of God in your life can you celebrate today? List as many reasons as you can think of and pour out your joyful thanks.

Great Expectation

I will say to my soul, "Don't be discouraged; don't be disturbed,
for I fully expect my Savior-God to break through for me.
Then I'll have plenty of reasons to praise him all over again."
Yes, he is my saving grace!

Psalm 43:5

Father, on days when it takes some work to trust you, I will remind my own heart of your faithful love. At times I feel discouraged, but you have not changed. You remain my Savior-God whose mercy always makes a way. Even when I cannot see how the unknowns will play themselves out, I trust that you see the end from the beginning. You see all possibilities, and you will lead me on the path of your peace. Whether I come or go, you are there, and you will lead me straight into your kingdom.

You are my great expectation. You are the God of my breakthrough. This is not the end of my story. Even when it feels like nothing will change, I know that you are my saving grace. Nothing is impossible for you. So, soul, don't be discouraged. Trust in your God, for he is your help and your salvation. He will come through for you.

When you feel discouraged, what can you do to redirect your expectations?

Even So

*Even when bad things happen to the good and godly ones,
the Lord will save them and not let them be defeated
by what they face.*

Psalm 34:19

Lord, I know that even when bad things happen, it doesn't mean that you have left me. It doesn't mean that I am doomed. Life is full of surprises, some of them joyous and others devastating. I will not let my circumstances dictate my trust in you. I know that you will never leave me. I rely on your help, and you have not abandoned me in my great need. You are near. You are powerful. You are full of wisdom, knowing just how to lead me through the stormy seasons of life.

I trust you, God. Even when everything falls apart, I trust you. My hope is not in the ease of my life but in the love of your heart. Minister to my soul with the mercy of your presence. Permeate my mind with your peace. When all around me is shifting, I will not be shaken, for I stand on the foundation of your nature. I stand upon your Word. I stand upon you. Surround me with your wraparound presence and give me rest, building my hope in you once more.

Do you trust God in the hard times?

Path of Life

*Because of you, I know the path of life,
as I taste the fullness of joy in your presence.
At your right side I experience divine pleasures forevermore!*

Psalm 16:11

Savior, you are the path of life. You made a way to the Father where none existed. You showed us how to approach the Father's throne. Not only that, but you also sent the Spirit to help us, to dwell with us in your absence. The fruit of your presence is powerful, and it is real. It is palpable and life-changing. There is fullness of joy in you, and I have tasted and seen this goodness.

Yielding my life to you isn't the boring choice. In your presence there are unimaginable joys into eternity. There isn't just a little happiness in you; there is fullness of joy. I long for a fresh encounter with your presence to remind me of the overwhelming goodness that comes with knowing you. I'm so glad that I don't have to wait a moment to fellowship with your Spirit. You are here, right now, and always so very near.

Have you experienced the joy of Jesus? Do you know the pleasure of the Spirit's company?

Keep Rejoicing

Shine and make your joyful boast in him, you lovers of God.
Let's be happy and keep rejoicing no matter what.

Psalm 105:3

Worthy One, I will keep rejoicing in who you are today. I choose to give you the sacrifice of my praise when it feels just like that—a sacrifice. You are always worthy of my adoration and joy. You never change. I will not let the circumstances of my day dictate whether I feel joy in you. I delight always in your presence. I choose to honor you with the love of my heart.

Lord, I'm so grateful that you don't want me to deny my experience or my feelings. I can always come to you with the fullness of my reality and all that I am going through. Still, that doesn't mean I can't set aside the sadness and enter into a time of rejoicing on my own. I choose to celebrate your goodness today, even in the midst of a battle. Your love fuels my fire, and I can't help but pour that love back on you.

What period of time can you set apart today to simply rejoice in God? Give him what you have—five, ten, fifteen minutes— and fill that time with joy and celebration.

June

Replenishing Spirit

*When you release your Spirit-Wind, life is created,
ready to replenish life upon the earth.*

Psalm 104:30

Spirit of God, when you move, you create life. You revive and replenish barren lands. You refresh my soul. Breathe, oh breath of God, into my soul today. Revive my mind with the inspiring life of your Spirit within me. Like rain on dry soil, you refresh me, giving me the sustenance I need to grow and thrive. I am yours, Lord, so pour into me once again.

There is no challenge that you can't overcome. Oh Lord, what hope that is to my heart! There is no problem that the strength of your Spirit cannot overcome by empowering me. I lean on your creative insights and your wise guidance to lead me today. Refresh my soul with your Spirit-Wind and let freedom be the joy that rings through my being. When you move, I am liberated in love. Oh, how I long for a fresh encounter with you today!

How has the Spirit's presence refreshed and revived your hope? Invite him to breathe on you once again.

Flourishing in Strength

Look how you've made all your devoted lovers to flourish like
palm trees, each one growing in victory, standing with strength!
Psalm 92:12

Loving Lord, I am devoted to you. You have drawn me in with loving-kindness, and you keep me there with the power of your peace, the wonders of your wisdom, and the generosity of your heart. You empower me with the grace of your Spirit, giving me strength to stand upon your truth. I am like a tree planted by pure waters, growing strong and tall in the light of your love. Thank you for the incredible blessing of your presence that feeds me every single day.

I want my life to reflect the power of your mercy, Lord. May it be a beautiful offering to you. I choose to walk on the path of your loving-kindness, for that is how you move. I choose to follow you in pursuing peace, for that is what your kingdom does. Your life in mine refreshes me, satisfies my hunger, and causes me to flourish. Be glorified, oh God, in my surrender and in my active choices.

What does flourishing look like to you?

Overwhelming Delight

Whenever my busy thoughts were out of control,
the soothing comfort of your presence calmed me down
and overwhelmed me with delight.

Psalm 94:19

When my thoughts are out of control, breathe peace into my mind through the comfort of your presence. Soothe my worried heart with the nearness of your love. Draw me into your heart and settle me down with the assurance of your reliable strength. I trust you, Father. I know that you can handle the things that I cannot. You are my great confidence.

When you relieve my fears, the delight of your love overwhelms me. I cannot help but be enthralled with joy. Your presence is persistent and capable of more than I can even imagine. I lean into your love and trust you to do what only you can do. Like a child in her mother's lap, I long for you to wrap around me with the tenderness of your affection and settle my heart with the steady beat of your own. You hold me, and you love me. You care for me, and today I have no reason to fear.

What out-of-control thoughts do you need God's comfort for?
Take time to turn your attention to God with you and ask him
to settle your heart and mind in his presence.

The Wise Judge

Here he comes, the Lord God, and he's ready to judge the world.
He will do what's right and can be trusted to always do what's fair.

Psalm 96:13

Lord God, you are the only wise judge. You know exactly what to do at all times, and your mercy is overwhelming in its power. You always do what is right, so I relinquish the need to see things play out in my own way. I give up the illusion of control I have, and I trust you to do what I cannot. You are more powerful than I could ever dream of being. Your wisdom is thorough, and it doesn't miss a thing. I don't want to jump to judgment when you say that I should be quick to love. Help me, Lord, to slow down in compassion and open my heart in generosity and kindness.

Only you are perfectly equipped to judge, for you see into every heart. I focus my heart on walking in your wisdom rather than on trying to fix others. Help me to keep my attention on what I can do to choose love, trusting you to do your powerful work in the lives of others. Thank you.

Are you quicker to judge others or to offer grace and love?
God can handle others; today, focus on your own heart.

Powerful Principles

> YAHWEH's teachings are right and make us joyful;
> his precepts are so pure! YAHWEH's commands challenge us
> to keep close to his heart! The revelation-light of his Word
> makes my spirit shine radiant.
>
> Psalm 19:8

YAHWEH, your wisdom is higher than the wisdom of this world. You always do right, moving in mighty mercy and sowing new life into those who yield their lives to you. Your teachings bring me joy. They are not burdensome; they are liberating. Your pure precepts show me the way to move in this world, to put love above everything, and to be honest, just, and true. I cannot walk that road alone. I need your love to direct me.

Your light radiates and makes me shine just as the moon and stars reflect the light of the sun. May my life reflect the glory of your ways as I put your practical wisdom into place in my life. As I walk through this day, build me up in your grace. I choose to be honest, a woman of my word, and to offer compassion instead of judgment. Thank you for your invigorating Spirit that transforms me as I walk in your ways.

What principles of God's kingdom can you focus on incorporating into your life today?

Overwhelming Goodness

*Good people will taste your goodness.
And to those who are loyal to you,
you love to prove that you are loyal and true.*

Psalm 18:25

Lord, I have tasted your goodness, but I want to know even more of your incomparable kindness. I will not ignore what I can do to reflect your nature in my own life. There are multiple opportunities to show your mercy-kindness and to choose generosity in my interactions and close relationships. May I be a pursuer of peace and a generator of joy. How satisfying it is to partner with your goodness in my day-to-day activities. You are so good, and I get to join with you and be good to others.

Let your loyal love fuel my own as I share from the overflow, pouring out kindness on all around me. I will not waver from your wisdom, for you always know best. I choose your ways, and I trust you to continue to lead me along the paths of your goodness.

How can you show God's goodness to others today?

Searcher of Souls

*Once and for all, bring to an end the evil tactics of the wicked!
Establish the cause of the righteous, for you are the righteous
God, the soul searcher, who tests every heart to examine the
thoughts and motives.*

Psalm 7:9

Mighty God, you are the one who searches souls and tests
every motive of our hearts. You know our thoughts and our
deepest desires. This doesn't make me uncomfortable, Lord; it
makes me stand in awe of you. I don't have to explain myself to
you, for you know what motivates and moves me. Even so, you
transform my heart in the liberating power of your love. Align
my motives with the values of your kingdom, God.

Search me and know me, Lord. Test my heart and examine
my thoughts. Reveal the areas that need to be fine-tuned in
you. Show me false narratives that I hold about you and reveal
the truth of your nature to me in deeper ways. I am so grateful
to love and be loved by you.

*Have you invited God to search your heart? Are you afraid of
what he'll reveal, or do you trust his kindness?*

Wonder Worker

May we never forget that Yahweh works wonders for every one of his devoted lovers. And this is how I know that he will answer my every prayer.

Psalm 4:3

What a powerful psalm to meditate on today. You work wonders for every one of your devoted lovers. This includes me! I can be confident in your response to my prayers because you are a wonder worker for all your children. This is almost too much for me to take in. I am overwhelmed and in awe of your tender awareness, your complete care of me—body, mind, and soul. You watch over my life and lead me along the paths of your peace. I will not be afraid, for you, my ready help and loving Father, are with me.

You know the areas of my heart where my hope has waned. You see the areas of my belief that are weak. Thank you for your steady hand of mercy that does not let up from my life, no matter the weakness of my faith at any given moment. Today, Lord, I pour out my heart to you again. I will pray without holding anything back. I know that you work wonders for your people, and you will continue to work wonders for me.

If you were confident of God's answer, what would you pray for today?

Radiant Hope

Lord, prove them wrong when they say, "God can't help you!"
Let the light of your radiant face break through and shine upon us!

Psalm 4:6

Lord, you are my help, and I depend on you. Even when I am surrounded by those who doubt your faithfulness, I will not stop looking to you. You are loyal in love and generous in grace. Your nature is constant, and resurrection life brings power to me. You are the one who turned my disappointment into a garden of glory before, and I trust you to do it again. Only you can take what seems completely hopeless and breathe new life into it. I trust you to redeem and restore the barren areas of my life.

Reveal your overwhelming goodness in my life, Lord, and faithfully follow through on your promises. I trust you. Shine upon me with the radiance of your presence and light up my life with the breakthrough of your powerful love. You are my God, and I rely on you. I know you will come through, Lord.

What is the radiant hope you are holding on to today? Do you trust God to follow through in faithfulness?

Completely Known

Lord, you know everything there is to know about me.
Psalm 139:1

Father, I'm completely undone before you. I'm so grateful that you already know everything there is to know about me. I can let go of the need to defend or explain myself to you. You will never misunderstand me. You won't get me wrong, ever. You are my closest friend, and I can depend on you to be there through the ups and downs of this life. Come close, Lord. Speak to my heart, for I am listening.

Read the pages of my life and remind me who you created me to be. Speak your life into me and revive my hope again in you. You see what everyone else misses. Your patience is astounding. Thank you for your incredible love that never leaves or lets me go. I will not take your presence for granted today, for you are life and breath, hope and joy to me.

How does it make you feel to know that God knows everything about you? Have you asked him to tell you what he loves about you today?

Better Still

You perceive every movement of my heart and soul, and you understand my every thought before it even enters my mind.

Psalm 139:2

Spirit, how is it that you love me so thoroughly when you know me so well? I am thankful for your kindness, your care, and your wisdom. You never leave me to fend for myself or figure things out on my own, so why would I? You understand my thoughts before I even entertain them. Meet me in the place of my mind and overwhelm my understanding with the power of your truth, the presence of your peace, and the inspiration of your mercy.

You see every shift of my heart, every movement of my attention, and your love meets me in all of it. Will you free me from the weight of shame that threatens to keep me stuck in destructive cycles? You are the God of my liberation, and your love removes my guilt. Thank you.

How often do you invite God into your mind? What is your imagination filled with?

Like an Open Book

You are so intimately aware of me, Lord. You read my heart like an open book and you know all the words I'm about to speak before I even start a sentence! You know every step I will take before my journey even begins.

Psalm 139:3–4

Lord, I am confident of your love and aware of your goodness today. You read my heart like an open book. I don't have to come up with the words to describe how I feel. You already know. You know what I will say even before I open my mouth to speak. Your knowledge of me is intimate and true. You don't misunderstand or misinterpret anything. You see it all.

Let your lavish love saturate every part of my being today. I want to be revived by mercy and empowered by your grace as I move through this day. You know the thoughts that put a crease in my brow, and you know the cares that consume my mind. Answer the longings of my heart like you do the prayers I breathe and guide me in your goodness.

Do you trust God to meet you in the emotional reality of your heart today?

Covered in Kindness

You've gone into my future to prepare the way, and in kindness
you follow behind me to spare me from the harm of my past.
You have laid your hand on me!

Psalm 139:5

Oh God, you are the God over my past, present, and future.
I trust you to prepare the way, going before me into my future.
I know you will be with me every step of the way. You already
know the path to tread; I follow your lead. I trust you to follow
behind me and cover my steps with your kindness, as well.
Your mercy covers the error of my ways. I know I cannot out-
run natural consequences, but I know, too, that your mercy
smooths over many mistakes. You guide me in the faithfulness
of your love. Thank you.

I will not fear the unknowns of tomorrow, nor will I rumi-
nate on the mistakes of my past. I choose to ground myself in
the present and turn my attention to your Spirit with me here.
There is so much goodness in the reality of this day. As I look
around, reveal the fingerprints of your mercy in the world. I
love to find you in your creation.

Are you stressed about the future or worried about the past?
Trust the Lord to take care of both as you look to engage with
what today brings.

Deep Wonder

This is just too wonderful, deep, and incomprehensible!
Your understanding of me brings me wonder and strength.

Psalm 139:6

As I meditate on you today, reveal the thoroughness of your love to me in new ways. Show me the depths of your mercy-kindness and the generosity of your grace. I don't have to look far and wide. You are here, and so is your lavish love. It meets me everywhere I am, in every single moment. The fullness of your incomparable nature is never far. What a glorious reality!

I am humbled to know that your love never lets up from my life. Even when I get too busy to lean into you in the ways I want to, you are not deterred from showing affection. I take my time in your presence today, slowing down to remember the power of who you are. You know me, all of me, and you love me completely. How could I not be overcome with awe at this thought? Your awareness of me gives me strength. Increase my ability to know you even as I am overwhelmed by the revelations you offer. I love you.

Have you taken time to meditate on God's thoughts toward you? Spend time in his presence and listen for his voice.

Where Could I Go?

Where could I go from your Spirit?
Where could I run and hide from your face?

Psalm 139:7

Lord, you see me in my wandering and in my leaning in. You are aware of my comings and my goings. I don't find that intrusive because I know how you feel toward me. You are a loving Father, a wise leader, and a merciful friend. You never reject me, even when I stay away from you. Father, I don't want to waste any more time trying to get by on my own. I come to you today with an open heart and a ready spirit.

Your kindness draws me in time and again. I don't need to hide anything from you. Lord, no matter the situations I walk into today, I trust that your Spirit is with me. There is nowhere I go that you are not. Empower me by your presence and comfort me with the power of your Spirit as I move through this day. Be my help and my guide. I rely on you.

How does it make you feel knowing there is nowhere to escape God's Spirit? Does it give you the strength to face the day?

He's There

If I go up to heaven, you're there!
If I go down to the realm of the dead, you're there too!
Psalm 139:8

Creator of heaven and earth, I'm relieved by the realization that even in death, you are with me. Though I want to enjoy every day of this life and pour out my gratitude to you, I don't want to live in fear of the end of this short bodily experience. I cannot escape death; none of us can. Teach me through the seasons and cycles of the earth, the beauty of every cycle of life, including death. Whether I am grieving the loss of a loved one, facing the end of a season of my life, or dealing with the limitations of my own body, bring deep comfort and peace through the power of your presence.

Here you are with me, wrapping around me with the embrace of your mercy. Breathe your peace deep into my heart and rewrite my expectations of your goodness to include when things reach their natural end. You are good, and your love endures through it all. You are alive in the land of the living and in the realm of the dead. I can't escape you, and for that I am eternally grateful.

Are you securely trusting in God's power over death?

From Dawn to Dusk

If I fly with wings into the shining dawn, you're there!
If I fly into the radiant sunset, you're there waiting!

Psalm 139:9

From dawn to dusk, we breathe oxygen, and our bodies use it to keep us alive. We don't have to think about it for it to be true. There's nothing we have to do to make this happen. We can say the same of your presence, God. As I open my eyes to each new day, there you are, just as oxygen fills my lungs. As I lay my head down at night, you are still there. You are present in every breath, in every movement. You are here. And I am overwhelmed by the constancy of your love.

Awaken my senses with the gift that each day is. Reveal your living truth to me through the cues of nature, of your higher wisdom that works in the way the stars shine and the earth rotates on its axis. There is so much more to discover of you, but even when I take you for granted, there you are, all the same. Open my eyes to your goodness that is already in me, around me, and moving through me.

What are things that sustain you that you may take for granted in the day-to-day?

Empowered

Wherever I go, your hand will guide me;
your strength will empower me.

Psalm 139:10

Holy Spirit, it is your hand that guides me through this life, and it is your strength that empowers me every step of the way. I don't have to rely on my own strength. You meet me in my weakness and empower me with all that I need in every moment. Why would I be afraid of what today will bring when I know that you are with me? Your power is constant, and your attention to detail is impeccable. Encircle me with your arms of strength and remind me of who you are and who I am in you. You always have a solution, and you make paths through the wilderness where there are none. I trust you.

I go into this day with the confidence of your presence. You are my guide, and you are my strength. You are my help, and you are my wise teacher. There isn't a problem that you can't fix or a puzzle that you can't piece together. You are my trustworthy guide and the fortitude I need. Be my courage and my great hope through it all.

Do you trust God's hand to guide you steadily? What do you need his strength for today?

Light to My Night

*It's impossible to disappear from you
or to ask the darkness to hide me,
for your presence is everywhere,
bringing light into my night.*

Psalm 139:11

Father, there are areas of my life that I don't seek to hide from you but are a mystery to me. You bring light into my night, and I need you to shine the light of your mercy on these places in my heart and mind. Where I only see shadows in certain areas of my life, I trust you to light them up and reveal what is hidden. I don't strive for this, Lord. I trust you and your timing. I know that the light of your mercy is powerful and it is kind. I don't have to fear what is clear as day to you.

Open my eyes in your presence and give me wisdom to grow in your love. May I have compassion for others and for myself. May I live with your peace as my pursuit and my offering to others. May your delight be the fuel of my own joy. You shine and darkness flees. What a powerful Prince of Peace you are.

Is there an area of your life that you would like God to shine on to bring clarity?

So Very Clear

There is no such thing as darkness with you. The night, to you,
is as bright as the day; there's no difference between the two.

Psalm 139:12

Wise God, when I am clouded with confusion, you always know just what to do. There is no such thing as darkness with you. It's almost too much to comprehend because there is so much I cannot sense or see in this world. I am limited in knowing, but you are limitless. You see what is hidden from every other eye. You sense what everyone else overlooks. You cannot be fooled, and you cannot be misled. What glory is yours! What wisdom you hold!

I will trust you today with a heart that holds back nothing. I am standing on the confidence of your loyal love, and I am rooted in the truth of your very being. You are the God who created this world and everything in it. Every person is a reflection of your creativity. You know what lies hidden in our hearts. You know what motivates each choice. I choose to humble myself before you and follow your lead. I know that your ways are the best ways.

What have you been struggling to trust God with?

Delicate Design

You formed my innermost being, shaping my delicate inside
and my intricate outside, and wove them all together
in my mother's womb.

Psalm 139:13

Father, I am your dearly beloved daughter. Come in close with your love and your unrivaled wise advice as I turn my heart, my soul, and my full attention toward you today. You are the one who formed me. You know what makes me tick, what motivates me, and what delights my soul. You created every quirk. You delight in my personality, sharing in the things that I love. You wove me together in my mother's womb, and I am in awe of your handiwork.

Let me see myself through the lens of your Creator-eyes. What do you love about me? What parts of my personality do you enjoy the most? I know that I am lavishly loved by you, Father, but I need reminders of your affection too. Will you share your heart with me? Will you love me to life again in the embrace of your presence? I am yours, and you have my attention.

What do you love about the way God made you?

Mysteriously Complex

I thank you, God, for making me so mysteriously complex!
Everything you do is marvelously breathtaking. It simply amazes
me to think about it! How thoroughly you know me, Lord!

Psalm 139:14

God, you are so creative. Everything you touch is wonderfully complex and beautiful. When I look at the night sky filled with stars and consider the galaxies filled with planets, moons, and more, I cannot help but feel the overwhelming wonder of your majestic wisdom and powerful creativity. Everything you do is marvelously breathtaking. Everything.

There is no lack in you. I have everything I need in you and so much more than I could ever think to ask or imagine. When I start to forget how marvelous and mighty you are, remind me of your power. Remind me of the lengths of your creativity, of the things you put into place that I have not even given thought to. Show me your glory, Lord, in this created world, in your people, and in me. Thank you for making me so mysteriously complex.

What takes your breath away? Do you know that you contain
that same glory within you?

From Nothing to Something

You even formed every bone in my body when you created me in the secret place; carefully, skillfully you shaped me from nothing to something.

Psalm 139:15

Lord, you are the God who makes glorious creations out of nothing. You speak, and the world comes alive. You move, and suddenly there is light. You sing, and we come out of our shells. You shout, and everything is put in its place. Oh you have done great things, and I trust that you will do them still. I am not lost in the darkness, for if you could create me in the secret place, there is nowhere I could go that your grace doesn't meet me.

Take my heart, Lord, and shape it in your mercy. Take my life, Lord, and shine your light of love through it. Take my hands, Lord, and use them to sow kindness into every interaction that I have. May my life be filled with the fruit of your Spirit. Lord, shape something out of the nothing that I can't mold or mitigate. Shape something beautiful out of my surrendered heart.

Is there a lack you feel in your life? Ask God to meet you with the abundance of his creative wisdom. He can shape beautiful things out of nothing.

Before Me

You saw who you created me to be before I became me!
Before I'd ever seen the light of day, the number of days you
planned for me were already recorded in your book.

Psalm 139:16

Lord, nothing about my life is a surprise to you. You saw every possible path before I took it. You saw the choices I could make before I made them. You see it all, and your wisdom can guide me in any and every circumstance. You were powerfully at work in the world before I was born, and you will be intricately involved long after I leave this earth. You are good, and you are true. I can always trust you.

Lord, I trust your timing, and I trust your strength. There are no mysteries to you. There are no unsolvable problems. There are no paths that lead to places you have not already tread. Your power is persistent and unwavering. I am in awe of your mighty mercy, your generous grace, and your powerful presence. I am in awe of your love for me.

Do you know that God's love reaches you in every choice,
every situation, and every possible chaotic circumstance?

Every Moment

Every single moment you are thinking of me! How precious and wonderful to consider that you cherish me constantly in your every thought! O God, your desires toward me are more than the grains of sand on every shore! When I awake each morning, you're still with me.

Psalm 139:17–18

When I think of the amount of sand on the seashore, the grains that filter like dust through our hands, and remember that your thoughts toward me are more than all the sand in the world, I can't even comprehend it. I am overwhelmed and awed by the knowledge of your love for me. There isn't a moment when I am absent from your thoughts. How, oh Lord, can you be so incredibly thoughtful and good?

As I set my heart on you today, share your thoughts with me. Tell me what you are thinking about me. It is wonderful to know that I am on your mind. I love to pour out my love on you, and I am awed by the way you pour your love on me in incomparable generosity. Thank you for your goodness, for your presence, and for your kindness.

What precious thoughts can you share with those you love today?

Choosing What Is Right

I cry out, "Depart from me, you wicked ones!" See how they
blaspheme your sacred name and lift up themselves against you,
but all in vain!

Psalm 139:19–20

God, at times it feels as if the world has gone crazy. People
have so much hatred and do so much violence in your name,
oh Lord. When it feels disheartening and like there is no one
who chooses to stand upon your love, your truth, and your
mercy, I still choose you. Thank you for the bonds of love that
are stronger than death. Remind me of the power of your righ-
teousness that is still working in many of your faithful in this
world. I will not stand for what Jesus so clearly stood against. I
choose the path of your love, your peace, and your truth.

Lord, when I am tempted to treat others with anything but
love, remind me of the power of your kindness that liberated
me. I am alive in your mercy, and your grace empowers me. I
will stand in your truth, and I will not focus so much on those
who defy you when I can redirect my heart in hope. Open my
eyes to see where love still reigns.

What is the fruit of the voices, influences, and people you
surround yourself with?

Proper Perspective

Lord, can't you see how I despise those who despise you?
For I grieve when I see them rise up against you...
Your enemies shall be my enemies!

Psalm 139:21–22

Jesus, when I am tempted to see as an enemy anyone who disagrees with me, remind me of how you spoke of these things. When I am hasty to defend you, show me what you actually want from me. Like Peter in the garden, who cut the ear off of the soldier, sometimes I rush to action with anger as my motivation. But I know that you, Jesus, are the peacemaker. You are the one who laid down his life so that we could live.

When I start to see people as my enemies, remind me that your love does not discriminate. My enemy is not another person but the dark forces behind violence, cruelty, and abuse. Give me a heart of discernment and compassion that remembers to offer mercy instead of vengeance. Jesus, if you did not lead a violent revolt, why should we? You are so much better than that. I know that your path is one of laid-down love. I choose to follow you.

How do you treat people whom you disagree with?

Thorough Examination

God, I invite your searching gaze into my heart. Examine me through and through; find out everything that may be hidden within me. Put me to the test and sift through all my anxious cares.

Psalm 139:23

God, you are my maker and my Father. You are always kind, and you are marvelously merciful. There is no reason to keep you at a distance. I invite your searching gaze into my heart. See if there is anything in me that does not align with your kingdom ways and shine the light of your love upon it. Show me the areas that I can yield more fully to you. I trust your wisdom and your heart to find out everything that may be hidden within me. You see the good and the bad, but it is always your kindness that leads me to repentance.

Sift through all my anxious cares. There is so much that I can get preoccupied with that distracts me from how capable you are. I want to rest in trust, to anchor my hope in the power of your faithfulness. I am yours, and I invite you to do what only you can do in my heart of hearts. Transform my mindsets, my desires, and my hopes in the waves of your mercy.

Have you invited God to examine your heart and your life?

Lead Me Back

*See if there is any path of pain I'm walking on,
and lead me back to your glorious, everlasting way—
the path that brings me back to you.*

Psalm 139:24

Glorious One, I want to walk on the shining path of your mercy that always brings me back to you. You know the ways that I have been caught off guard in the past, and you know my vulnerable spots. You know the pain points in my heart and life, and you do not want me to walk along painful paths. Lord, lead me back to your everlasting way, the path of your life-giving love, the path where I find peace, hope, and joy.

I want to walk in step with you, Lord. I want to remain close to your heart. I don't want to get distracted by the power or wealth of this world. I don't want to be led astray by compromise or the empty promises of shortcuts to success. I know that your way is the way of patience; it is the way of trust. It is also the way of truth, of relief, and of salvation. Lead me back to the peace of your path.

Is there a path of pain that you have been walking from which it's time to turn away?

Make Time

Come and kneel before this Creator-God;
come and bow before the mighty God, our majestic maker!
For we are those he cares for, and he is the God we worship.
So drop everything else and listen to his voice!

Psalm 95:6–9

Creator-God, I kneel before you today. I choose to take time away with you, to drop everything else, even for a few moments. You have my full attention. It is the least I can do. I bow in wonder before you, remembering how good you have been and how lavish your love is in every moment. Meet me here as I humble my heart before you.

When I choose to distract myself instead of spending time with you, pull me back to what's important. I know that I need to make time for you, and when I do, my heart overflows with gratitude for who you are. You are so faithful and kind, so gentle and wise. Even as I move about my day, I leave an open line of communication between my heart and yours. Every time I turn my attention to you, flood my senses with the radiance of your glorious light. You are wonderful, God. You are majestic, faithful, and true. There is no one else like you.

How much time do you make to connect with your maker?

July

Advocate and Defender

*YAHWEH does listen to the poor and needy
and will not abandon his prisoners of love.*

Psalm 69:33

YAHWEH, you are the God of my hope. But not only that—you are also the hope of every heart. You listen to the poor and needy when they cry out to you. You advocate for the oppressed, and you defend the vulnerable. I want to be more like you, Lord. Open my eyes to the poor and needy I encounter. Show me ways I can extend your love in practical ways to those around me.

I'm so grateful you are such a good listener. You hear my heart as I pour out my prayers throughout the day. You know my hope is in you. As I lean on your love, may it spread through my heart and hands to everyone around me. I want the refrain of my life to be one of exuberant love and unflinching mercy. I will not judge those who find themselves in need, for I have known need as well. I will be a helping hand and a ready shoulder. Thank you for the people in my life who have listened well to me and had such an impact. May I in turn be a good listener to those around me.

How do you treat the poor and needy around you?

Where I Belong

The lovers of God will be glad, rejoicing in the Lord.
They will be found in his glorious wraparound presence,
singing songs of praise to God!

Psalm 64:10

Glorious One, wrap around me with your powerful presence as I come before you today. May I be found in you every moment of every day. You are the reason for my joy, the reason for my great relief, and the reason for my peace. I belong in your embrace. This is where I am loved to life over and over again. It is where I remember who I am. You graciously empower me with your strength. You whisper words of kindness and correction. You embolden me.

Before I move on with my day, I will sink into the present moment and lavish my love on you. There is no one else like you. You are worthy of my praise, for you are my salvation. You are my loving leader, my wise counselor, and my holy help. I have so many reasons to thank you, and I will offer you the gratitude of my overflowing heart today.

What reasons do you have to rejoice in the Lord today?

Continual Trust

Trust only in God every moment!
Tell him all your troubles and pour out your heart-longings to him.
Believe me when I tell you—he will help you!

Psalm 62:8

Father, when my plans fall apart and the illusion of control evaporates, may I be firmly rooted in your faithfulness. You are the one I trust. You are the one who listens to my heart as I pour it out to you. You hear the troubles and heart-longings that I share with you. You haven't forgotten, and you will not start now. You are my sure help in every trial and trouble, and I put all my faith in you.

God, I want my heart to so rely on you that every moment is filled with trust. You are reliable, and you won't ever fail. I remind myself today of the wonders of your faithfulness. You are the God who covers me in loving-kindness and leads me in grace. I bind my heart to yours, for you are good, and there is no one else who deserves my trust like you. You are better than the most loyal of friends. I love you.

How can you nurture dependence on God today?

Famously Faithful

YAHWEH is always good and ready to receive you. He's so loving that it will amaze you—so kind that it will astound you! And he is famous for his faithfulness toward all. Everyone knows our God can be trusted, for he keeps his promises to every generation!

Psalm 100:5

Faithful Father, you are famous for your loyal love. You always follow through on your promises, and you never fail to keep your word. Who else can claim such powerful perfection? You may not move how I imagine, lining my life up with my limited expectations. No, you are so much better! Your wisdom is more thorough than my finite imagination. Thank you for your kindness that astounds me time and time again. You are trustworthy and true, keeping your promises to every generation.

I can't help but be overcome with awe as I contemplate your goodness. When I think of how your mercy has met me in the messes of my life and brought redemption and restoration of hopes I thought had long since died, I am overwhelmed by gratitude. Thank you for your care that doesn't miss a thing. I am so thankful for all you have done.

How has God revealed his faithfulness to you?

Fully Restored

*You open the eyes of the blind, and you fully restore those bent
over with shame. You love those who love and honor you.*

Psalm 146:8

Healer, you are the one who opens the eyes of the blind. You restore vision to those who cannot see. Lord, you see the areas of my life where I am blind. Open the eyes of my heart and let me see where you are moving in mercy. Give me discernment and eyes of compassion. You are the God who brings restoration to those bent over with shame. You lift us up and heal the pain of our past. You know the areas where I need the touch of your restorative love. Where I have felt the crippling weight of shame, lift it with the power of your mercy-kindness and set me free. Thank you.

I know that you will not leave me to waste away in pain. You are my healer, my restorer, and my hope. I lean on your love that lifts me from despair. Arise, Lord, and shine on me. You are my God, and I rely on you.

*Are there any areas of your life where you need the healing
touch of God's redemption?*

Springs of Gladness

May you be pleased with every sweet thought I have about you,
for you are the source of my joy and gladness.
Psalm 104:34

Lord Jesus, no one brings me quite as much joy as you do. You are the source of gladness, and I rejoice in you today. Your presence breathes new life and new hope into my heart each day. Here I am, ready to fill up on your refreshing mercy once again. Spring up from the deep wells of your Spirit and pour out over me. I drink deeply from the living waters of your love.

I have known the gravity of pain and sorrow, but that does not mean that your joy is lost. I will embrace joy and gladness as they bubble up in various circumstances today. When I catch a glimpse of beauty that makes me stop in my tracks, I won't rush on from it. I will treasure each moment of mercy like a breath of fresh air. Revive my heart and restore my joy in glimmers of your glorious love today.

What brings you joy in your day-to-day life? What lightens the
heaviness of pain?

Established

When Yahweh delights in how you live your life, he establishes your every step. If they stumble badly they will still survive, for the Lord lifts them up with his hands.

Psalm 37:23–24

Yahweh, I surrender my life to you. I don't want you to only be honored in my heart but also in how I live your love. In every relationship, every situation, I want your kindness on display in me. May my life glorify and honor your precious name. Establish my steps as I follow your guidance. Your wisdom is life-giving, and it sharpens my focus and helps me to let go of the things that aren't for me. Thank you.

As I follow your loving lead today, lift me up. Even in my stumbling, your gracious hand is there to help me up and set me on the path of your peace. I choose to walk in your ways, for they are not only my best choice but also the best thing for me. I love that you never leave me to flounder on my own. You are always there with a ready hand to help and support me and to right me when I am in the wrong. You are incomparably wise and incomprehensibly good.

How can you live your life to honor God?

Wise Counsel

God-lovers make the best counselors.
Their words possess wisdom and are right and trustworthy.

Psalm 37:30

Holy Spirit, your wisdom is unparalleled. You speak, and clarity comes. Clouds of confusion clear away with the next right step to take. Doubts settle in the peace of your Word. Your wise counsel is clear and to the point. It shows me how to partner with your ways in practical steps. It reminds me that how I treat others matters. Your Word is trustworthy and true. It speaks to the power of your simple truth. May I never forsake your wisdom, no matter how it comes or whom it comes through.

Let me lean on the advice of those who sow your Spirit-fruit in the ways they live their lives and in how they speak to others. Humility is a wonderful sign of your wisdom, as the Proverbs say over and over again. May I make the humble ones my counselors, those who love your Word and are concerned with living it out more than being in places of power. Your counsel is wise, right, and trustworthy, and so is the counsel of your wise ones.

What are the qualities you look for when seeking advice from others?

Cheering Each Other On

When you succeed, we will celebrate and shout for joy.
Flags will fly when victory is yours!
Yes, God will answer your prayers, and we will praise him!
Psalm 20:5

Holy One, you are a good God to all who depend on you. You don't discriminate against any of your children. You give your lavish and loyal love in the same limitless measure to all who call on your name. May I not sit back in envy or disappointment when you bring breakthrough in other people's lives. I want to champion their victories as much as I would my own. May I be a woman who celebrates the successes of other women, knowing that it leaves no less room for my own success.

I love to see your power at work in real ways in the lives of those around me. It encourages my own hope as I see you answering the prayers of friends. Lord, you are such a gracious Father, and you don't withhold any good thing from your children. I delight in your powerful mercy in this world, both in my own life and in the lives of those around me. I am confident of your faithfulness to all of us.

Do you celebrate other people's success?

Stronger than Fear

We will never fear even if every structure of support were to crumble away. We will not fear even when the earth quakes and shakes, moving mountains and casting them into the sea.

Psalm 46:2

Creator, your love is stronger than fear. Your Word says, "Love never brings fear, for fear is always related to punishment. But love's perfection drives the fear of punishment far from our hearts" (1 John 4:18). When the structures of this world crumble, your love is still present. You are not bringing punishment to your children, for you have liberated us in your great love. May I stand strong and steady in faith even if all I've known is stripped away. You have not changed. You will not change.

You are a powerful place of refuge at all times. I run to hide myself in your heart. You are more than enough to sustain me. You meet my needs from your abundance. Don't let dread tear at my heart. Root and ground me in the perfect peace that your love offers. You are my God, and I will not be afraid.

When fear threatens to take over your nervous system, what helps ground you in peace?

Listen, Lord

Lord, listen to my prayer! Listen to my cry for help!
You can't hide your face from me in the day of my distress.
Stoop down to hear my prayer and answer me quickly, Lord!
Psalm 102:1–2

My God, when my heart is desperate and my needs are instant and overwhelming, I ask you to meet me with the power of your presence. Answer my prayers with the marvelous mercy of your hand. Some answers can take their time, but Lord, some I cannot wait on. When the matter is urgent, please don't delay. When I need your help, answer me quickly, Lord.

God, I will not hold back what is on my mind and heart today. I need your counsel, your direction, and your provision. So much is unclear about the future. The unknowns can drive me crazy, but there are no mysteries to you. I will lean into you, praying to you as often as I think to do it. Listen to me, Lord, and draw near in my distress. Bring calm to the chaos I feel. You are powerful, you are faithful, and you are steady. I trust you.

Do you ever hold yourself back from asking for help?

Kept Safe and Secure

He will guard and guide me, never letting me stumble or fall.
God is my keeper; he will never forget nor ignore me.

Psalm 121:3

God, you are my keeper. You never lose sight of me. What an encouragement this is to my heart today. You see me right where I am. You haven't missed a moment. You take notice of the things that hurt and harm me, and you guide me back to your love every time. You keep me on the paths of your peace. You protect me in ways I am not even aware of. Thank you.

I breathe deeply of your peace as I remember that you never let me go. I have not wandered too far away. You are with me. Your love pursues me all the days of my life. You chase me down with mercy, and you cover me in the canopy of your kindness. I pour my love on you, Father, for you have never stopped being good to me. I am safe and secure in your presence, and you surround me with your love.

Can you see where God's love reaches you even in times of stumbling?

Gardens of Glory

Those who sow their tears as seeds
will reap a harvest with joyful shouts of glee.
Psalm 126:5

Comforter, you don't despise my sadness, so I won't either. You meet me in the depths of my pain and minister comfort and peace to my soul. I cannot escape the grip of grief in this life, but I also cannot escape the power of your presence. The seeds of my tears will reap a harvest. Of this I'm sure. I will one day look back and see beauty where once I could only sense pain. Thank you.

You take the ashes of destruction and sow hope. You create gardens of glory in the death of old dreams with the power of your redemption. No pain is so deep and devastating that your restoration cannot bring shouts of joy. I trust your timing, and I walk hand in hand with you through the painful seasons of life. Even if all I can do is keep trusting you, I will do it. Your redemptive power is coming for me, and I await the fulfillment of that hope.

How have you seen God's restorative love go above your expectations?

Alive and Well

You brought me back from the brink of death, from the depths below. Now here I am, alive and well, fully restored!

Psalm 30:3

Restorer, you are my help and my strength. You can bring me back from the brink of despair. I know you can. You don't leave me lost under the crushing weight of sadness and suffering. You don't leave me to destructive cycles. You are my Redeemer, and you bring me back to life.

Life-giver, bring me to the place of your nurture and care where you will restore me in love and peace. I can't help but think of the parable of the Samaritan and how the wounded man was brought back from the brink of death by the intervention of the Samaritan. He picked up the injured man and took him to a place of rest where he would be well tended and cared for, and the man got better. Oh Lord, you do that for me. You fully restore my hope, my peace, and my body. I love you for it, my Rescuer and my Redeemer.

How has God's redemption brought you back to life?

Miracles of Mercy

Magnify the marvels of your mercy to all who seek you. You are the loving Savior of all who turn aside to hide themselves in you.

Psalm 17:7

Savior, you stand with open arms, welcoming all who run to you. You don't turn away anyone who seeks you. You surround each person who turns to you with your wraparound presence. You allow them to hide in your eternal arms. How generous you are! Lord, let every heart that needs hope, every person who needs protection, everyone who needs to know the lengths of your love be fully restored in you.

Reveal the marvels of your mercy, lighting up every heart with the hope that your great love brings. May the miracles of your love shine bright for all to see. Don't hide your goodness from anyone, least of all those who hide themselves in you. You are steady and true, a loving Savior and powerful Redeemer. Draw me close to your heart as I lean into your voice today.

What marvels of mercy have you witnessed? How can you join with God's loving-kindness and lift up his wonders to others?

Close to the Brokenhearted

*The Lord is close to all whose hearts are crushed by pain,
and he is always ready to restore the repentant one.*

Psalm 34:18

Lord, you are ever so close to those who are brokenhearted. You do not turn away from those who are suffering in any way. Lord, I am still learning how to accept sorrow as a part of the human experience. But sorrow does not scare you, and pain doesn't put you off. If you don't despise it, there is no reason I should either. Be close, Lord, especially when I am feeling the weight of grief. I cannot make myself feel better, but I know that you are persistent in peace and your comfort relieves the burden.

When I see others whose hearts have been broken, may I not turn away from their sadness. You never ask us to come to you in any way but how we are. In the same way, may I be a safe space for people to let down their defenses. You are close to the brokenhearted, and I want to be a comfort as well. Thank you for the power of your presence that changes everything.

Have you known God's nearness in pain?

Endless Joy

Let them all be glad, those who turn aside to hide themselves in you...Overshadow them in your presence as they sing and rejoice. Then every lover of your name will burst forth with endless joy.

Psalm 5:11

God of my joy, I have experienced your life-giving help more times than I can count. May I never forget the kindness of your love at work in the details of my life. When I hide myself in you, covered in your kindness, I am at peace. Your grace overwhelms me. Your presence brings light and life and strength to my soul, no matter the kind of day I face.

I will not hold back my gratitude for all you do. I will pour out my gladness in praise and in thanks. You are wonderful in all your ways, my God. I sing for joy at the marvelous ways that you love me. You are thoughtful and generous, so specific in your kindness, oh God. I can't help but burst at the seams with joy every time your presence overwhelms me. You are my strength, my hope, and my love. You are my truest source of joy.

When was the last time you felt overcome with joy?

Shelter of Faith

My faith shelters my soul continually in YAHWEH.
Why would you say to me: "Run away while you can!
Fly away like a bird to hide in the mountains for safety."

Psalm 11:1

Lord, my soul finds its rest in you. You are my shelter. I will not run away when you call me to stand my ground. I will not hide when you say that you have me surrounded and that you will not fail me. I trust you more than I do the threats of this world. I trust you more than the fearmongers who never stop sowing distrust. You are my God, and I trust in you.

Settle my soul in your peace when I am distracted by things that don't matter. I will not get caught up in what-ifs or unknowns. I will remain grounded in truth and in the reality of your presence. I know that there is no reason to fear when I am rooted in you. Give me discernment and wisdom when I am looking for a next step. Be clear, Lord, and let your love always be the compelling force in my life.

How much are you motivated by fear versus faith?

Plentiful Goodness

*YAHWEH is my best friend and my shepherd.
I always have more than enough.*

Psalm 23:1

YAHWEH, I have no closer friend than you. You are more reliable than anyone I have known. I am not alone in this life, but even if I were, I would have more than enough in your fellowship. You are better to me than I am to myself. You know me through and through. You know my motivations and can speak clearly to my soul and correct me in your kindness. Your love never, ever fails.

Guide me, my Good Shepherd. As I walk through this life, you go with me. You are my closest confidant and friend. I am overcome with gratitude and joy when I think about your persistent presence in my life. You never leave me or forsake me. Your interests are not divided. You are lavish in love, and you meet each of your children where we are. How I love you for it! Thank you, Lord, for your plentiful goodness to me. I am in awe of your wonderful and faithful love.

What do you need today? Can you find it in friendship with God?

Firm Foundation

As you guide me forth I'll be kept safe from the hidden snares of the enemy—the secret traps that lie before me—for you have become my rock of strength.

Psalm 31:3–4

Savior, you are my rock of strength. I have built my life on you. As I follow you into the great unknowns of this life, I trust you to keep me safe and secure. You won't let me fall into the hidden traps of the Enemy. You are my good guide, my faithful Shepherd, and my rock of salvation. I trust you more than I trust my own understanding. Lead me on in love, oh Lord.

As I move through this day, make me aware of your leadership in new ways. Show me how you keep me safe, guiding me around snares that the Enemy lays. Even as I hear your voice, I will listen and follow your ways. Help me to not second-guess your wisdom when it is clear that you have my best at heart. I want to be free to follow you, so I heed your words and follow you all the way. What a good God you are!

Is there a time when you could see that God saved you from a terrible situation?

Revived

Revive us again,
that we may trust in you.
Psalm 80:18

Lord, in the depth of my need, I call out to you. You are the way, the truth, and the life. You are the one who breathes hope in my heart. You see the ways I struggle to trust you, but you don't look down on me for that. What grace I find in the generosity of your love! When I am worn down and weak, come close and revive me. All so I can walk in confident trust.

It all comes down to fellowship. Your Spirit is not some elusive mystery that I hear whispers of; it is the powerful peace I crave when I can't seem to sense your face. Come close, oh Lord. Calm my senses by the peace of your presence. Align my vision with your heavenly perspective. Revive my heart in the life-giving source of your loving-kindness. Thank you.

Is there an area of your life that is desperate for revival? Ask God to breathe on it and invite him to permeate your heart, soul, mind, and body with his presence. Be revived in his life-giving love today.

Supportive Love

You watch over strangers and immigrants
and support the fatherless and widows.
But you subvert the plans of the ungodly.
Psalm 146:9

Merciful Father, your love knows no bounds. You don't look through a lens that dichotomizes people or nations. Where others put borders, you break down walls. You are God over all, and your love pursues every one of your children. Thank you for the reminder of your tender nature and your powerful nurture. You don't overlook anyone who needs your help.

Oh God, may I be more like you. I want to care for strangers and immigrants as much as I do my neighbors and friends. You support the fatherless and widows, and I know that it's important that we do the same. Show me ways I can reach out in practical acts of kindness that make a difference for those living in need. I want to partner with your heart and with your kingdom ways. May I see opportunities to show generosity and compassion and take them.

How generous and helpful are you? How do you want to grow in compassion and practical kindness?

Deep Longings

*How I long for my life to bring you glory as I follow
each and every one of your holy precepts!*

Psalm 119:5

Father, I desire you more than I can express. I want my life choices to honor your name. As I walk in the path of your wisdom and truth, I know that I will find you every step of the way. You are worthy of my surrender and my trust. Your ways are higher than the ways of this world and its systems. Your motivations are purer than even the best-intentioned among us. You are the one who deserves my attention, so I won't neglect the power of your love that leads me today.

Lord, I want to live a good life. Not one that is impressive by the world's standards but a life that is full of integrity. I know that when I live in authenticity and in humility, I will continue to grow in you. I will never reach the pinnacle of knowledge in this life, though I grow with each revelation you offer in your powerful mercy. Every time I catch a glimpse of your glory, I am left hungering for more of you. Reveal your nature to me as I walk in step with you and be glorified in my life.

How can you honor God with your choices today?

Keep Hope Alive

My soul, why would you be depressed? Why would you sink into despair? Just keep hoping and waiting on God, your Savior. For no matter what, I will still sing with praise, for you are my saving grace!

Psalm 42:5

Savior, I will keep hoping in you, no matter how despondent I feel. When I am broken down by the world and the troubles all around me, I trust that you have not changed. You are still mighty in mercy and persistent in peace. You haven't failed me yet, and I believe that you won't fail me now. No matter what comes, I will still sing your praise as I wait for you, for you are my saving grace.

I take hope in your Word that says, "Even in times of trouble we have a joyful confidence, knowing that our pressures will develop in us patient endurance. And patient endurance will refine our character, and proven character leads us back to hope" (Romans 5:3–4). I will persist in patience, holding on to hope and waiting for your help. You refine my character as I wade through the troubles of this life. You are the God of my breakthrough, and I trust in you.

When you are feeling down, how do you keep hope alive?

God of Peace

Everyone look! Come and see the breathtaking wonders of our God. For he brings both ruin and revival. He's the one who makes conflicts end throughout the earth, breaking and burning every weapon of war.

Psalm 46:8–9

Wonderful Father, I long to see your peace come to earth in extensive and lasting ways. Oh, that you would manifest your kingdom realm on the earth and have your way here, just as it is in heaven. You are the Prince of Peace, Jesus, so release your peace over the chaos and violence and bring restoration. Your Word says that you are "the one who makes conflicts end throughout the earth." How I pray you would do that today.

It breaks my heart to see so much suffering in the world at the hands of violent people. There are so many victims, so many refugees displaced from their homes, so many who long to know true peace in their homelands. Show us the way of your kingdom and break the yoke of violence. May your people be pursuers of peace, always, and extend kindness instead of inciting violence. Thank you.

How do you practice and pursue peace in your community?

Shadow of Strength

When you abide under the shadow of Shaddai,
you are hidden in the strength of God Most High.

Psalm 91:1

Almighty One, I want to dwell under the shadow of your strength today and every day. Hide me in the power of your love. Give me vision to see when I need to move and when I need to stay perfectly still. I will follow your lead, for I trust you. There is so much safety in your presence. You soothe and settle my soul as you watch over me.

Like a child who spots her parent in a crowd and knows she is not alone, so my heart is strengthened when I see your hand of mercy present in my life. I know that you are with me and that you are watching out for me. I choose to stay rooted in your presence, and I won't wander far from your gaze. Even if I did, you are never far away, and for that, I am eternally grateful. Build me up in the power of your love and the kindness of your care today.

Do you know the confidence of God's watchful care over your life?

Drink Up

Drink deeply of the pleasures of this God.
Experience for yourself the joyous mercies he gives
to all who turn to hide themselves in him.

Psalm 34:8

Faithful Father, when I drink from the springs of your love, I am overwhelmed by the deep delight you pour over me. You are so full of mercy toward me. How can I begin to thank you for all the ways you fill me up each and every time I turn to hide myself in you? When words fail, I will not give up. I will offer you my gratitude and praise in every movement of my heart and in the sacrifice of my work presented as a fragrant offering to you.

Before I do anything else, I will soak up the realities of your presence with me here and now. I will sink deeply into this moment, taking notice of everything that is true. You are with me, and you offer me wisdom that encourages my soul, informs my steps, and clarifies my questions. You are so very good to me. I drink deeply of the pleasures of your heart and kingdom, oh God, for you are overflowing in mercy and constant in kindness.

What kind of delights do you find in fellowship with God?

Heal Our Land

The earth quivers and quakes before you,
splitting open and breaking apart.
Now come and heal it,
for it is shaken to its depths.

Psalm 60:2

Father, you care more about this world than anyone else does. You are Creator, and you are also caretaker. May I join with your heart and seek restoration, not only for the people of this earth but also for the earth itself. Come heal our land, oh Lord.

The weather patterns are changing, and that affects our lands. There are earthquakes, storms, and other natural disasters. We need your help, Lord, and we need your grace. Empower us as your people to bring solutions rather than ignoring the problems. May we look to you for help in all things, both the natural and the supernatural. You are God, and you can do whatever you set your mind to. Come and bring healing, restoration, and peace. Restore our hope as we lean on you in all things.

Do you believe that God cares about the earth and all that is in it? Do you think he cares about how we treat it?

Wonderful Diversity

O Lord, what an amazing variety of all you have created! Wild and wonderful is this world you have made, while wisdom was there at your side. This world is full of so many creatures, yet each belongs to you!

Psalm 104:24

Creator, you are so incredible. You are the most creative being in the entire universe. You have made all sorts of creatures and landscapes. You made people in your image, but that image is varied and beautiful in its diversity. As I marvel at your handiwork, I remember that I am a unique reflection of your creativity too. You don't make any mistakes, and you made me with wonder and care. May I see myself through the lens of your love, cherishing what it is that makes me different and beautiful to you.

I don't want to venerate sameness when you have made us to reflect you in different ways. I truly want to celebrate diversity and differences. Just as we cannot compare the beauty of the mountains to the glory of the ocean, I know that there are different aspects of beauty in each of your created ones. I celebrate the beauty of variety that you have put into creation and into each person.

Are you put off by people's differences, or do you celebrate them?

Luxurious Rest

He offers a resting place for me in his luxurious love. His tracks
take me to an oasis of peace near the quiet brook of bliss.

Psalm 23:2

Loving God, you are my resting place. In your luxurious love, I find deep restorative healing for my body, my mind, my heart, and my soul. All that I am rests in the peace of your presence. What an incredible Shepherd you are to lead me to the quiet brook of your bliss. I need refreshment more than I can communicate. As I quiet my soul in your presence, restore me.

You see my heart, Lord. You see my busy life. Sometimes it feels as if I am on a hamster wheel and can't get off. Lord, when I am spinning and getting nowhere, I follow your lead. I step off and follow your path that leads to an inner oasis. Your love is so accessible. It is pervasive, flooding my entire being and creating space to expand and find my rest. Like the light of your sun, I am warmed and revived by your love. Thank you.

When was the last time you felt refreshed and truly rested?

Powerful Love

His people don't find security in strong horses, for horsepower is nothing to him. Manpower is even less impressive! YAHWEH shows favor to those who fear him, those who wait for his tender embrace.

Psalm 147:10–11

YAHWEH, your favor is worth waiting for. My hope is not in the strength of my body or in the force of any government or leader. Your strength is better. Your love is the most powerful force in the entire universe, and you don't abuse it. You don't use it to manipulate, control, or put people in their place. Your love is generous, sufficient, forgiving, and kind. Your mercy is abundant. It isn't a cheap substitute for manpower; it is far and above the most incredible force.

May I remember that when others are quick to move in vengeance, in hatred, or in self-promotion, your favor is worth the wait. Your love is full of comfort, strength, and peace. It is better than the ways of men, and it is no competition. I choose to wait on you, not putting my trust in mankind but in the source of all things.

Do you believe that God's love is better than the security of mankind?

August

Like a Watchman

*I long for you more than any watchman would long for the
morning light. I will watch and wait for you, O God,
throughout the night.*

Psalm 130:6

O God, I watch and wait for you like a watchman watches
and waits for any sign of danger. What longing he feels for the
relief of morning light, and what longing I feel for the relief of
your presence lighting up my heart and mind. Meet me here,
Lord. Even so, I will wait for you.

My hope is sure. You will shine on me just as surely as the
dawn will bring morning light upon the earth. You are faithful
and true, and I can always count on you. As I watch and wait,
fill me with peace. As I long for your return to the earth, Jesus,
encourage my heart in your hope. You are present by your
Spirit. You have not left us without help. Thank you for your
presence.

How can you watch and wait for God today?

Delightful Unity

*How truly wonderful and delightful it is
to see brothers and sisters living together in sweet unity!*

Psalm 133:1

Faithful Father, when I feel alone, remind me that you have set me in a family. I am your daughter, and I am not an only child. Far from it, you have created me to thrive in community. Though disagreements can cause division if we let them become the most important thing, your love covers a multitude of wrongs. Help me to overlook things in others that I don't need to keep track of. I want to know what it is to dwell in sweet unity with your children.

What wonder and delight there is in the unity of your love! May I clothe myself in your mercy each and every day. Then I can choose patience, kindness, and encouragement. You know how I need your love, Lord. May I give freely from the kindness you so generously offer me, and may I find those who do the same. Thank you.

What keeps you from being united in love with others today?

Breathtaking Beauty

Breathtaking brilliance and awe-inspiring majesty radiate from his shining presence. His stunning beauty overwhelms all who come before him.

Psalm 96:6

Brilliant One, you shine brighter than the sun. The glory of your awe-inspiring presence is too much for me to take in. All the poetic verses that have ever been used to describe you fall short. No language can contain your stunning beauty. The closest I get to taking in your brilliance is when I feel awe wash over me. It is a glimpse of your glory, and it floods my senses with the expanse of your incredible being.

Lord, I want to be inspired by awe today in your presence. Wash over me again with the power of your presence and increase my awareness of your mighty goodness. You truly are better than life, my God. The expanse of sky cannot contain you, so how could my meager mind stand a chance? Even so, shine on me.

When was the last time you were overcome with awe? What was the sensation it brought? How did it make you think of and relate to God?

Hide on High

*I will hurry off to hide in the higher place, into my shelter,
safe from this raging storm and tempest.*

Psalm 55:8

God, you are my shelter from life's storms. You are my safe place and my refuge. I hide myself in the higher place, in the place where you dwell. I run to you every time I feel the threat of this world closing in. You are my holy confidence, and you are the place of my peace. You have set me in the place of your presence, and you allow me to lean into your heart, safely tucked under your arm. You, God, are my help and my Savior.

Help me to remember that you are always near, and you are always a ready help and a safe shelter in which to hide. When I have been privileged by periods of peace, I may forget the importance of turning to you quickly when trouble stirs up. When I feel the stirring of fear in my chest, I will set my eyes on you, my courage and my sure Redeemer. You will come through, and your love will carry me as I burrow into your presence.

How can you hide yourself in God even when you can't escape the real storms of this life?

Holy Highways

How enriched are they who find their strength in the Lord;
within their hearts are the highways of holiness!

Psalm 84:5

Lord, you are my strength at all times but especially in my weakness. Your Word says, "Those who entwine their hearts with YAHWEH will experience divine strength. They will rise up on soaring wings and fly like eagles, run their race without growing weary, and walk through life without giving up" (Isaiah 40:31). This is the kind of strength I need. As I wait on you, I will experience your divine strength overcoming my weakness. I will rise up, run without growing weary, and walk through this life with perseverance and confident hope.

Be enthroned upon my heart, oh Lord, and lead me to highways of holiness. These are the inner roads that lead to your holy presence. What grace is mine in your powerful Spirit-life overwhelming my heart with your presence. I can't help but be overcome by your goodness as you flood like the noonday sun into my inner being.

Where do you need God's strength to flow into your heart,
your mind, your body, or your life?

Always Seeking

Seek more of his strength! Seek more of him!
Let's always be seeking the light of his face.

Psalm 105:4

Abundant God, there is always more of your wisdom to learn, more of your love to discover, and more of your glory to shine on the shadows of my heart. There is an abundance of every good thing in your presence. Why would I stop seeking more of you? I don't want to grow complacent in my pursuit of your nature, your strength, or your presence. I am seeking the light of your face today.

Jesus, I remember your powerful words in Matthew 7:7–8, "Ask, and the gift is yours. Seek, and you'll discover. Knock, and the door will be opened for you. For every persistent one will get what he asks for. Every persistent seeker will discover what he longs for." How could I sit back in apathy when you promise that you will meet every persistent seeker with what they search for? I am seeking more of your strength, more of you, to see the light of your face today.

How actively are you pursuing God? How do you seek him?

Tenderhearted

Hurry to our side, and let your tenderhearted mercy meet us in our need, for we are devastated beyond belief.

Psalm 79:8

Faithful God, I need your tender love to meet me where I am today. There is nothing I can do but offer my surrendered heart to you now. In my great need, in my overwhelming grief, rush in with your comfort. Don't delay, God, for I need your strengthening peace. I need you, my God.

I know that you are tenderhearted and quick with compassion. Draw near to my heart and wash over me with the kindness of your love. I cannot conjure up strength or pretend that I'm okay when I am devastated by loss. You, Lord, are the one I call upon. You know my pain, and you don't try to dismiss it. Your comfort meets me in my deep distress. Wrap around me with your presence like a warm blanket. Tuck me in tightly to your gentle love. You are my good and faithful Father, and I depend on you.

When you are overcome with sadness, do you try to dismiss it, or do you invite God into it?

Faithful to the End

YAHWEH, turn to me and rescue my life
because I know your faithful love will never fail me.

Psalm 6:4

Lord, you are my only sure rescue. Reveal your mercy-kindness to me again and overwhelm my need with your sufficient grace. Rescue my life because of your faithful love. I know that you won't ignore my cries for help. You are the God who rushes to help those who call on you. Lord, reveal the power of your miraculous mercy as I wait on you.

When my hope begins to wane, come in close with the power of your redemption to encourage my heart in your faithful love. I need a fresh glimpse of your wonderful character. I need a new understanding of your nearness. Open the eyes of my understanding and reveal how very close, how very ready, and how very capable you are to help. You are my great hope, my confidence, and my biggest advocate. You are my all, Lord.

How can you see God's faithfulness at work in the world or in your life today?

Entwined Hearts

Be there for me, my God, for I keep trusting in you. Don't allow my foes to gloat over me or the shame of defeat to overtake me. Could anyone be disgraced when he has entwined his heart with yours?

Psalm 25:2–3

My God, I keep trusting you through the highs and the lows of this life. I can't let go of you, for you have never let go of me. You are my highest hope. Be there for me today. In the realities of my challenges, show me how to follow you along the path of your loyal love. Open doors that were walled off. Reveal where your mercy is sowing new life in the ashes of my disappointment. I know that you are working.

My heart is entwined with yours, Lord. Your compassion fuels my own. Your perspective reveals the heights, the depths, and the lengths your love will go to free your children. We won't be disgraced, for you are the liberator of the imprisoned, the healer of the sick, and the advocate of the accused. I am yours, Lord, and I stand upon your promises. I keep trusting in you, for you never fail.

How has God's heart transformed your own?

Compassionate Gaze

Give me grace, YAHWEH! Always look at me through your eyes of love—your forgiving eyes of mercy and compassion. When you think of me, see me as one you love and care for.

Psalm 25:6–7

YAHWEH, you are a generous grace-giver. I look to you today. Will you look at me through the eyes of your love? As I raise my gaze to meet yours, may I see the compassion in your eyes, the mercy of your heart piercing my own with your powerful gaze. When I keep my eyes on my problems, I am overwhelmed by them. But when I look up to you, I realize that my problems are small in your eyes. You have solutions for every challenge. You transform my chaos and confusion into peace with the grounding presence of your love.

I can't begin to thank you for the ways you love and care for me. You are the best caregiver, the most thoughtful friend, and the most thorough healer. Your mercy doesn't miss a thing. Your redemption life restores my hope, and it causes deep joy to well up from within.

How limited is your perspective? What are your thoughts consumed with? Look up to meet the gaze of your heavenly Father.

Walk in Grace

I will live enthroned with you forever!
Guard me, God, with your unending, unfailing love.
Let me live my days walking in grace and truth before you.

Psalm 61:7

God, you have called me as your own child, and I cannot begin to thank you. You are my true home, and my soul finds its rest in your presence. This life may be short, but your kingdom goes on forever. When I dwell with you in eternity, there will be fullness of wisdom. There will be wholeness of hope, love, and joy. What confident expectation I have in you!

As I walk through the hills and valleys of this life, I lean on your leadership. You are my wise guide, and you see every obstacle ahead. As I yield to your leadership, may I walk in your grace and truth. May I never withhold good when it is in my power to offer it. May I be openhearted in forgiveness, lavish in mercy-kindness, and generous in grace. Thank you for your wonderful example to follow, Lord Jesus.

How can you share God's grace with others in tangible ways today?

Friends of God

The Lord sees all we do; he watches over his friends day and night.
His godly ones receive the answers they seek whenever they cry
out to him.

Psalm 34:15

Gracious God, your goodness far outweighs the disappointments in this life. You are incomparably kind, and your friendship is worth more than all the influence in this world. I don't want to get caught up in what others think of me. Help me to remain grounded in who you are and who you say that I am. You are trustworthy and true, and you will never lead me astray.

I will not ignore you today, Father. I will press in to know you more. I know that takes time and intention. Just as I would reach out to a friend throughout the day, I turn my attention to you again and again, knowing I have a warm reception with you. You see all I do, and I don't have to explain myself to you. You already know me fully. Even so, you correct me with kindness, you encourage me with love, and you align me with your kingdom ways through your compassion and truth. Share your heart with me today, Lord, for I long to know you more.

How can you make more room in your schedule and in your mind to know God more deeply as a friend?

Cycles of Blessing

May the fame of his name spring forth! May it shine on, like the sunshine! In him all will be blessed to bless others, and may all the people bless the One who blessed them.

Psalm 72:17

Famous One, you are renowned in mercy. No other is known for such powerful love. I don't want to lose sight of the important things in life. As I set my heart on you, remind me of the power of this love that transforms, redeems, and restores. You are the wonderful healer, the way-maker, and the Savior of the world. You bless all who turn to you, and you fill us up so that we may, in turn, bless others.

When I forget that I am a vessel that can pour out what I receive, open my eyes to the power of your mercy-kindness fueling my life. No matter how much or little I have by this world's standards, I have abundance in you. What I have is a blessing, and I know there is much to share. May I bless others with generosity and intention, and may they bless you, their maker and Creator, in return.

What gifts do you have that you can use to bless others today?

Mystical Music

I will break open mysteries with my music,
and my song will release riddles solved.

Psalm 49:4

Lord, I know that you do so much more than our minds can comprehend. You use sounds and melodies to transcend language. There is such a depth to the spiritual connection I find through music. I'm so incredibly moved by the spirit-to-Spirit relationship that occurs through the texture of the sounds that various instruments make. What a gift music is to us.

Instead of trying to logically understand what is happening when I hear a song that moves me and breaks open deeper understanding, may I engage with my heart and emotions, allowing it to flow through me. I don't want to intellectualize something that is meant to be felt. You do such incredible things through melodies and songs. Some songs release deep healing, others inspire curiosity and compassion, and still others create connections that offer new ways to express ourselves creatively. Break open mysteries, Lord, and solve riddles through music and sound today.

What songs have moved you beyond words?

Recall His Kindness

*Lord, as we worship you in your temple, we recall over and over
your kindness to us and your unending love.*

Psalm 48:9

Kind Father, there aren't enough blank pages to fill with gratitude for all you have done. But I don't want to just offer you tropes. Your mercy-kindness gets into the nitty-gritty of my life. Your compassion gets into the messes of life with me and offers redemption. I won't offer you showy, shallow gestures, but I will give you the honest gratitude of my heart for how you have really come through for me.

As I recall your kindness toward me, open up new memories so I can give you even more thanks. You are faithful and true, and you have not failed me. Here is my honest account of your goodness toward me. Move in waves of love as I offer it to you, expanding my awareness even further, for you are incomparable. There truly is no one else like you.

When was the last time you took time to recall the kindness of God toward you? Set aside time to do it today. Write a list and add to it whenever you think of it. Let it act as a personal record of God's kindness.

True Hope

Human strength and the weapons of man are false hopes for victory; they may seem mighty, but they will always disappoint.

Psalm 33:17

Mighty Father, I don't want to get caught up in the ways or the weapons of this world, thinking that's where our answers lie. I know that you are steadfast in love, and your peace prevails over violence. I don't put my hope in leaders or governments of this world who make promises that they cannot keep. You are the true promise keeper, and I know that I can always depend on you.

You, oh God, are my true hope. Where everyone else falls short, you stand strong. I don't want to depend on who others say you are. I want to stand strong in you, experiencing the restorative power of your love and the strength of your grace in every season. You are faithful, and you are so very near. As I draw near to you, draw ever closer to me. I depend on you.

Where does your hope lie? Are you banking on leaders or ideologies, or are you rooted in Christ?

Paths of Righteousness

*That's where he restores and revives my life. He opens before me
the right path and leads me along in his footsteps of righteousness
so that I can bring honor to his name.*

Psalm 23:3

Redeemer, open the right path before me as I look to your
leadership. When I am stuck and don't know which way to
turn, lead me in the footsteps of your righteousness. You know
how I want to honor your name. I don't have to worry about
your presence waning; I know that you are with me every step
of the way. Even so, Lord, sometimes I just can't seem to find
my way. Bring clarity to my confusion and show me the next
right step to take.

You are the God of my restoration and revival. You sow
peace into my heart as I rest in your love. Oh God, may I never
take your loving-kindness for granted. It is what unravels my
worries and rejuvenates my soul. Restore and revive my life
as I lean into your love and rest by the oasis of your delight.
Thank you.

What do you need from the Lord today?

Streams of Refreshing

Now, Lord, do it again! Restore us to our former glory!
May streams of your refreshing flow over us
until our dry hearts are drenched again.

Psalm 126:4

What joy fills my heart when you move in miracles of mercy! When you restore what seemed completely lost, the relief and overwhelming joy of your wonderful redemption overcome my soul. I want to be washed in the streams of your refreshing flow once more, Lord. Drench my dry heart with the life-giving waters of your love.

You are my hope, and I depend on you, God. There are dry areas of my life that long for the refreshing rains of your presence. I need you to move because, without you, there is no hope. Lord, I trust you. I call out for the waters of your powerful presence to rain down over me, over the arid places of this world and of my life, to restore and redeem what is lost without you. Only you can restore me, and I pray that you will do it again. Bring restoration and refreshing like only you can.

What part of your life do you need the Lord's presence to fill?

Daughters of Praise

Let the people of Zion rejoice with gladness;
let the daughters of praise leap for joy!
For God will see to it that you are judged fairly.

Psalm 48:11

Father, I am your daughter. I am your beloved child. I don't forget this or take it for granted today. You are the mighty maker of all that is and ever will be. You are the one who set the earth into motion, who formed the great deep and the mountain peaks. You are my Creator, and you are my Savior. I have so many reasons to praise you.

I will not forget the low place from which you have brought me up. I won't neglect the power of your mercy-kindness in my life. You are the one who turned my mourning into dancing, and I know you can do it again. Though the ache of loss remains, your redemptive mercy sows new life and opportunities. The grief and joy comingle in hearts surrendered to you. No matter the pain I carry today, I also carry gladness. I won't neglect the joy you have brought me.

What reasons do you have to be glad and rejoice before God today?

Time to Praise

*How could I be silent when it's time to praise you? Now my heart
sings out, bursting with joy—a bliss inside that keeps me singing,
"I can never thank you enough!"*

Psalm 30:12

Wonderful One, today is not a day for my silence. It is an
opportunity to offer you the deep gratitude and delight of my
heart. As I count off the reasons I have to thank you, I am over-
come by your goodness. Meet me in the praise I offer, for you
deserve all the honor.

I enter your presence with thanksgiving, and I pave the
way into your courts with praise. You are worthy of every bit
of trust and surrender, Lord, forever and ever. May I grow only
stronger in trust and obedience to the law of your love as I
follow you along the journey of this life. You give me so many
reasons to burst out into song. Your joy is not a shallow thing
that comes and goes like a whim. It is deep, flooding up from
the innermost parts of my being. You are my source and my
gracious King. I worship you, Lord.

What is it time to praise God for today?

Rescued and Protected

The Lord says, "Now I will arise! I will defend the poor, those who were plundered, the oppressed, and the needy who groan for help. I will spring into action to rescue and protect them!"

Psalm 12:5

Savior, you are the rescuer of the weary and broken-down ones. You are the hero of the oppressed and those taken advantage of by abusive people. You don't overlook a single person in need, and you never turn a deaf ear to those who cry out for help. You are such a gracious God, and you are mighty to save.

Lord, arise and defend the poor and oppressed among us still. I partner with your heart, and I will do my part to help the needy and vulnerable. I cannot stay silent or still in my comfort zone when people are perishing around me. Empower me with your strength and give me clear ways to meet the needs of those whom others may overlook. Even so, Lord, come soon. Move on behalf of those who are stuck in situations where they have no means of their own to escape. You are great, and you are good.

Are there people around you who need help? How might you engage with them in the light of God's love today?

Limitless Love

*You, O Lord, your mercy-seat love is limitless, reaching higher
than the highest heavens. Your great faithfulness is infinite,
stretching over the whole earth.*

Psalm 36:5

Lord, I need your help understanding just how limitless your
love is. When my knowledge of your mercy grows stale, I need
a fresh perspective, a new revelation of how incredible it is. I
know that you are unchanging in miraculous mercy, and you
are powerfully gracious each and every moment. You never
change. Oh, how I need a deeper knowledge of your great-
ness today.

I will not forget how powerful the feeling of awe is in expand-
ing my experience of your greatness. I will look to the natural
world around me for hints of your grandeur and for glimpses of
your loyal love. As I look into creation, reveal how vast you are
and how capable you are of meeting me in the realities of my
little life. Whether I sit beneath the sky, wondering at its heights,
or stand beside great waters where I cannot see to the other
side, remind me of how big you are and how minuscule I am in
the midst of it. What a comfort I find in knowing you are grander
than anything I could dream of achieving in this limited life!

*What helps give you perspective of your life and of God's
greatness?*

Never Forget

Don't you ever forget his miracles and marvels.
Hold to your heart every judgment he has decreed.

Psalm 105:5

Marvelous One, every promise you make is bound to your faithful nature. Every word you speak is loyal to your love. You are kind and forgiving. You are just, and you are true. You are powerful and patient. You never give up, so I won't give up on you. Lord, as I meditate on the ways you have moved in miraculous mercy and wonderful marvels, increase my own faith and patience as I wait on you.

You are the hope of my heart, and not only that, but you are also the hope of the entire world. I am but a small particle in this great universe, and still you are mindful of me. You are wonderful, and your love reads as too good to be true, yet it is that good! I hold your law of love close to my heart. I won't depart from your ways, Lord, for they lead me to you.

Have you forgotten the miracles and marvels that God has done? What helps ground you in God's powerful love?

Unite Us

Save us, O Lord, our God! Gather us from our exile and unite us together so that we will give our great and joyous thanks to you again and bring you glory by our praises.

Psalm 106:47

Lord, I'm calling out for your powerful love to unify your people. Where there is division, help us choose love that covers over offenses. Your mercy-kindness is a bridge builder, and I don't want to sit back and wait for others to do that job. I don't want to isolate myself from others who think differently than me. Help me to clothe myself in love and to move in kindness to all, even those I disagree with. I know that your love is more powerful than the façade of control. Break through our biases with your mercy.

When it is all said and done, may it be said of your people that we were gracious and compassionate, humble and forgiving. May we be known as pursuers of peace and as creatures of kindness. May we be generous when others are stingy. May we cross barriers where others put up walls. May we be relentless in love, never giving an excuse for our apathy. May we follow your example, Lord Jesus, and be living reflections of your radiant mercy.

What does the work of unity in your community look like today?

Complete Compassion

He will care for the needy and neglected when they cry to him for help. The humble and helpless will know his kindness, for with a father's compassion he will save their souls.

Psalm 72:12–13

Father, your compassion is overwhelming in its scope. You are a good Father, a tender Father who cares for his children. You don't just look after those who look after themselves. No, you are there for the needy and the neglected. You don't require that anyone "have it together" to receive your help. You are the God who reaches out to those whom others overlook, and you don't miss a single soul.

Lord, when I have it backward, remind me that you are always near and ready to help the humble and the helpless. May I see through the vision of your compassion not only my own lack and need but also those of my neighbors. Instead of judging others for their misfortune, I will clothe myself in your compassion and see that they are your people, the ones you nurture. Help me to do the work of your kingdom and care for them as well. Thank you.

What role does compassion play in how you see those who are needy and without resources of their own?

Beyond Beautiful

Beautiful! Beautiful! Beyond the sons of men!
Elegant grace pours out through every word you speak.
Psalm 45:2

Glorious God, you are beautiful beyond the most elegant among us. Your visual beauty isn't what sets you apart, though your glory is too much for our eyes to behold. It is the incomparable beauty of your character that shines most glorious of all. Who else is like you in kindness, in generosity, or in grace? The power of your love is greater than the force of the winds and waves, of thunder and earthquakes. It is greater than the pull of the grave.

Lord, you are beyond beautiful. Speak your words of life over me again and rejuvenate my hope as I listen for your voice. Reveal the wonders and kindness of your nature as you open my eyes to the miracles of your mercy upon the earth. Beautiful! Beautiful! Beyond the sunrise or sunset, beyond the daughters and sons of men, beyond the precious jewels of this earth. You are more beautiful still. Give me vision to see how wonderful you are through the faithfulness of your love at work in the world. You are worthy of my attention, Lord.

What about God's nature is most beautiful to you?

Eat until Satisfied

Let all the poor and broken eat until satisfied.
Bring YAHWEH praise and you will find him.
May your hearts overflow with life forever!

Psalm 22:26

Gracious God, you don't offer crumbs to the hungry. You offer true nourishment to all who need it. You say to them, "Eat until satisfied." This is the kind of God you are. Thank you. Lord, you see the need in my own life. You see where I am lacking, and I don't have to be ashamed of it. I will not pretend to have it all figured out. No, Lord, I come to you with my real need. Nourish me with the resources of your kingdom and your presence. May I find satisfaction in you, for I know you have the answers I seek.

As I partake of the power of your love in your presence, overflow my heart with your life. Pave new pathways of peace, restore my hope in your generous grace, and move in healing to bring wholeness to broken areas. I trust you with this work. You are good, and I am yours. I sit at the table you set for me, and I feast on all you offer me today. This is where I am satisfied.

What unsatisfied needs do you have today?

Every Single Time

I will answer your cry for help every time you pray,
and you will feel my presence in your time of trouble.
I will deliver you and bring you honor.

Psalm 91:15

Father, every time I pray, I know that I can trust in you. You are faithful to answer. When times of trouble upend my life and bring anxiety, soothe me in the peace of your presence and settle my heart in quiet confidence. You are the one who holds my future, and you will not let me down. Lead me on, Lord, for I trust you.

I won't stay away from you or stop myself from praying one more prayer when I need to. You are the one who is always there, always ready to hear me and save me. Your presence calms my heart and settles my soul. You bring clarity to my confusion, peace for my fear, and generous help for my lack. You are my support, and you hold me in the strength of your arms. I will not be afraid. And when I do feel my heart begin to quake, I call out to you again. Thank you for your quick answer and your ready presence.

How often do you pray to God throughout the day?

Soul-Speak

I say to my soul, "Don't be discouraged. Don't be disturbed. For I know my God will break through for me." Then I'll have plenty of reasons to praise him all over again. Yes, he is my saving grace!

Psalm 42:11

Father, when I am struggling, remind me that I can take my thoughts captive and surrender them before you. I can speak to my soul and remind it of truth. I take that to heart today. When I am discouraged, I will remind my soul that I am confident of your goodness. You will come through for me. Your faithfulness will outshine my troubles. Thank you for the promise of your loyal love that will always break through like the dawn.

You are my saving grace, God. You are my holy hope. No matter what I face, you are stronger still. You have not grown tired or sleepy to my cause. You have not grown impatient with me. You have not become bored and moved on to something else. In this fast-paced world, I am even more grateful for your persistent love and your generous grace. So, soul, don't be discouraged or disturbed today. I know with certainty that my God will break through for me again.

What does your soul need reassurance about today?

Embrace of Protection

Protect me from harm; keep an eye on me as you would a child who is reflected in the twinkling of your eye. Yes, hide me within the shelter of your embrace, under your outstretched wings.

Psalm 17:8

Good God, you don't put me in a tower of isolation to protect me. You are the God who pulls us in close and keeps us tucked into your embrace. The power of your protection is in your presence, not in your absence. You are not like the weak men of this world who leave at the first sign of trouble. You are not like fickle friends who desert us when challenges arise. You are the God who sticks close, a loyal friend and a sure help. Thank you.

You know exactly what I need from you today. Protect me in the warm embrace of your presence. Cover me in your love and push out the dread that has creeped into my thoughts. I know that you are powerful and true. You are greater than I can imagine and better than I hope for at every turn. I trust you.

How can you stay connected to God and others rather than isolated in pain today?

Light to the Eyes

Take a good look at me, Yahweh, my God, and answer me! Breathe
your life into my spirit. Bring light to my eyes in this pitch-black
darkness or I will sleep the sleep of death.

Psalm 13:3

When the light of my life has dimmed and I can find no hope to hold on to, breathe your life into my spirit again. I need your renewal and your life-giving love to refresh my body, soul, mind, and heart in you. My spirit needs your Spirit to thrive. Minister deep within, to the very depths of my innermost being, and saturate my heart with your love. Bring light to my eyes so I can see with new vision.

You know how much I rely on you, God. You know the lengths to which I have gone to remain connected to you. And even in my weakness and in my failings, your love has remained constant and true. I need a fresh vision of your true nature, God. I need to see where you are, Lord. When you light up my life, I am encouraged in hope and walk with the confidence of your loyal love. Breathe your breath in me again. I need you.

What is an area of your life that needs God's light to refocus your vision?

September

Defend My Reputation

He will rescue you from every hidden trap of the enemy, and he will protect you from false accusation and any deadly curse.

Psalm 91:3

Lord, when others falsely accuse me, whether outright or by their insinuations, will you protect me? You know me through and through, and as I remain humble before you, I am able to learn and grow with every trial and every misstep. I know that I can trust you to defend me when others treat me unfairly. You will bring the truth to light, and in the meantime, I can depend on your grace to cover me.

Lord Jesus, you know the pain of rejection. You walked through it first, so I believe you when you say that you really do understand me in my troubles and in my pain. You have known sorrow and disappointment; minister to me in my own. You don't ask me to gloss over my heartbreak when others stir up baseless arguments against me. Help me to remain rooted in your love and established in your peace all the days of my life, especially the hard ones.

Have you ever known the bitterness of false accusations or rejection? How does Jesus' experience inform your own?

Keep Coming Back

You're the only place of protection for me.
I keep coming back to hide myself in you,
for you are like a mountain-cliff fortress where I'm kept safe.

Psalm 71:3

Shield and strength, I keep coming back to you. Though I may have wonderful seasons filled with joy and peace, I also face difficult times that cause me to turn to you for help. When life is hard, the world is noisy, and peace is not easy to come by, I run to you. You are my only place of true protection. Your presence is my place of peace and my soul's saving grace. I come to you over and over again, and I won't stop.

I'm so relieved that you receive me with welcome every time I turn to you, Father. When the world is going haywire, you are constant in compassion and a powerful and ready help. I hide myself in you, for you will never change. You remain faithful, and I find myself loved to life over and over again in your protective presence. Steady my heart and clear my vision in you today, my God.

How is God's presence like a protective home to you?

Perspective Shift

One day I was brought into the sanctuaries of God,
and in the light of glory, my distorted perspective vanished.
Psalm 73:17

God, your presence relieves my fears, renews my hope, and sharpens my vision. There is so much that I don't see clearly, and I fear that I have built mindsets around that lack of understanding rather than in the truth of your nature, your power, and your love. Lord, bring me into the sanctuary of your presence and renew my vision. Shift my viewpoint in the clarity of your perfect perspective.

I don't rely on my limited understanding, Lord. I rely on you. Your wisdom is higher, your thoughts purer, and your strategies more thorough than any I have ever known. You are smarter than the most brilliant of men. You are more compassionate than the warmest person on the earth. Your love and wisdom go hand in hand. Light up my mind with the truth of this partnership and transform my thoughts in the atmosphere of your peace.

When was the last time you questioned your understanding of a topic? Knowing that we are all still learning (and always will be), what can you ask God for clarity about today?

Pools of Blessing

Even when their paths wind through the dark valley of tears, they dig deep to find a pleasant pool where others find only pain. He gives to them a brook of blessing filled from the rain of an outpouring.

Psalm 84:6

Good God, you are with me in the bright days of celebration and in the dark days of mourning. When my path winds through the dark valley of tears, you are no less present with me. You are persistent in love, and you teach me where to dig deep rather than staying on the surface level. As I dig with you, I find there is a refreshing pool where others find only pain. Thank you for leading me beyond the wound to the place of my healing.

I won't be afraid when hard times don't seem to let up. Rather than push ahead, I will dig deep when you keep me in place. I know there are brooks of blessing in the trials. There are outpourings of refreshment even in the middle of arid places. I trust you, my God, for you are my Sustainer, my healer, and my Redeemer.

Where have you found treasures in the midst of pain?

Stronger with Each Step

They grow stronger and stronger with every step forward,
and the God of all gods will appear before them in Zion.

Psalm 84:7

Faithful Leader, you are the one who leads me through the highs and lows of this life. With every step forward, you build my strength. My confidence in your faithful love grows stronger as you continue to meet me with mercy. There is no trouble I could go through where your grace is insufficient. You are more than enough for me, no matter my need or challenges.

Do not leave me to my own strength today, God. I long to grow stronger in the ways of your kingdom. I want to be courageous in compassion, reaching out in practical ways to those around me. I want to hold on to hope in more than just theory. I want to step out in faith when you call me to do something brave. I want to be forgiving when others are quick to cancel. In all the ways of your nature, I want to grow stronger with each step.

In what ways of God have you grown stronger? In which areas do you want to grow stronger still?

Everything I Am

Lord, I will offer myself freely,
and everything I am I give to you.
I will worship and praise your name, O Lord,
for it is precious to me.

Psalm 54:6

O Lord, I don't withhold anything from you today. I offer myself freely. Everything I am—everything—I give to you. You have seen the areas that I've held close to my chest, waiting you out. And still, I know that you are more trustworthy even than I am to hold these areas close and dear. You won't betray my confidence. You won't waste my hope or my surrender. I trust you.

You can have it all today, Lord. You have earned my trust with your faithful love. You are not like shifting shadows or waning winds. You never change. You are always overflowing in mercy, generous in grace, and powerful in truth. I allow you into every area of my heart and life, and I yield to your leadership, for you are wise, capable, and kind. Everything I am I give to you.

Is there something you have had a hard time trusting God with? Will you invite him into it today?

Hide in Him

Keep me in this glory.
Let me live continually under your splendor-shadow,
hiding my life in you forever.

Psalm 61:4

What an invitation you've given me, O Lord, to live under your shadow all the days of my life. I can hide my life in your presence in every season. Thank you for your persistent presence that covers me at all times. You are my God, and I get to live under your splendor-shadow, the place of your protection and peace.

Your love is a constant covering that never lets up or gives in. It doesn't mean I cop-out of my responsibilities or give up agency over my choices. Your love informs what I do. It is the canopy under which I live. I am hidden in your love, but your love is also the fuel that lights up my passion and my purpose. Thank you for the power of your presence and for the partnership of your law of love that I get to live out every day of my life.

What does it mean to you to hide your life in God in good times and in hard times?

Fullness of Love

"All the love you need is found in me!"
Psalm 62:12

Author of love, there is no love apart from you. Every expression of love, therefore, is a glimpse of what you are like. You do not overlook even my weakest attempts at love. You delight in every sacrifice of kindness and in every offering of compassion. When I take time to understand someone else rather than jump to conclusions, I make space for love to move. Thank you for the power of your love at work in my real challenges.

Your Word says that without love, all of life amounts to nothing. Even our best attempts are but fog and mirrors, noise and chaos, without love. You are the source of love; therefore, everything finds its meaning, its essence, its purpose in you. I am no different. All that I need, every facet of love that I am looking for, I find in you. You are the beginning and the end, the all and the everything, and I come running to you today.

Look for the marks of love in your life. How do they reflect the purpose of your being and who God is?

Sufficient Provision

He provides food for hungry men and animals!
His tender love for us continues on forever!

Psalm 136:25

Father, you never turn away the poor or the broken. You always offer more than enough to satisfy every need in your presence. I won't neglect my own need today. I come now to sit at your table and feast from your abundant nourishment. I offer you praise, knowing praise is the gateway to your presence. I have so much to be thankful for, even as I sense my real lack today. Thank you for the abundance you offer at every turn.

I am overwhelmed by love for who you are, God. You are a generous Father and a faithful friend, and I can always, always, always count on you. I praise you for your persistent presence in my life, for the power of your peace in my mind and heart, and for the joy of your fellowship. I have never known a love like yours that never ebbs; it is always overflowing. Thank you for being so very easy to find, God. I love you.

How has God revealed his love to you through his provision?

Pause to Consider

From heaven he will send a father's help to save me.
He will trample down those who trample me.
Pause in his presence
He will always show me love by his gracious and constant care.

Psalm 57:3

Faithful Father, I take time today to consider how your faithful love has helped me in the past. May it serve as fuel to my faith for both the present and the future. Here, in this place and in this moment, your presence is perfect. You have all that I need, and I lean into you. I slow down in this moment and remember how reliable your love is and how generous your grace has been in my life.

You won't stop showing me love; of this I know. You are a tender and attentive Father. Every time I come to you, you meet me with kindness, even when you have to correct me. Don't stop showing your constant care, Father, for I rely on you more than I do anyone else, including myself. Show off in loyal love and strengthen my heart in your compassion. I love you so much.

When you pause in his presence today, what does God have to show you about his faithful love?

Lyrics of Love

O my strength, I sing with joy your praises.
O my stronghold, I sing with joy your song!
O my Savior, I sing with joy the lyrics of your faithful love for me!
Psalm 59:17

Lord Jesus, you are my strength and my song. All the good in my life is from your hand. You are the one who sows beauty among the ashes, who brings new life out of decay. You are wonderful, and I can't help but worship you today. When I think of all the things that bring me joy, your love, oh Lord, is at the top. You lavish your loyal love over me every time I turn to you. It is always flowing, refreshing my heart and soul in the reviving waters of your affection.

When questions are swirling around my head and there don't seem to be answers, speak your truth over my mind, heart, and very being. The truth of my identity—of being fully seen, known, and loved—I find always in you. Rejuvenate my heart in your presence and speak your words of life over me, and I will have all the more to offer you in return. May these lyrics of love please your heart and draw my own heart closer to you today.

How has God shown his love to you today?

Continual Saving

YAHWEH is the God who continually saves me.
I weep before you night and day.

Psalm 88:1

Savior, when my heart is full of sorrow, you are the one who meets me with comfort. There are so many challenges in this life. Some come out of nowhere, while others slowly build. You are the one who continually saves me, and you help me through every trial. I am grateful that I don't have to be ashamed of my need. You are my provider, and you are my saving grace.

Jesus, I take your words to heart today. In Matthew 6:34 you said, "Refuse to worry about tomorrow, but deal with each challenge that comes your way, one day at a time. Tomorrow will take care of itself." I lay aside my worries about the future and instead focus on today. I know that there are challenges here, but none of them are too much to face with your help. Give me your wisdom and solutions for every challenge that comes my way, for I trust in you. Help me to remain rooted in the present and in your presence. Thank you.

Are you overwhelmed by the unknowns of tomorrow?
Take Jesus' words to heart and lay aside your worries about tomorrow. He will help you with every challenge as it comes.

Strong Confidence

Because I set you, YAHWEH, always close to me,
my confidence will never be weakened,
for I experience your wraparound presence every moment.

Psalm 16:8

Lord, I place you at the forefront of my attention. I set you close to me, turning my gaze to your faithful nature over and over again throughout my day. Because you are the one I lean on, your grace strengthens me. My confidence is in you, my dear God. Your wraparound presence surrounds me and gives me courage. I can feel you with me, closer than the air I breathe. You cover me with kindness.

Lord, even when I struggle to sense your nearness, I know that you are still near. Your love never lets me go. I am immersed in it every moment of every day. Strengthen me in my inner being. You have enfolded me in your presence, and I am never without it. Thank you. You are my greatest confidence, Lord, and I know that you will not fail.

What helps build your confidence? When your faith feels weak,
what strengthens it?

Firmly Held

The king trusts in YAHWEH, and he will never stumble, never fall.
The forever-love of the Most High holds him firm.

Psalm 21:7

Lord, I am not a king or a queen. I am not powerful by the world's standards. Yet it is not influence that I want. It is not wealth I am after. It is you. Everyone everywhere can put their total trust in you, and I am not left out of that. You, oh Lord, are constant and true. You are full of mercy-kindness and powerful justice. You are trustworthy, and I can always count on you. Your eternal love, the love that never ends, is the love that holds me firm and steadfast. Thank you.

Jesus, in your resurrection life, I come alive. There is no shadow that you don't light up with your love. Come shine on the dark places of my being—my heart, my mind, my very life—and bring peace, wisdom, and mercy. I submit my heart to you again today, for you are worthy. You straighten my steps and lead me forward in steadfast love with every step.

How has trusting in God kept you from stumbling?

Cradled by God

Since the day I was born, I've been placed in your custody.
You've cradled me throughout my days,
and you've always been my God.

Psalm 22:10

Father, from my very first breath as a newborn, you have been my keeper. You have cradled and kept me. You have been watching over me from the beginning, and I trust you to continue to lead me in loyal love all the days of my life. I see the signs of your mercy-kindness in my youngest days, even amidst hard times. You have always been my God, and I am your daughter.

I come to you as a dearly loved daughter today. Speak your words of wisdom and grace over me. I have known you to be good, though sometimes I need a reminder of just how good you have been. I need a reminder of your consistent care and compassion in my life. Show me where you have protected me along the way. I love you, Father. I follow your footsteps and walk in your ways because you are incomparably kind, faithful, and true.

Can you see areas where God has cradled you throughout your life?

Feast of Favor

The Lord alone is my Savior.
What a feast of favor and bliss he gives his people!

Psalm 3:8

I have known the favor of your love, oh Lord, more times than I can count in this little life of mine. When I begin to thank you, I find more and more reasons to pour out gratitude. You have been so good to me. Lord, I will not hold back from you my genuine appreciation and love today.

What bliss fills my soul as I taste your goodness, Lord. I have tasted and seen your goodness, and I know those days are not solely behind me. I will see your miraculous mercy play out in my life as I continue to trust you. You haven't finished your work in me, and for that I am extremely grateful. Take this heart of mine and bind it up in your love, for it is yours. I love you.

Are there areas of your life that feel without hope? What joy have you had in God? Ask the Lord to reveal what joys still lie ahead of you.

Marvelous Creator

You keep all your promises. You are the Creator of heaven's glory,
earth's grandeur, and the ocean's greatness.

Psalm 146:6

Faithful One, you are so very loyal to your word. You do not make a promise and then break it. You keep all your promises. Encourage my heart in the hope of your loyal love that carries the weight of your faithfulness behind each of the promises you make. As I look at the clouds above me, the stars that shine by night and the sun by day, I will remember just who created them.

You are the grand architect behind this world. Why would my faith in your power or abilities waver when you made all this out of nothing? With a whisper, you can do more than the most brilliant person can scheme. With just a glance, you take down nations. With a breath, you bring new life where there was none. Thank you, marvelous Creator, for all that you have done and for all that you will do. I know you're not finished working in creative and miraculous ways.

What promise of God are you waiting for? What helps build
your hope in the waiting?

New Day

*A new song for a new day rises up in me every time I think about
how he breaks through for me! Ecstatic praise pours out of my
mouth until everyone hears how God has set me free. Many will see
his miracles; they'll stand in awe of God and fall in love with him!*

Psalm 40:3

Father, your love is indescribable, yet it is this love that renews
my heart in hope every new day. I'm so thankful that life in
you is not static. It is fluid, constantly changing with each new
morning. I don't have to depend on yesterday's bread to sat-
isfy me. You have new nourishment to feed my soul today. I
will not offer you the same scraps either. For a new day, you
get a new song, a new expression of my love for you.

When I think about how you have brought breakthrough
to my life, I am overcome with joy. You, my God, are the one
who makes a way where there doesn't seem to be one. You
can make a path in the sea and a way in the wilderness. That is
why I trust you. Receive the adoration I offer you and pour out
your fresh word over me today. I wait for you.

What honest words can you offer God today?

Plans

His destiny-plan for the earth stands sure.
His forever-plan remains in place and will never fail.

Psalm 33:11

Father, my plans often don't go the way I think they will. I prepare as best I can and follow through, but I cannot see the knots that will form as I continue. I'm so glad that your destiny-plan is trustworthy. No matter what happens, you will fulfill your promises. Help me to let go of my expectations and trust you with the reality. Nothing surprises you, including the things that completely turn my world upside down.

Lord, your unchanging nature is the foundation I build my life upon. You are the bedrock of my faith, God. What you do is a reflection of who you are, and I know that you are good. When I cannot see what you are doing, help me to remember what your nature is like. Then I will see the glimpses of your mercy as it works in the details of this world, in my life, and unto the very end. Thank you.

When your plans are upset, does it change your view of God?
Or does it cause you to lean into him and trust him more?

Fleeting Shadow

What a brief time you've given me to live!
Compared to you my lifetime is nothing at all!
Nothing more than a puff of air—I'm gone so swiftly.

Psalm 39:5

The shortness of this life does not limit the amount of hope I have. It gives me a greater fervor to follow you, God. I don't want to be so focused on tomorrow that I forget to enjoy the life that is mine in the present. The friendships and relationships you have given me are worth my investment. There is reason to slow down and relish the beauty of the natural world, for it is a reflection of your creativity and goodness.

Help me to simplify my life in this season and focus on what truly matters. I don't want to play games with my life or continually grasp for something that is out of reach. I want to delight in the life that is mine to live, to enjoy, and to grow in as long as it is called "today." This life is but a fleeting shadow, but one filled with gifts from you. May I walk in your ways until I enter your forever-kingdom and dwell with you in the fullness of your glory.

What can you do today to appreciate the life you have?

Bodily Rest

My heart and soul explode with joy—full of glory!
Even my body will rest confident and secure.

Psalm 16:9

Holy Spirit, your wraparound presence brings joy to my heart and soul. I could burst when your love floods my being. You do not just reach the inner parts of my soul with your peace, but you also give rest to my body. I know that you have created us as whole beings, not just bodies with souls. Everything is connected. When my heart is full of joy, my body also relaxes. When my mind is at peace, my nervous system calms down too.

I don't want to neglect any part of the person you have created me to be, God. You say that I am loved. That means— body, soul, and spirit—I am wholly loved by you. As you move in me today, affect everything about me with the power of your presence. Bring calm to my nerves and to my body. Strengthen my soul and my muscles. You are the God of my peace, and I can rest confidently and securely in you.

What restful things can you do for your body today? Perhaps it's a bath, a massage, or a walk in nature. Whatever you choose, do it with intention and gratitude.

Songs to Sing

I will sing my song to the Lord as long as I live!
Every day I will sing my praises to God.
Psalm 104:33

Creator, I am so grateful for the gift of music. I don't want to neglect the power of it in my personal devotion to you. Whether it's a song I've sung a thousand times or a new melody of praise that I offer you today, may it honor the truth of who you are.

I recognize how personal song choices are. You don't need a popular song to bless your heart. You don't expect me to offer you praise that everyone else has already given. I get to sing to you from my own heart and place in time. Lean down and listen, Lord, and open my ears to hear heaven's melody, as well. I don't have to come up with something brand new either. What is new under heaven, anyway? But this expression from my heart in this moment is one that has never happened before, and it won't be repeated. You get my love and attention, the true state of my heart and my need, and all that I have in this moment. Meet me in it.

Do you take time to sing to the Lord in your day-to-day life?

Blessings of Trust

Blessing after blessing comes to those who love and trust the Lord. They will not fall away, for they refuse to listen to the lies of the proud.

Psalm 40:4

YAHWEH, my hope is set firmly in your love. It is rooted in your unfailing character. You are better than anyone this world has ever seen. Your intentions are good, and your heart is kind. I'm so grateful for the power of your nature that is stronger than the cruel intentions of this world and its leaders. May I not compromise my faith by listening to the lies of proud people. May I remain rooted and grounded in the law of your love, just as Jesus taught us to do.

I know that living for you, Lord, is not always easy. It requires sacrificing my need to get even. It means that I don't get to harbor hatred or rush to judge others quickly. But your ways are so very worth following. They are life-giving and have nothing to hide. I choose to trust you and to live with your love as my covering and my guide. You are worth it.

What do your interactions with others show about your trust in God?

Surrounded by Grace

Those who trust in the Lord are as unshakable, as unmovable as mighty Mount Zion! Just as the mountains surround Jerusalem, so the Lord's wraparound presence surrounds his people, protecting them now and forever.

Psalm 125:1–2

Lord Almighty, "the revelation of your Word makes my pathway clear" (Psalm 119:105). Your truth shines a light onto the path I am walking. When the way gets narrow, your presence hovers around me. You are my wraparound shield and my place of protection. Just as the mountains surround Jerusalem, so your presence surrounds me.

God, you know exactly what I need today. Your grace is always more than enough for me. I wait for the strengthening power of your presence to move in on me now, Lord, for I am weak. Oh, you see me in my weakness. I throw my anchor of trust into the sea of your loving-kindness and wait for you to settle the raging waves. Even if the waves do not settle, though, I am safe in your presence. I am safe in your care. Thank you.

What gift of grace do you need from the Lord today?

His Wisdom Carries Through

He is the Lord our God,
and his wise authority can be seen in all he does.
Psalm 105:7

Lord my God, everything you do is a reflection of your high wisdom. I know that not all that happens in this world is your doing. I won't oversimplify you that way. There are forces at work that I cannot see, but this one thing I know: you reveal your character in the things you put your hand to. Where there is mercy and redemption, there you are. Where there is justice and righteousness, you are there working.

Teach me your higher ways, Lord, so that I can walk in your truth. I don't want to leave room for compromise in my life. May I walk in the light of integrity with nothing to hide and remain humble in your love. Jesus, you are the one I follow. It is your example, your teaching, your love that transforms my mindset, my habits, and my heart. Thank you.

Do you see God's wisdom at work in your life? How about in your community? How do you recognize his wisdom?

It Keeps Going

Hallelujah! Praise the Lord!
Everyone thank God, for he is good and easy to please.
Your tender love for us, Lord, continues on forever.

Psalm 106:1

Lord, your tender love never stops. It continues forever. I cannot comprehend the depths, the lengths, or the heights of this love. Your Word says that "there is nothing in our present or future circumstances that can weaken" your love (Romans 8:38). Nothing. When the tides of my circumstances change and I feel overwhelmed, your love is as strong as it has ever been. When I mess up in big or small ways, your tender love is constant. It is no less powerful or persistent than it will ever be.

Thank you for this lavish love. It overwhelms my troubles with the power of your presence. Psalm 34:19 encourages my heart in hope, for it reminds me that "even when bad things happen to the good and godly ones, the Lord will save them and not let them be defeated by what they face." Let your love wash over me and fill me with the courage to continue to trust you, for your love is near, and it will not let up.

Have you ever felt like you lost God's love? How does the power and persistence of his love empower you today?

Gently

Come to your beloved ones and gently draw us out.
Answer our prayer for your saving help.
Come with your might and strength, for we need you, Lord!
Psalm 108:6

Savior, you are so powerful in love and so gentle in your approach to your people. You are the kindest Father, drawing your children out with thoughtful leadership. You don't overlook us in our pain, and you never refuse our cries for help. You are the reliable one, our holy help, oh Lord. Come with your might and strength to transform my life and lead me out of cycles of shame, fear, and compromise.

I need you more than I can say. My deep need cries out to the deep wells of your faithful love. Rise up, God, and meet me right in the middle of my messes. I am not afraid of you seeing me as I am, in weakness and chaos. You are the God who comes to your beloved ones and gently draws us out. Come and draw me with gentleness today, my faithful Father.

Have you ever been astounded by the gentleness of God?
How about his kindness? How does that inform the way you
approach him today?

True Hero

Trust in the Lord, all his people. For he is the only true hero,
the wraparound God who is our shield!

Psalm 115:9

In a world that is constantly pinning its hopes on people, I know that only you are a true hero. You are pure in motive and overwhelmingly kind and fair in power. You don't pit people against each other. You don't use fear as a tactic. You don't intimidate us into trusting you. You draw us in with loving-kindness and keep us there with peace, wisdom, and joy. Why would I put my ultimate trust in those who are bound to disappoint?

I trust in you, my God and my salvation. You are a shield in the tumult of this world. You give peace when others shout for war. You offer kindness and consideration when others turn cold shoulders and bitterness. Lord, there truly is no one else like you. You are my hope, my shield, and my strength. May I be found in you, my hopes all pinned on your unfailing nature, for all my days.

What about God's nature do you trust the most?

Fuel for Worship

*I bow down before your divine presence and bring you my deepest
worship as I experience your tender love and your living truth.*

Psalm 138:2

Great God, as I humble myself before you, wrap around me
with the power of your divine presence. Love me to life in your
peace, calm my thoughts in your grace, and strengthen me in
your mercy. As I experience the very real tender love of your
heart toward me, I offer you the deep gratitude and awe of my
worship. You are wonderful, Lord. Your living truth lights up
my mind with inspiration and clarity.

Open my eyes to see where you meet me in practical ways
today, my God. Every time I see the fingerprints of your mercy
in my life, I will praise you. I worship you for the small suc-
cesses, the little breakthroughs, and the glimpses of grace that
you bring with your presence. I am astounded by your good-
ness and humbled by your attentive love. You remember what
everyone else forgets, including me sometimes. Thank you for
your persistent presence that brings transformation and hope
to my life. I love you.

*As you go about your day, where do you feel or see the fruit of
God's Spirit around you? Let every moment be fuel for worship.*

He Really Is That Good

Let everyone give all their praise and thanks to the Lord!
Here's why—he's better than anyone could ever imagine.
Yes, he's always loving and kind, and his faithful love never ends.

Psalm 107:1

Just when I think I understand you, you go and break the mold I had put you in. You are good, so good that it is astounding. You are better than anyone could ever imagine. Oh, how I want to stretch my imagination to know your goodness more. I won't be afraid of dreaming too big. My thoughts about you don't contain you, and you do not disappoint. As I dare to dream bigger about how kind, how loving, and how faithful you are, expand my understanding of you.

I do believe that you are good, my God. I have tasted and seen your kindness at work in my life. But it's only been just that—a taste. I long for more of you. I want to wade in the waters of your goodness, to be submerged in the seas of your unfailing love. Thank you for new mercies every moment, for fresh opportunities to experience your incomparable kindness, your pervasive peace, and your complete compassion every single day.

How has God been better than you could have imagined?

October

This Is What I Ask

You keep every promise you've ever made to me!
Since your love for me is constant and endless, I ask you, Lord,
to finish every good thing that you've begun in me!

Psalm 138:8

Faithful Father, you have never gone back on a promise, and I trust that you won't start now. You are a good Father who cares attentively and tenderly for his children. As your daughter, I know that you won't micromanage me, but you also have my back when I need you. Oh Father, please continue to work out your kindness in my life. Finish every good thing that you've begun in me.

I have started projects that I've never completed. But you never start something that you don't see through to completion. You are faithful, you are wise, and you never give up. Help me to keep seeing you for who you are—wonderfully good and loyal to your word. I know that the better I know you, the more confidence I have in your unfailing nature. Draw me close to your heart and encourage my hope in the loyal love that you always show.

What do you want God to continue to work on and through in your life?

Spill Your Heart Out

God, I'm crying out to you!
I lift up my voice boldly to beg for your mercy.
I spill out my heart to you and tell you all my troubles.

Psalm 142:1–2

God, I come boldly before your throne of grace today. I know you hear me when I cry out to you. Why would I hold back my earnest prayers when you are ready to receive me as I am? I won't hold them back. I spill my heart out to you and tell you all the joys and troubles that I carry. You are such a good listener, and you are the best problem-solver. I love that you take the time to hear my heart. You never turn me away, and you let me say it all.

As I pour out everything, come sweeping in with the relief of your presence. Counsel me in wisdom and comfort me in love. I trust you to hold my heart with a tender touch. You are my God, my friend, and my healer. I don't hold back anything from you today, for you are the most trustworthy friend I have.

Do you share your heart openly with God? Do you tell him your fears, your hopes, your disappointments? He listens to all that you want to share with him.

On the Verge

When I was desperate, overwhelmed, and about to give up,
you were the only one there to help. You gave me a way of
escape from the hidden traps of my enemies.

Psalm 142:3

Gracious One, thank you for always being ready to help me.
I don't want to give up in desperation, stopping before you
intend for me to. I know that you are with me in everything.
Whenever I need to change course, you are there to help guide
me through it. When I am afraid, your peace overwhelms me
with courage. When I am filled with sorrow, your comfort is
near. Give me vision to see when you want me to let go of
something and when I need to push forward for breakthrough.

You are the God of my breakthrough. You are the God of
second chances. You are the God who redeems and restores,
making a way in the wilderness. Lord, you are my greatest
help, so I look to you. I am on the verge here, and I need your
help and your direction. Guide me.

What do you need help with today? Is there an area where you
need breakthrough or clarity? Ask God for his help. He is there.

Intercessions of Peace

*I intercede for the sake of my family and friends who dwell there,
that they may all live in peace.*

Psalm 122:8

Holy One, I have spent so much of my energy praying for my own needs, but I won't neglect praying for those around me. I intercede for my family and friends that you would bring peace to their lives and to the lands where they dwell. For people I know who live in places where violence is unpredictable, I ask for your hand of protection over them. Be near to them, Lord.

I pray for the nations of this world, including the one I dwell in, to know peace and unity. I know that we can find true peace only in you, Christ Jesus. I pray for your love to bring calm and clarity to chaos and for your peace to settle violence. So many nations are at war, and countless innocent victims are in their midst. Lord, bring peace. Bring healing. Bring revival and hope and justice. Lord, for the sake of all your children, I pray for your kingdom to come to earth and establish itself as it is in heaven. Have your way, King Jesus.

Who is on your heart to intercede for today?

Shift Your Perspective

I look up to the mountains and hills, longing for God's help.
But then I realize that our true help and protection is only from
the Lord, our Creator who made the heavens and the earth.

Psalm 121:1–2

Great God, sometimes I look to the predictions of others to see where you are coming, but then I remember that we can find you, our true help and Savior, everywhere. You are already in our midst. My hope is not in the armies of this world or in the governments and their laws. My hope is in you, God. Your Word says that you watch over us "both day and night" (v. 6). You are not far away, and you are not blind to what is going on in this world or in my life.

When I remember that you are my Father, never failing in times of need, I can rest in your provision and your timing. You guard me, keeping me safe when I leave my home and when I return to it. You are the keeper of my soul, and you are my great confidence. I lift my eyes the slightest bit and see that you are already closer than I knew. Thank you.

Are you looking for help beyond yourself when there is already help that is close and ready?

Flawless God

*All God accomplishes is flawless, faithful, and fair, and his every
word proves trustworthy and true. They are steadfast forever
and ever, formed from truth and righteousness.*

Psalm 111:7–8

God, you are not only faithful and flawless, but you are also
fair. You are impartial in every situation. You don't take sides
or push people out because of bias. You alone can judge truly
and fairly. I give up the need to judge others, and instead, I
follow the lead of your love. Help me to clothe myself in your
kindness and redemptive grace every single day.

I trust you to do what is yours to do. I don't have to control
or keep others in line. I don't have to save anyone. I get to
walk in your ways, partnering with your heart and purposes
and clothing myself in compassion. I get to remain humble
before you and the people in my life. I get to walk in wisdom
and never shy away from the truth of your love. Thank you for
all you do and all that I can let go of and trust you with today.

*Is there something that only God can do that you've been
trying to control?*

Burgeoning Dawn

Let the sunrise of your love end our dark night.
Break through our clouded dawn again!
Only you can satisfy our hearts,
filling us with songs of joy to the end of our days.

Psalm 90:14

Lord, let the sunrise of your love end our dark night. There is no darkness to you, and you have guided me through this dark night of the soul. But how I long for the breakthrough of morning to come! Shine the light of your love on my heart and push back the shadows of fear with your glorious presence. You are the one I need. You are the one I've been waiting for.

Only you can satisfy our hearts, my God. Only you. You fill me with songs of joy until the end of my days on this earth. Meet me with a fresh portion of your love to strengthen my soul so I can face this day. Give me perspective in your wisdom. Give me guidance in your grace. My soul longs for the fog to lift, for the darkness to disperse, and for your light to shine brightly on my mind, my heart, and my body. Shine on my life once again.

What do you need God's love to light up in your heart?

Overwhelmed

*We've been overwhelmed with grief;
come now and overwhelm us with gladness.
Replace our years of trouble with decades of delight.*

Psalm 90:15

God, you are the one who brings revival to even the most devastated places. You give beauty for ashes, joy for mourning, and garments of praise for despair (Isaiah 61:3). You are so much better than I expect at every turn. Where I have been overwhelmed with grief, oh God, come and overwhelm me with gladness. Replace the years of trouble, of suffering, and of pain with decades of delight. Redeemer, restore what everyone else sees as a wasteland.

You really are that good, and I trust you. You have revived my heart in hope more times than I can count. I need that again, and not just hope, but also the lived reality of your goodness. Lighten my load with your love and bring relief by the glory of your presence. Thank you.

Have you ever looked at an area of lack or need in your life and felt completely overwhelmed? Invite God to overwhelm that area with his grace, his peace, and his joy. Watch what he does for you.

No One Compares

O Lord, our God, no one can compare with you.
Such wonderful works and miracles are all found with you!
And you think of us all the time with your countless expressions
of love—far exceeding our expectations!
Psalm 40:5

Lord God, your thoughts toward me are countless, and your love is always reaching toward me. How can I begin to grasp the magnitude of your powerful kindness? I want to know this love that stretches further than anything I've known. You exceed the expectations of your goodness far and wide, over and over again. Do it in my mind, my heart, and my life today.

No one compares with you, God. You are more generous than the most benevolent among us. You have more resources than the storehouses of the wealthy. You are more creative than the most ingenious minds at work in the world. You are innovative, trustworthy, and wise. You are more than enough for every need, for every heart, and for every hope. You are more than enough for me.

What miracles and wonders have you experienced in God?
What has left you wanting to know him even more?

Meditations of Goodness

May the words of my mouth, my meditation-thoughts, and every movement of my heart be always pure and pleasing, acceptable before your eyes, YAHWEH, my only Redeemer, my Protector.

Psalm 19:14

Father, I truly want my life to be a reflection of your mercy-kindness. I know that won't happen by accident. It takes intention, thoughtfulness, and follow-through. It takes reliance upon your love and humility to continue to learn and do better when I fall short. Thank you for your grace that empowers me to live for you.

May the words of my mouth, my meditation-thoughts, and every movement of my heart be always pure and pleasing to you, my God. Jesus, you said, "What has been stored up in your hearts will be heard in the overflow of your words" (Matthew 12:34). Start, then, in the place of my heart by transforming my thoughts in your faithful and forgiving love. May grace reign over judgment and mercy over fear. I set my mind on you, my wonderful God, and meditate on your goodness. As I do, may the movements of my heart more readily be rooted in your love.

Look at the fruit of your thoughts today. Are they pure and pleasing? Do they look like the fruit of the Spirit?

Always There

I've poured out my life before you,
and you've always been there for me.
So now I ask: teach me more of your holy decrees.

Psalm 119:26

Lord, I keep coming back to you. I can't help myself, for you are my Savior and my God. You have been my help, my comforter, and my closest friend. You have been my confidant and my wise guide. You have never let me down, even when I've wandered from your ways. You've always been there.

I want to walk in your truth, God. I am not afraid of what you say, for I know what you are like. Your nature is faithful, you are relentless in kindness, and you cannot be surprised by what you already see so clearly. Thank you for loving me the way that you do. Thank you for your grace that meets me in the middle of my mess and gives me room to grow, wisdom to pick up the pieces, and courage to restore what has been broken. You are wonderful, and I long to know you more today.

How has God always been there for you?

Faithful and True

*God, glorify your name! Yes, your name alone be glorified,
not ours. For you are the one who loves us passionately,
and you are faithful and true.*

Psalm 115:1

Faithful One, may the fame of your name spread far and wide. May the truth of your loyal love extend to the ends of the earth. May all people know you as the good Father that you are, famous for your justice, peace, and mercy. May your grace be renowned. You are the one who is faithful and true, and you will never change.

Lord, your people rely on you. I rely on you. I don't need anyone to know who I am. I don't want fame or recognition. I want to be found in you. May I never resist the leading of your love that keeps me on the path of open-heartedness. May I choose your love far more than I choose my own comfort. You are worthy of my life and my surrender. Be glorified in me, Lord.

If someone were to look at your life from the outside, would they be able to see what God is like?

God's Dwelling

God is in the midst of his city, secure and never shaken.
At daybreak his help will be seen with the appearing of the dawn.

Psalm 46:5

God, your Word says that you make your home in the midst of your people. When you dwelt in the tabernacle, you were there among your people. When Jesus tore the veil in the Holy of Holies after defeating death and rising back to life, you sent your Spirit to dwell in your people. First Corinthians 3:16 says, "Together you have become God's inner sanctuary and…the Spirit of God makes his permanent home in you." What a wonderful truth!

God, I am yours. I belong to you. Your Spirit has made its home in me. Thank you for the reality of your very near and very real presence. With you reigning on the throne of my heart, I will never be shaken, for I am secure in your presence. You will not forsake me no matter what comes. May I never forget that.

Is the Lord your confidence? Do you know the peace of his presence in your innermost being?

Connections for the Lonely

To the fatherless he is a father.
To the widow he is a champion friend.
The lonely he makes part of a family.
The prisoners he leads into prosperity until they sing for joy.
This is our Holy God in his Holy Place!

Psalm 68:5–6

Holy God, not only are you perfect in all your ways, but you also perfectly fill every need we have. You are Father to the fatherless, tenderly caring and providing for them. You are a champion friend to the widow, providing for her needs. You are the liberator of the captive, leading them into their freedom and into their joy. You are all that we look for and so much more than we expect.

Thank you for the ways that you overwhelm me with the perfection of your nature. You see my very real lack, and you are the one who fills that need. Your Word says you set the lonely in families. You see where I need connection, my good Father. Please provide quality community. I trust you, and I depend on you. You always come through, and I know that this will be another testimony of your goodness in my life.

Is there an area where you feel alone and in need? Do you trust your good Father to provide for you?

Light Up My Path

Let the dawning day bring me revelation of your tender, unfailing love. Give me light for my path and teach me, for I trust in you.

Psalm 143:8

Lord, when the night is dark, I don't need more than a little bit of light to see where I can take my next step. I know that you see everything clearly. I don't have to. I trust you to guide me in goodness all the days of my life. I lean on your leadership today and every day. I know there will be days when I can see miles ahead, and there will be days when I can see only a few inches in front of me. In either case, you are confident in the way you are leading me, so I will be confident in you.

I do ask for greater revelation of your unfailing love. Reveal how very present, how very powerful your love is. Give me wisdom to know when to wait and when to walk. I will not stop pressing in to know you more, for your friendship is like a fresh burst of hope, joy, and peace in my soul.

What has the Lord recently been teaching you? Do you trust him to continue to guide you in love?

Heart Healer

He heals the wounds of every shattered heart.
Psalm 147:3

Faithful One, I'm so grateful you don't leave us to waste away in our pain. Though suffering may last for a night season, your love is faithful, and it will not let me go. You know the heartbreak I have gone through, and you are the only one who can heal my wounds. Don't just patch me up, Lord, but make me whole again.

When trauma creates a gaping hole within me, you rush into that space with your lavish love. There isn't a crack you can't fill. Pain may have broken open a crevice within me, but your love expands to completely cover it. I can't go back to the way things used to be, but that's not the point of your love. Your love redeems and restores, but it doesn't gloss over the pain. It heals it and creates new pathways of peace, of understanding, and of compassion. Thank you for healing my heart and for doing so much through the beautiful process.

How has God healed the wounds of your heart? How has it helped you relate to others in different ways?

Restorer

*When they are sick, lying upon their bed of suffering,
God will restore them. He will raise them up again
and restore them back to health.*

Psalm 41:3

My God, you do what no one else can do. You take the shattered pieces of our lives and weave them together with the thread of your miraculous mercy. You sow restoration into lands that have been broken at the seams. You are the Redeemer of the broken, healer of the sick, and the hope of every suffering soul. You are more than we can describe, always overflowing in love to all that you have made.

I can't help but think of those suffering with sickness in my life. Lord, meet them in their need. Touch their bodies with the healing power of your hand. Bring restoration to their bodies and to their hope. Raise them up again and restore them back to health so that they may live and praise you for it. You are so good, God. Do what you do best and breathe new life into the desolate places. You are my God, and I worship you.

Have you ever witnessed a miracle of healing? If not, do you believe that God loves his children enough to meet them in this way?

Praise Is My Purpose

Everything you have made will praise you, fulfilling its purpose.
And all your godly ones will be found bowing before you.
Psalm 145:10

God, you display your love in this world in everything you have made. What you do, you do well. You knit everything together in marvelous mercy. My greatest purpose is to recognize you and praise you. It is my highest honor to know you. Your mercies never come to an end. No, they are new every single morning. Every time I catch a glimpse of your love in a new way, I am filled with awe and overcome with gratitude. How can I not praise you?

When I lose sight of who you are, reveal your goodness to me, Father. May I see even a glimmer of your grace, for just a small bit is enough to remind me of your greatness. You are lavish in love and powerful in peace. You are worthy of all the praise I could ever give you. You are worthy of the praise of all your creation. I join with creation and offer you the response of awe, of adoration, and of grateful worship for the beauty of who you are and the glorious nature of all you do.

What do you have to praise God for today?

A Fresh Chance

*Lord, so many times I fail; I fall into disgrace. But when I trust
in you, I have a strong and glorious presence protecting and
anointing me. Forever you're all I need!*

Psalm 73:26

Father, I know you are not surprised when I fail. Perfection
isn't what you expect from me. You applaud my efforts every
time I try, and when I mess up, you encourage me that there
is a new chance to do better. I want to have the attitude of a
learner for my whole life, Lord, so I don't come under the illu-
sion that I will one day "make it." No one is perfect, and that is
not the point of following you.

Your love lights up and transforms my inner world. You
make me better, and that's what I hope to be as I follow you
through this life: better with every step. More seasoned after
every mistake. Humble in my approach and willing to grow
from each failure. You are so gracious to me, and I want to be
as compassionate with others as you are with me.

*When you fail, what is your response? How does God's view
of you help you move ahead without shame?*

A Safe Shadow

*When we live our lives within the shadow of God Most High,
our secret hiding place, we will always be shielded from harm.*
Psalm 91:9–10

God, you are my hiding place. You are the one I run to in times of trouble and when I just need a break from the pressures of this world. Your presence is my shield, and your nearness is always available to bring relief. I can never thank you enough for your powerful protection. King of Glory, be honored and lifted high in my life as I make room for you.

Some things about this life feel incredibly overwhelming. There is pain and loss, suffering and death. But you, my God, are near in every part of this life, including the hard pieces. You don't shy away from my pain even if I do. This is why I live in you and for you. You are lavish in love, shielding me from harm and healing me from the wounds I carry. You are so very good to me, and I won't stop relying on you.

What do you want to hide from today? As you go to the Lord, invite him into the vulnerable places of your heart and life.

Prisoner of Love

It's not sacrifices that really move your heart.
Burnt offerings, sin offerings—those aren't what bring you joy.
But when you open my ears and speak to me,
I become your willing servant, your prisoner of love for life.

Psalm 40:6

God, you don't need me as your servant, but you delight in my offering all the same. Thank you for the power of your love. You don't need a token of guilt from me. No, you open my ears and I hear your voice speak in kindness and truth. It is my response to pour that love back on you. I am your willing servant, God. I am your daughter, and I long to reflect your heart to all who don't know you.

I'm so grateful I don't have to prove myself to you. And still, I want to please you. I want you to be honored for all the ways you overwhelm me with goodness. I won't sit still and stay comfortable. I move my heart and my hands to show you just how grateful I am to you today. I am your prisoner of love, for your love has captivated me in a way I never knew I could be. You have liberated me in the power of your care for me. Why would I keep that to myself?

Are you motivated by obligation or by love?

Canopy of Kindness

Lord, how wonderfully you bless the righteous.
Your favor wraps around each one and covers them
under your canopy of kindness and joy.

Psalm 5:12

Joyful Father, I live under the canopy of your kindness. It is where I am refreshed, rejuvenated, and restored. It is where I find my strength to live out your love in my family and in my community. I don't want to take your compassion for granted or let compromise sow bitterness in my heart. I want to walk in the light of integrity and reflect your grace and mercy in all I do.

Be glorified, my God, in this little life of mine. You have blessed me in wonderful ways, and I thank you for each of those blessings today. No blessing is insignificant to me. I thank you for the peace I know in my home, for the acceptance I experience in friendship, and for the creativity I gain from your creation. There is so much beauty around me, and I won't pass by even a morsel of it without paying attention and thanking you for it.

How has God's kindness transformed the way you look at the world or, at the very least, at your life?

Saturated in Meaning

Depths of purpose and layers of meaning
saturate everything you do.
Psalm 92:5

Wonderful One, you move with masterful clarity and wisdom. You don't miss a detail or leave out a necessary element. All that you do, dear Father, you do well. There is so much purpose and meaning saturated in everything you do. I may have a shallow understanding of what you have done, but I want to go deeper today. Show me an element of purpose that I have not yet known. Reveal the depths of your meaning that run beneath the surface.

As you reveal deeper understanding, I will take it to heart, my God. If the angels and creatures in your presence are blown away by new revelations of your glory every time they look at you, how much more will I be? Open my eyes and show me what I have missed until now. I long to know you more as you peel back the layers.

Is there something you thought you knew but then found greater meaning through learning more about it? Pick a specific area and ask God to peel back the layers in his wisdom today.

Ponder It

*I ponder all you've done, Lord,
musing on all your miracles.*
Psalm 77:12

Holy Spirit, you bring peace to my chaotic thoughts and clarity to my confusion. You have done it before, and I'm asking you to do it again. Breathe your breath of life into my mind. Wrap around my heart with the purity of your presence. Revive me all over again today.

I ponder all you've done, Lord. I remember the miracles that astonished me. You moved in mighty ways and blew all my expectations out of the water. You are powerful and gracious, and you are so patient with me. I won't overlook the relief I felt when you moved, God. You know how I long to experience the goodness of your love again. I'm so grateful that you move in new ways. I don't want to put you in a box where you are limited to moving in ways I have already experienced. Come, do something new, even as I remember what you have done before, my Lord.

Think about the miracles God has done. Do you have faith for him to move in a new way?

Fountain of Grace

*Please, God, show me mercy! Open your grace-fountain for me,
for you are my soul's true shelter. I will hide beneath the shadow
of your embrace, under the wings of your cherubim, until this
terrible trouble is past.*

Psalm 57:1

Gracious God, I come to you just as I am. Whether I am desperate or satisfied, you meet me with the same abundance of love, the same generous grace, the miraculous mercy of your heart, and your pervasive peace. There isn't anything I need that I cannot find in you. You are my source, my shelter, and my supply. I can't stay away from you.

Father, open your grace-fountain and pour it over me. I step into the waters of your life-giving love, and you cover me in the palpable peace of your very being. You strengthen me from the inside out, and I come alive. Your arms support me when I stumble. You keep me from falling, and you hold me close to you when trouble is at my door. I trust you.

What will a fresh dose of grace help you face today?

Kindness Shown

Lord, show me your kindness and mercy,
for these men oppose and oppress me all day long.

Psalm 56:1

Lord, when others oppose me, you show me kindness. When people argue and misunderstand me, you show me mercy. When others oppress me because they love their power more than they love the person standing in front of them, you show me favor. No matter what anyone does against me, you are for me. You offer love. Your reception is one of grace and compassion.

Lord, I want to be just like you. I don't want to oppose others for no reason. Justice is worth fighting for, but my vanity is not. When some jump in to silence others, may I be quick to listen and slow to accuse. I want to be like you in love, offering kindness and mercy to all, especially to those whom others overlook. What kindness I have found in you; what kindness I have to share with others! I choose to follow your lead, Lord, for your love is always the right path.

How do you respond to kindness? How can you show
kindness to others today?

Confident Steps

Following your word has kept me from wrong.
Your ways have molded my footsteps,
keeping me from going down the paths of the violent.
Psalm 17:4

Faithful God, I follow your Word, for you do not lead me astray. Though I may wander from your ways from time to time, you remain faithful and true. I know that your way is the way of peace. This isn't to say that yours is the easy path or that I won't be uncomfortable. Peace comes at a price, but it is better than walking in the way of the violent. Some people want to fight no matter what. I want to fight for peace.

Teach me to walk in your ways, God, and to stay true to your nature. I am learning, and I know that means I won't always get it right. But you do, Lord, and I trust you to guide and teach me. I remain humble before you and before others, knowing that it is your love that keeps me close to you. Make my steps firm, molding them and setting me on the paths of your peace.

What kind of paths are you walking by the company you keep and the motivations of your heart?

Heart-Knowing

In the depths of my heart I truly know that you, YAHWEH, have become my Shield; You take me and surround me with yourself. Your glory covers me continually. You lift high my head.

Psalm 3:3

YAHWEH, in the depths of my heart, you are the one I depend on. From deep within my soul, I reach out to you. You take me and surround me with yourself. What could be better than that? I am undone in the love you pour over me every time I turn to you. You surround me with the power of your presence. You are my shield, my covering, and my protector.

God, you see everything I am dealing with, and none of it overwhelms you. You know exactly what to do in every challenge. You are my shield, so surround me with your presence that I may rest in the confidence of your faithfulness. Watch over me and show me what I need to do. You are the glory that covers me continually, and I am safe and sound under your thoughtful care. My heart is yours.

What do you know in the depths of your heart to be true about God?

Inner Strength

You will be the inner strength of all your people, YAHWEH,
the mighty protector of all, and the saving strength
for all your anointed ones.

Psalm 28:8

Mighty Protector, you are my saving strength. I need you. Empower me from the inside out and give me courage. I know that courage doesn't require an absence of fear. In the face of fear, courage rises. I trust you to give me the inner confidence and strength I need to follow you today. Your ways are always best, so I won't abandon your wisdom.

Father, you are the one who leads your people with cords of kindness and with ties of love (Hosea 11:4). Lead me today. You are the God who restores, redeems, and brings new life out of nothing. I trust you to lead me in your goodness and to give me everything I need along the way as I follow you. You are my source, my strength, and my provider. I rely on you.

What do you feel an inner resolve to believe and act on today? If you don't have one, ask God to bolster your heart in courage and strength and show you the way to walk.

Prayers for Right Now

God, you have to do something!
Don't be silent and just sit idly by.
Psalm 83:1

Father, today is a new day, and I know you are with me in each and every one of the fresh needs and challenges the day will bring. I won't hold back my prayers for help today, and I won't overlook the urgent needs of others. I take them all before you, even if it means I spend my whole day offering prayers to you. Open my ears and my eyes to hear your voice and see your mercy at work. I know that you care, and you won't sit idly by.

Settle my heart in your presence as I turn my attention to you. You are the God of my peace and the God of my provision. When I have no answers, you are the one who holds them. When I don't know where to turn, you guide me with your steady right hand. You are always faithful, and you are full of all the wisdom I need. I trust you.

How often do you keep an open line of prayer going throughout your day? Try it today, and don't be ashamed to repeat your prayers if you need God's help. He hears, he answers, and he will come through.

The Better Way

*Yes, it is so much better to trust in the Lord to save me
than to put my confidence in celebrities.*

Psalm 118:9

God, you know the way this world works. Through power and wealth, people have great influence. Yet this is not how you work. You help the poor as readily as you do anyone else. You flood all your people with love. You are close to the broken-hearted. You are attentive to those who are lonely. You are the God who loves his children thoroughly, and you do not favor those who seem to have it all together.

Keep me from putting my confidence in impressive people, Father. They are just people, and I know they have their faults, just as any of us do. It is so much better to trust in you. You are near in my times of trouble when many others are absent. You never leave me, and you don't have limits to your love. You are the God who saves me over and over again, so why would I put that confidence in anyone else?

Is your confidence rooted in the reality of who God is? How has God helped you when others fell through?

He Listens

I am passionately in love with God because he listens to me.
He hears my prayers and answers them.

Psalm 116:1

Near One, you are the God who leans down in love and listens to me. I don't ever have to question whether you hear my prayers, for you are my faithful friend and a ready help in times of trouble. You are the one who answers my prayers. I know you haven't stopped listening to the cries of my heart, so I take courage and confidence in your loyal love today.

When I feel isolated in my circumstances, will you remind me just how very near you are? Open my eyes to see the power of your presence at work in my life. You provide both big and little things to assure me of your tender care. God, show me today that you listen. Remind me of your goodness and astound me with your gracious heart. You are wonderfully attentive, and I don't want to miss a thing. I am yours, and I depend on you.

How has God shown you that he listens to your prayers? What answers has he provided?

Glorious in Power

For he's the awe-inspiring God, great and glorious in power!
We've never seen anything like him! Mighty in miracles, you cause
your enemies to tremble. No wonder they all surrender
and bow before you!

Psalm 66:3

Wonderful One, you inspire awe through all you do. You are glorious in power and great in glory. Your mighty miracles cause the nations to tremble. Every knee will bow before you in surrender. Lord, until that day comes, continue to move in mercy and awe-inspiring miracles. There is no one else like you on all the earth.

Unveil your glory in new ways to me today. Open my eyes to see where you are already at work. Open my ears to hear what you are saying. You are my God, and I worship you. I bow before you with a humble and expectant heart. Move, Lord, and do what only you can do. Bring beauty from ashes and joy from the paths of sorrow I have walked. I love you more than I can say, and I know that I have only tasted a sampling of your goodness. There is still so much more to come.

How has knowing God inspired you or left you in awe?

My Only Hope

I cried out to you, Lord, my only hiding place.
You're all I have, my only hope in this life, my last chance for help.
Please listen to my heart's cry.

Psalm 142:5–6

Lord, when my back is against a wall and I cannot see a way out, you are still my hope. You are the God of my strength, and even when all other options evaporate, you are faithful. You are the God of my last chance. You are my help, and I won't stop crying out to you.

Hide me in your heart today, Father. Wrap around me with the peace of your presence. Empower my heart in courage to trust you still. You have never failed, and you won't now. You have never left me to fight my battles alone, and I trust that you are with me now. God, listen to my heart's cry and lean close to answer me. I need you. Wash over me with your grace and renew me in your restorative love. No matter the outcome of the challenges I face, I know that you will never let me go.

Has God ever stepped in as your last chance and helped you out of an impossible situation?

Still Yours

In spite of all this, I still belong to you; you hold me by my right hand. You lead me with your secret wisdom. And following you brings me into your brightness and glory!

Psalm 73:23–24

God, even when I have made senseless choices, I remain yours. You still guide me along the pathways of your life-giving mercy. Thank you for your redemption and your renewal. Lord, forgive me for the times when I have made ignorant and foolish decisions. I am not too proud to admit when I've been wrong. Help me to restore relationships that have been hurt by these choices. Help me to walk in the light of your integrity. Restore me and lead me with your wonderful wisdom. You always know just what to do.

I take responsibility for my actions, Lord, and I also hold tightly to your love that sets me free from guilt and shame. You lead me along the liberating path of your truth. I am not perfect, and I stumble, but I thank you for loving me through it. I still belong to you.

Are you holding on to guilt? Give it to God and let his love lead you in restoration.

Expansive Mercy

Here's my chorus: "Your mercy grows through the ages.
Your faithfulness is firm, rising up to the skies."

Psalm 89:2

Father, your faithfulness is like a mighty mountain, like the tallest peak reaching into the atmosphere. It cannot be moved. Yet even when the mountains quake and fall, your faithfulness remains. Jesus, your mercy is ever-expanding through the generations. It is not used up or stale. It is always increasing, offering new strength to every person who partakes of it. Thank you.

I want to experience the power of this growing mercy and this firm faithfulness. It is greater than I have known, and it will continue to be greater still when I return to dust. In the meantime, reveal the lavish lengths of your love to me in fresh ways each new day. Renew my heart in hope as I witness your faithfulness in every step of this journey that is my life. You are great and greatly to be praised.

What are your expectations of God's mercy as it meets you?
How about God's faithfulness?

Satisfied

You satisfy my every desire with good things. You've supercharged
my life so that I soar again like a flying eagle in the sky!

Psalm 103:5

Oh God, you are a giver of good gifts. James (Jacob) 1:17 says, "Every gift God freely gives us is good and perfect, streaming down from the Father of lights." You truly satisfy my every desire with good things. When I think of how you have provided for me, I can't help but be overcome with awe and filled with gratitude. You are so very good to me, and I know you haven't changed a bit.

When I am weak, you are the one who carries me. When I thought all was lost, you redeemed me and set my feet on the firm foundation of your mercy. You have kept me, and you have revived my soul. You are the one who restored my life, and I know that you will also restore my joy. My life is connected to you, my source and my strength. Supercharge me again so that I fly like an eagle in the sky, soaring over the landscape with the winds of your Spirit.

How has God satisfied your desires with good things? Pour
out your gratitude to him today for all he has done.

Set Free

Lord, because I am your loving servant,
you have broken open my life and freed me from my chains.
Psalm 116:16

Lord, thank you for the ways that you have broken open my life and led me into freedom. Your kindness is astounding. I can't help but be filled with joy when I think of all the snares from which you have freed me. You are the one who brings peace to anxiety, courage to fear, and incredible love even in my worst moments. You are wonderful to me.

Be honored in my life, Lord, for I want others to experience the liberty of your love too. As I share the testimonies of your goodness with the people around me, release miracles of mercy in their own lives. You love to move through your people, and I am your loving servant, my God. I am a prisoner of your love, for you have done more for me than anyone else has or could. I will not stop following you, for you are worth it. I experience only goodness in your leadership, even in correction. I love you, Lord.

How has the Lord set you free and brought breakthrough in your life?

Broad Place

Out of my deep anguish and pain I prayed, and God, you helped me as a father. You came to my rescue and broke open the way into a beautiful and broad place.

Psalm 118:5

Loving Lord, you have overcome my fear with the power of your love. You have met me in my deepest pain with your lavish mercy-kindness. Your presence brings comfort, and your peace settles my raging thoughts and brings clarity. You are a good Father who helps his children when they need it, and I have known this help as your daughter.

Continue to rescue me, Lord, when I need it. I know that I can count on you. You don't just heal my wounds and comfort me in my suffering, but you also lead me out into a beautiful and broad place where I can rest. There is room to jump, to dance, and to explore. You lead me out of the craggy, closed-in places and into a vast meadow of your mercy. Thank you.

Is there a place of pain where you need your heavenly Father to meet you? How have you experienced the expansiveness of his rescuing love before?

Shine On

May the fame of his name spring forth! May it shine on, like the sunshine! In him all will be blessed to bless others, and may all the people bless the One who blessed them.

Psalm 72:17

Famous One, I want all the world to know how wonderful you are and how gracious you have been to me. I will use the blessings you have given me to be a blessing to others. What an honor it is to generously share what you have so graciously offered me. May it all create a beautiful cycle of blessing that goes on and on until we stand before you in your kingdom realm.

I don't want to take your love for granted, Father. I don't want to hoard your mercy for a rainy day. I know that is not how your kingdom works. It is ever-expanding, and so I can join with your generosity and freely bless others out of what you have blessed me with. May I not turn a blind eye to the needy around me. No, I want to be like you in generosity. Give me wisdom to walk in your ways and to be a blessing to those around me.

What can you use to bless others today?

Revitalized in His Presence

*I'm energized every time I enter your heavenly sanctuary to seek
more of your power and drink in more of your glory.*

Psalm 63:2

Heavenly Father, I am invigorated in your presence and
renewed in your lavish love. You flow over me in waves of
grace, and I am ready to face the day. You are my strength,
God. Why would I stay away from you? Like a river that reaches
the lowest place, you meet me in my deepest need. Not only
that, but you also fill it to overflowing. What a wonderful God
you are!

I long for a fresh filling of your grace today. I don't have to
beg you; you are already pouring it out over me. You renew
me like a dry and wilting plant is refreshed by a good drink
of water. I am stronger as you rain down your love. My heart
drinks it in, and I can feel the rest of my body coming back to
life. Thank you for the power of your presence that renews me
each and every time I turn to you.

*Have you spent time being watered in the presence of the
Lord today?*

Streams of Pleasure

I long to drink of you, O God, to drink deeply from the streams of pleasure flowing from your presence. My longings overwhelm me for more of you!

Psalm 42:1

Great God, as I turn to you, you flood my longings with the reality of your love. You are the God who satisfies the thirst of his children. I know that whatever I bring to you, whatever need I have, you offer more than enough to satisfy it, to satisfy me with your generous grace.

Jesus, you said that "every persistent seeker will discover what he longs for" (Matthew 7:8). You went on to ask, "Do you know of any parent who would give his hungry child, who asked for food, a plate of rocks instead?" (v. 9). How much more will you fill the longings of your children! I know that I can come to you earnestly and boldly and expect you to meet me with your goodness. I stand before you with a heart wide open, longing to drink deeply from the streams of your presence. Satisfy my thirst, Spirit of God.

How have you experienced the power of God's delight and lavish love satisfying your soul?

Delightful Wisdom

I know that you delight to set your truth deep in my spirit.
So come into the hidden places of my heart and teach me wisdom.
Psalm 51:6

God, thank you for the power of your wisdom that leads me into your truth. Everything you do displays your love, including the wisdom of your Word. Teach me, Lord, and set your truth deep within my heart. When you reveal the ways of your kingdom within me, I can see more clearly. Thank you for your incredible nature that is the best teacher of all. May I never neglect your character, and may I become more and more like you in all I do.

Come into the hidden places of my heart and reveal the depths of your wisdom. Light up the path of my life with the life-giving power of your ways. You are not like people who make promises and change their minds. You are a promise keeper, a way-maker, and you are loyal in love in all that you do. I delight in knowing you, for you are better to me than anyone has ever been.

How do you actively engage with the wisdom of God? What has it taught you?

Faithful at Any Age

*God, now that I'm old and gray, don't walk away. Give me grace
to demonstrate to the next generation all your mighty miracles
and your excitement, to show them your magnificent power!*

Psalm 71:18

Faithful Father, you are my God, not only in my youth but
also in my aging. You are close to the young and to the old.
I will never age out of receiving your love. I will never be too
old to know your incomparable peace or your overwhelming
delight. I want to know you in even deeper and more mean-
ingful ways as I walk with you. I trust that you are not finished
with me, even if others seem to be.

May your grace empower me to share with others the wis-
dom I have learned in my years with you. Through the power
of my testimony, I want to share the stories of your goodness
and to pass on the miracles I have known. Show me how I
can sow into the younger generations, keep me connected
to those who are even older than I am, and teach me through
them. Thank you, Father, for being faithful through every age
and every season of this life. You are wonderful.

*What testimonies of God's faithfulness can you share with
others?*

Fervent Devotion

With passion I pursue and cling to you.
Because I feel your grip on my life,
I keep my soul close to your heart.

Psalm 63:8

My God, deep within my soul, I am desperate to know you more. I am devoted to your love, for it has done more good in and for me than any other force in this world. You are the God of my salvation, my restoration, and my hope. There is no barrier you cannot break, no distance that you cannot close, and no need that you cannot fill. When I remain close to your heart, I am strengthened in hope. I am bolstered in courage.

Thank you for the power of your presence in my life. I am never without your lavish love, and I cannot begin to thank you. This is why I pursue you with passion, and I cling to your faithfulness. I know that even when my grip loosens, your grace has me firmly in its grip. You seem too good to be true, yet you are full of truth and the power of your living love.

What does devotion to God look like in your life?

In His Hands

My life, my every moment, my destiny—
it's all in your hands. So I know you can deliver me
from those who persecute me relentlessly.

Psalm 31:15

Lord, everything about me is in your hands. I trust you with the details and with the bigger picture of my life, from the smallest second today to the furthest future. You are faithful, and I know you can deliver me out of any trouble. Settle my heart in your peace and overcome my fear with your perfect love. I submit my heart, my mind, my spirit, and my body to you.

I know that you are loyal to your promises, and you always follow through on your word. Encourage my heart in hope as I wait on you today. You are as present with me in this very moment as you have ever been. I remember the days of ease, and I see how your mercy has met me in my grief. You haven't abandoned me yet, and I know you won't do it now. I rest in your hands, Father, for I am yours.

Do you trust that God has got you today? He knows the trajectory of your life, and he will be with you in every moment.

No Need to Run Away

YAHWEH is my revelation-light and the source of my salvation.
I fear no one! I'll never turn back and run,
for you, YAHWEH, surround and protect me.

Psalm 27:1

YAHWEH, light up my heart and mind with the light of your revelation. Remind me of the power of your redemption and salvation. I am not alone, for you are with me. I won't give in to fear today, for you are my present peace. You are my overwhelming confidence. And when I do question which step to take, strengthen my heart in your truth, Father. Show me the way to go and give me the courage to walk in it.

I don't want to run away from what's ahead just because it feels overwhelming. With your steady leadership, help me face whatever comes. Keep your grip of grace firm on my life and empower my heart in your unfailing wisdom. Give me discernment and focus to keep my eyes fixed on you, the originator and perfecter of my faith. I will keep moving where you lead me, God. I have no reason to turn back, for you are my Good Shepherd, and I will stick close to your side.

When you are afraid, what gives you the courage to keep going?

My Deliverer

In my distress I cried out to you, the delivering God,
and from your temple-throne you heard my troubled cry,
and my sobs went right into your heart.

Psalm 18:6

Mighty God, some circumstances are too overwhelming for me to face alone. When the weight of grief feels as if it is closing in on me, crushing my lungs and hampering my ability to breathe, you are the one who creates space where I can breathe deeply and rest. You are my deliverer, and all I can put my hope on is that you will deliver me out of distress.

I cry out to you whenever I need you, Lord, and I'm not ashamed to do it. It doesn't matter how old we grow; we always want the comfort of our nurturing parents. The same is true of my relationship with you. I will never outgrow my deep need for you, Father. Come close and relieve me of my anxieties. Calm my nervous system with the power of your nearness and bring peace to this troubled heart of mine.

How has God delivered you in your distress? Is there an area of anxiety you need his help in today?

Live Unafraid

*Because of you, Lord, I will lie down in peace and sleep comes
at once, for no matter what happens, I will live unafraid!*

Psalm 4:8

Faithful Father, you are my confidence and my peace. When I
lay my head down at night, I also lay all my worries before you.
Not only do I offer them to you, God, but I leave them with
you. I can't do anything about them, but you can. You are more
than capable of handling all my anxieties and of working out
the wrinkles in the unknowns of tomorrow. I trust you to do it.

I will lie down in peace, and I will rest deeply because I
know that you care for me. I will live without fear hamper-
ing my faith because you remain the same faithful God. Why
would I let fear keep me from living in the fullness you have
for me? You are the one who liberated me in love, so I will
live in that freedom, and I will trust you with everything I can't
control.

*Are you able to rest well? What worries keep you up at night?
Each time they come up, practice giving them to God and
leaving them with him. Breathe in his peace and choose trust.*

Miraculous Reminders

God, we've heard about all the glorious miracles you've done
for our ancestors in days gone by.

Psalm 44:1–2

God, you are the miracle maker, and you have not stopped moving in marvelous power through your Spirit in these days. I don't want to forget your goodness, so may your Word act as a timely reminder of the strength of your power. Your heart of kindness still reaches out to your people. You haven't stopped loving us, and you haven't stopped moving on our behalf. May the remembrances of your glorious miracles serve as fuel for my faith today.

As I think about how you have faithfully delivered your people time and again, I can't help but feel my heart awaken with hope for what you have yet to do. Your miracles of mercy rescued your people from their captivity, healed bodies riddled with disease, and brought sight to blind eyes, to name a few. Jesus, I take to heart your words to your disciples before you returned to your Father in heaven: "The person who follows me in faith...will do the same mighty miracles that I do—even greater miracles than these" (John 14:12). I'm asking you to move in mighty ways today, Lord.

Have you ever asked Jesus to do a miracle for or through you?

Power to Persist

By your mighty power I can walk through any devastation,
and you will keep me alive, reviving me.
Your power set me free from the hatred of my enemies.

Psalm 138:7

Mighty God, your Spirit gives me strength to keep going when I'd rather give up. I know that perseverance is a fruit of the Spirit for a reason. "Patient endurance will refine our character, and proven character leads us back to hope" (Romans 5:4). You give me the power to persist even in the hardest times. This does not mean that I have to walk at the same pace, but I am resolved to keep going, even when that looks like pressing into you and waiting for your rescue.

Your power is able to set me free. In your lavish love, I am filled with hope. I realize this doesn't mean that life will feel easy. But you are the God who gets into the trenches of life with us. You are the God who carries us when our legs give way. You are the God who brings redemption out of the disasters of our lives. You are the God who does all this and more, and I trust you.

What has persistence taught you? How has God helped you to persevere through hard times?

Gracious and Kind

You may discipline us for our many sins, but never as much as we really deserve. Nor do you get even with us for what we've done.

Psalm 103:10

Gracious Father, you are so kind to us. You approach us with love, even in correction. You don't beat us when we are down, but you meet us in the dirt of our shame. You gently lift our eyes to meet yours, and you beckon us to stand. You whisper, "Go, and...be free from a life of sin" (John 8:11), and we are free to go on our way. Who else is like you?

You are so wonderful to me. There isn't another like you in all the world. When you discipline me, you do it with wisdom, clarity, and kindness. You do not shield me from the truth, but you call me up and out of the error of my ways. You challenge me with your wisdom, and you reveal your heart in your correction. Thank you for loving me enough to not let me stay in cycles of suffering, fear, sin, or shame. You are better than anyone in the world, and I love you.

How has God's kindness met you in his correction? How have you been encouraged to change your ways?

Perfect Hiding Place

*All who are oppressed may come to YAHWEH as a high shelter
in the time of trouble, a perfect hiding place.*

Psalm 9:9

God, I come looking for you like a child on a treasure hunt.
I know that you won't leave me hanging. When you meet me
with your presence, your peace pervades my heart and mind.
You are my resting place, and I can find shelter in you. Sur-
round me with your love, oh Lord, and guard me in the safety
of your embrace.

When others heap their burdens on me, I can feel over-
whelmed by the weight of it all. I can't carry the weight of
others' expectations, Father. I'm far from perfect. Help me to
let go of what isn't mine to carry and to trust you with the
needs of others that I cannot meet on my own. I come to you
for perspective and for shelter. Be my perfect place to hide
when I need to escape the pressures building around me. I
lean back into your arms of grace and let down my guard. I
know I can trust you.

*What weight are you carrying today? Can you give it to God?
Hide yourself in his heart, for he cares for you.*

Messages of Glory

All the world can hear its echo. Everywhere its message goes out.
What a heavenly home God has set for the sun, shining in the
superdome of the sky!

Psalm 19:4

Creator, when the sun rises high in the sky, I will remember that you have set it in the heavens as its home. Without the sun, there would be no life on our planet. Without you, the sun would not be where it is at all. Your creation reflects your glory, God, and you show your care through every detail within it, both what we can know and what remains a mystery.

I don't want to miss your glory just because something as miraculous as a burning ball of fire in the sky is commonplace to me. It is what humanity has known. Yet its very existence is a mysterious miracle. The same is true of this world and everything in it. The same is also true for humanity. And the same is true for me. Thank you for making me a unique reflection of your creativity, your power, and your wisdom. I am awed and overwhelmed before you as I consider your glory.

Look at yourself in the mirror. Consider that you are a
miraculous creation of God. What beauty do you see in front
of you?

His Beaming Face

God, keep us near your mercy-fountain and bless us!
And when you look down on us, may your face beam with joy!
Pause in his presence
Psalm 67:1

Father, I want to catch a glimpse of your joy in a way I have yet to see. I know that your Word says that you delight in your people. You spin with ecstatic joy as you sing songs of deliverance over us. You are full of exuberant affection. Oh, how wonderful the thought is! I long to experience the beaming of your smile over me.

Reveal what you think of me today as I look to you. What do you love about me? What do you delight in? Just as I love the people in my life and the little quirks that make them who they are, you know and care for each one of us personally. I know that you are a good Father, a tender Father, and that you are attentive to your children. You don't just sit with us in our sorrow, but you also rejoice with us in our victories. Do you laugh with us in our silliness too? Oh, how I long for a glimpse of this joyful God! Reveal yourself to me and allow me to see this side of you today. Thank you.

When was the last time you sensed the delight of the Lord over you?

Closer Than You Know

*You draw near to those who call out to you, listening closely,
especially when their hearts are true.*

Psalm 145:18

Lord Jesus, you are not a selective listener. You draw near to all who call out to you, and you listen closely to them. This brings me such relief. Knowing that you listen closely, leaning in, makes me feel seen, heard, and cared for. You aren't too busy to hear what I have to say. I don't have to wait to grab your attention. Thank you.

You see my heart and all that is in it. You know the questions and the struggles there. You also see the love and resolve in me. I trust you to sort through my thoughts and to read my heart just as you would an open book. You are the God who reads hearts. You don't have to take time to listen to me, but you do. You are the best friend I could ever ask for. You are always up and available, and you are all that I need in every moment. I delight in your fellowship, my God.

How does it make you feel to know that the God who created you is accessible anytime, anywhere?

Friend of God

*Guard my life, for I'm your faithful friend, your loyal servant for life.
I turn to you in faith, my God, my hero; come and rescue me! Lord
God, hear my constant cry for help; show me your favor and bring
me to your fountain of grace!*

Psalm 86:2–3

Lord God, I turn to you with faith today. I believe that you hear me and that you will help me. You are my champion defender and my ready rescue. You are the one I depend on when the circumstances are dire, and you are the one I hope in when all is going well. No matter what this day looks like, you are my God, and I am your friend. Keep me rooted in your love.

I am not your fair-weather friend, here when all is going well and then gone when things get tough. I know that you are not that way either. You stick closer than my blood relatives, and you are more faithful than my best friend. I turn to you because I have bet my life on you, Lord. You are the one I have surrendered and committed my life to, and I don't regret a moment of it. Today, I ask that you will show me your favor and bring me to your fountain of grace.

What has your friendship with God been like?

Righteous One

I trust you, Lord, to be my hiding place. Don't let me down.
Don't let my enemies bring me to shame. Come and rescue me,
for you are the only God who always does what is right.

Psalm 31:1

God of my hope, you are the one I have put all my trust in.
You are my hiding place and my shelter. You wash over me in
living love and bring me rest in your persistent peace. You shift
my perspective in your wisdom, and you give me clarity in
your higher perspective. There's nothing you cannot do. This
is why I ask that you will move in greater ways today. Draw me
nearer to your heart. I know that you always do what is right.

You are righteous and true, and everyone, everywhere can
count on you. I have put all my hope in you, and I trust that
you won't change from your incredible nature. With every dis-
appointment life brings, I learn more about myself. With every
victory, I learn more about your power. My expectations aren't
perfect, but you are. I trust you to do what is right today and
every day.

Do you believe that God will do what is right in your life?

Restored to Life

Let my passion for life be restored, tasting joy in every breakthrough you bring to me. Hold me close to you with a willing spirit that obeys whatever you say.

Psalm 51:12

Father, when you break through my doubts with your truth, I feel the strength of your peace come over me. You are greater than the most influential people on this planet. You always know exactly what needs to be done, and you move on behalf of your people. You are always full of love and generous in grace.

You see where my passion for life has waned, God. I long for a fresh touch of your reviving mercy to love me to life all over again. I want to taste the joy of breakthrough once more. I follow you because I love you and because I am convinced that you are the way, the truth, and the life. Revive me in your kindness and break through my sadness with the joy of your presence. I want to feel the ease of days gone by, when I walked with peace, joy, and love as my perfect portion. Do it again, please, God, and restore my heart to abundant life in you.

Is there an area where you need God's Spirit to revive your hope? Your peace? Your joy?

How He Works

Teach me more about you, how you work and how you move,
so that I can walk onward in your truth until everything within me
brings honor to your name.

Psalm 86:11

Everlasting God, I long to know more about you. Teach me how you work, how you move, and how you love us. I want to follow you in truth, but that means knowing what you are like. Reveal to me the details of your nature in what you do and how you do it. Give me the clues of your kingdom to see your way so that I can walk in it, no matter where in the world I am or what situation I'm in.

I want everything in me, my whole life, to bring honor to your name. I know that you see my heart, but I also know that you watch my actions. I want them to align in the ways of your kingdom. Clothe me in your compassion and cover me in your mercy so that I can follow your path of laid-down love with every step. I choose to pursue peace, to speak wisdom, to support the needy, and to speak up for the vulnerable. I know that this is how you work, and I want to be just like you.

How can you be more like God today?

Fragrant Prayers

*Please, Lord, come close and come quickly to help me! Listen to
my prayer as I call out to you. Let my prayer be as the evening
sacrifice that burns like fragrant incense, rising as my offering to
you as I lift up my hands in surrendered worship!*

Psalm 141:1–2

Father, I set my prayers before you like the fragrant incense
burning in your temple. I surrender my heart before you in
worship, offering all that I am before you. I am yours, Father,
and I lay it all out on your altar. I don't want to rush quickly
from your presence, for this is where I find my strength. This is
where I find my peace. Yes, this is where I find my joy.

You are my delight, Lord, and I come willingly into the
chambers of your presence. I don't want to miss a thing that
you are doing, so I humble myself before you and wait on you.
I pour out my heart. There isn't anything in me I withhold from
your gaze. You are trustworthy and true, and you have my ado-
ration today.

*Do you ever engage more than one sense in your prayer
practice? Light a candle or burn some incense as you spend
time in prayer today.*

December

Sent to Shine

*Send us out all over the world so that everyone everywhere
will discover your ways and know who you are
and see your power to save.*

Psalm 67:2

Savior, your glorious goodness is not reserved for only a few to experience. You long to pour out your lavish love on all that you have made. You want everyone everywhere to discover the astounding power of your kindness. With that in mind, I ask for you to send your lovers to the ends of the earth. Let the fame of your name spread far and wide, revealing to every nation, every language, and every tribe just how wonderful you are.

I am yours, Lord, and I humble myself before you. Wherever I go, whatever I do, I pray that your love will be lifted high in my life. May the oil of your presence saturate every place I step, and may all who know me know just how powerful, how good, and how true you are. Be honored over the earth and draw your people to you in loving-kindness.

How does God's character shine through your life? How about through your interactions, your words, and your habits?

Never Neglected

Everyone who knows your wonderful name keeps putting their trust in you. They can count on you for help no matter what. O Lord, you will never, no never, neglect those who come to you.

Psalm 9:10

Faithful Father, keep me close to your heart, especially when surprising challenges come my way. I have known your loyal love in so many different seasons of the soul, and I won't stop trusting you now. The truth of your powerful presence keeps me steady. You will never, no never, neglect those who come to you.

As I set my heart on the truth of your faithful love today, I remember how you have been with me before. Every moment is an opportunity to experience your nearness, for you are never far away. I count on you for help with every problem I have, and I trust you to keep me safe through the storms of this life. You are better than I expect at every turn, and I bind my heart to your loyal love in hope that far outweighs the fears of uncertainty. You are good, and I keep putting my trust in you today and every day.

What does it mean that God never neglects those who come to him?

Lovers of Justice

Remember this: YAHWEH is the Righteous One who loves justice,
and every godly one will gaze upon his face!
Psalm 11:7

YAHWEH, your Word says that your wise judgments run as deep as the oceans (Psalm 36:6). You have the fullness of wisdom in any and every situation. What others try to keep hidden, you see clearly. No one can get a thing by you. You work in marvelous and intricate ways, and you love justice. Though it may seem as if you are standing idly by while the world is in chaos, I know that you are moving in mercy and standing firm in righteousness. I will not use the chaos and corruption of this world as an excuse for why I shouldn't stand for justice. I want to be found walking in the way of integrity, of truth, of mercy, and of justice all the days of my life.

Empower me to stand both for and with you, God, and may I resist my own propensity toward judgment. I look to you, God, for truth and justice to reign. I want to be quick in compassion, especially to those who are disadvantaged and oppressed. May I always lean into your love when it would be easier to turn a blind eye in apathy.

How can you make a stand for justice?

Journey On

*Direct me, YAHWEH, throughout my journey
so I can experience your plans for my life.
Reveal the life-paths that are pleasing to you.*

Psalm 25:4

Good Shepherd, I follow your loving lead today. You are my God, and I trust you to guide me along the life paths that please you. I know there are so many possible choices I can make throughout each day, and I want to choose the paths that lead to life. As I journey with you, continue to direct me so that I can know and experience the plans you have for me, for I know that they are good.

Your Word instructs, "With all your heart rely on him to guide you, and he will lead you in every decision you make" (Proverbs 3:5). I do not take this lightly, Father. I don't want to wander through this life aimlessly, going from one whim to another. I want to walk in the power of your presence, to know the purposes you have for me to live out. As I focus on you, Jesus, I see that the most important things I do are in the ways that I interact with others. May I never overlook the little things each day, which are the ingredients that make up the majority of life.

How do you measure which next steps to take? How does God guide you in decision-making?

Revelation Light

The fountain of life flows from you to satisfy me.
In your light of holiness we receive the light of revelation.

Psalm 36:9

Lord Jesus, you are the fountain of life that flows into the deepest parts of my soul. You satisfy me like no one else can. Your love is refreshing to my heart and life-giving to my being. When you met the woman at the well, you told her, "If anyone drinks the living water I give them, they will never be thirsty again. For when you drink the water I give you, it becomes a gushing fountain of the Holy Spirit, flooding you with endless life" (John 4:14). Thank you for the power of your Spirit that satisfies the needs that no one else can even touch.

As your Spirit floods my being with endless life, revelation lights up my understanding. You reveal the power of your nature to me in new ways. Reveal yourself again, Lord, and give me deeper revelation of what you are like. Thank you for who you are and for the ways you satisfy my soul.

How does the Spirit-life satisfy you? What revelations have you received in God's presence?

Floodlight

God, all at once you turned on a floodlight for me!
You are the revelation-light in my darkness,
and in your brightness I can see the path ahead.

Psalm 18:28

Jesus, you said, "I am light to the world, and those who embrace me will experience life-giving light, and they will never walk in darkness" (John 8:12). I cling to this truth, Lord, that you are the life-giving light that brightens my path. In your light, shadows flee, and all is made clear. Where I feel confused, turn on the floodlight of your revelation and bring clarity.

As I stand before you, I trust you to show me what I cannot see on my own. Your presence lights up my life, and you are a faithful leader and counselor. I don't depend on my own limited understanding to get by today. I look to you, and I know you will give me vision to see the path ahead, where to walk, and what to avoid. I trust you, for you are faithful and true. You won't let me stay stuck in indecision or confusion. Thank you.

How has God lit up an area of darkness in your life with his revelation-light?

Over and Over Again

Our God is a mighty God who saves us over and over! For the Lord, YAHWEH, rescues us from the ways of death many times.

Psalm 68:20

Mighty God, you are so faithful, so wonderful, so dependable. You don't just save your people once or twice when they call on you for help. You save us over and over again. Though we do not deserve your incredible patience and overwhelming kindness, you are always merciful. You rescue us whenever we cry out to you. This is almost too much to comprehend, Father. My heart is moved with love for you as I consider the goodness of your faithful love toward me throughout my life.

Through you, I learn what a perfect parent is supposed to be. I see what nurture really looks like. You always speak the truth, but you don't use it to burden me. No, you use it to lift me up. You draw me in with loving-kindness time and again. You are gentle and patient. You are righteous and true. You are full of the peace I am looking for. You are my hope, my help, and my faithful Father.

Do you think you have run out of chances with God? There is always fresh mercy to meet you.

Blossoming with Joy

*Luxuriant green pastures boast of your bounty
as you make every hillside blossom with joy.*
Psalm 65:12

Great God, in your presence I come alive. Though I walk through the seasons of this life, just as the earth cycles through its seasons, I know new life is always around the bend. The promise of springtime gets me through the long, dark days of winter. This is as true for my spiritual life as it is for the way I approach the physical seasons.

Sometimes the soil of my life may look dry and barren, perhaps snowed over. I may have forgotten what the lush green pastures of summertime are like, the winter dragging on like it does in the northernmost parts of this world. Yet the promise of spring is still there. You will make the hillsides blossom with joy once again, and I will rejoice in the ease of those days when they come. In the meantime, I know you are at work under the surface. Help me to dig deep and trust you.

What spiritual season do you find yourself in? Do you trust that there is new life ahead?

Lifetime of Love

*I've learned that his anger lasts for a moment, but his loving favor
lasts a lifetime! We may weep through the night, but at daybreak
it will turn into shouts of ecstatic joy.*

Psalm 30:5

God, I have known this feeling in my own heart: anger that
rises for a moment and then settles into a curious and compas-
sionate stance. No strong emotion lasts forever, whether it be
sorrow, anger, or elation. No matter what I feel in the moment,
the undercurrent of your loyal love remains the same.

Though I may struggle through sorrowful seasons, I know
that daybreak is coming, and I will experience the relief and
joy of morning light again. No night lasts forever. But your ten-
der love does just that. It is as present with me in the dark
night as it is in the light of day. Thank you for your persistent
presence that overcomes every shadow of doubt. Your lavish
love is with me throughout my whole lifetime and further and
wider even than that. Wash away my fear and anxieties in the
presence of your peace as I meditate on your mercy that never
leaves or lets up.

How sure are you of God's lasting love in your life?

Listen and Wait

I stand silently to listen for the one I love,
waiting as long as it takes for the Lord to rescue me.
Psalm 62:1

Lord, I am in no rush today. You are worth waiting on. In a world that is full of constant movement, it can be hard to step back and ground myself in the present moment. But that is just what I will do today. I don't want to spin my wheels just because that is what others expect. I choose to move at a slower pace, a more deliberate one. I choose to sit with you and wait for you.

I settle my soul before you, making myself comfortable in your presence. I remain silent with you, waiting as long as it takes for you to move. I will not hurry in a panic or rush in fear. I choose to put myself in a position to listen for you today. This is what I need most: to hear your voice and know what is on your heart. Speak, Lord. I am listening.

Do you take time for silence and listening in your prayer
practice? What about in your daily life?

Happy People

*The happiest one on earth is the one who keeps your word
and clings to righteousness every moment.*

Psalm 106:3

Wonderful One, happiness can be fleeting in a world that is constantly moving on to the next new thing. How can we truly celebrate what we have if we are endlessly reaching for more? I don't want to live like that. I want to know true satisfaction in your presence, oh Lord. Knowing you is the greatest purpose I have on this earth. Living in your love is the way to follow the pathway to your kingdom.

Happiness is an experience, not just a thought. I will not rely on my thoughts about you to make me happy. I must know you to experience your power in my life. I do this by following your ways and keeping to your Word. I cling to your path of righteousness, Jesus, for it is life-giving. You always know just what to do and which way to turn, so I rely on your leadership every day. Thank you for the joy I find in living a life of integrity. Thank you for the joy I find in you each day.

Why do you think the Word says that people who follow God's ways are the "happiest"?

Rejoice in Trust

*As we trust, we rejoice with an uncontained joy
flowing from YAHWEH!*
Psalm 33:21

Father, trusting you is not just biding my time, twiddling my thumbs while I wait. No, I trust you because you are faithful and wonderful. Therefore, I rejoice even as I wait for you to do what only you can do. My heart is confident of your goodness. My soul is sure of the power of your mercy to meet me in every mistake and every challenge. You have never failed, and I trust that you won't change now.

The more I know you, the easier it is to trust you. The easier it is to trust you, the swifter I move to rejoicing in your palpable presence. You are incomparable in kindness, and your love doesn't leave anyone out. As Psalm 36:6 declares, "Your tender care and kindness leave no one forgotten, not a man or even a mouse." You have given me so many reasons to trust you, so I do it willingly and filled with joy that flows straight from you.

How can you rejoice in trust before God today?

At His Feet

Here's what I've learned through it all:
Leave all your cares and anxieties at the feet of the Lord,
and measureless grace will strengthen you.

Psalm 55:22

Loving Lord, I don't want to hold on to worries that only cause me anxiety and do no actual good for anyone, including me. You are the dependable one, and I don't have to carry the weight of the unknowns on my shoulders. I offer you my cares and anxieties today, leaving them at your feet. I don't want to pick them back up and be burdened by them again. Lord, as I offer these weighty things to you, fill me with your measureless grace.

Your grace strengthens me, God. It is like a fountain of fresh water to my soul. You are so good to me. You do not leave me empty-handed. When I lay my cares before you, you give me your gift of grace in return, and I am filled. What life-giving strength you offer! What hope I have in you! You are so trustworthy, God. This is why I give you even my most closely held cares and trust you with them. I know you won't let me down.

When you give God your worries, do you leave them with him, or do you pick them up again?

Surrender Your Pride

Surrender to the Lord YAHWEH, all you nations and peoples.
Surrender to him all your pride and strength.

Psalm 96:7

King of Glory, you are so worthy of my surrender. You are trustworthy and true, faithful to your Word, and constant in loving-kindness. You are better than the best of humanity. You are more loyal than the most dedicated friend. I don't waver in trust today, Lord. I willingly bow before you and humble my heart. I don't want to use pride as an excuse to not change. I want your loving leadership over my life to continually transform me, and I know that takes a willing and humble heart.

I am ready to admit when I am wrong. I know that I don't always see things clearly. Those who claim to know the truth yet aren't willing to question their own biases will be blinded by pride. I don't want to be so scared of getting things wrong that I refuse to entertain questions that are necessary to ask. Help me to remain humble before you and to allow your love to lead me into deeper waters of understanding, even when it means leaving behind old mindsets and ways of doing things.

Is there any area of pride you have been unwilling to surrender to God?

Hands-On Learning

Escort me into your truth;
take me by the hand and teach me.
For you are the God of my salvation;
I have wrapped my heart into yours all day long!

Psalm 25:5

God of my salvation, you are the one who leads me into truth. I trust you to teach me not only in theories and in theology but also in practical and useful ways. Take me by the hand and teach me. I am like an apprentice, and you are the Master. I learn from watching how you do things, and I practice alongside you, watching your every move.

Jesus, you said in John 5:19, "I only do the works that I see the Father doing." If you, the Son of God, learned from the Father in this way, how much more should I! Jesus, as I look at your life and your example, I will take on your approach. I don't want to claim to be working for you but doing something you never would have done. Open my eyes to your wisdom and lead me in your ways. Teach me, for I am your willing student.

What does the life and ministry of Jesus teach you about what the Father is like?

Heart Strength

My heart will not fear even if an army rises to attack.
I will not be shaken, even if war is imminent.

Psalm 27:3

Faithful One, it is your presence that brings me peace, and it is your hand that leads me in confidence through the winding paths of this life. I trust you more than I trust anyone else. It is for this reason that my heart will not fear even if an army rises to attack. Even when the worst-case scenario happens, fear is not my portion; rather, your perfect peace is.

God, you are the strength of my heart. I will not be shaken. No matter what is happening in the world around me or in my personal life, your loyal love still covers me completely. I have not somehow found myself without your help. You are always near, and you never leave those who rely on you. You know, God, how I rely on you. Encourage my heart in hope and strengthen my resolve to trust you completely, no matter what comes.

How confident are you of God's presence with you, even when everything seems to be falling apart?

Time Stands Still

Just one day of intimacy with you is like a thousand days of joy rolled into one! I'd rather stand at the threshold in front of the Gate Beautiful, ready to go in and worship my God, than to live my life without you in the most beautiful palace of the wicked.

Psalm 84:10

Lord, one day filled with your palpable presence is like a thousand days of joy. Time expands to include more meaning and delight than I could ever imagine. I have known the power of your love to stretch my humble time of prayer into significant moments packed full of your glory. Oh Lord, show me your glory again and increase the depth of my experience as I turn to you today.

The comforts of the wealthy can't compare to the beauty of your presence, my God. Nothing else comes close to how wonderful you are. Flood me with the glory of your fellowship. I am not looking to chat for a minute with you and then rush away. On the contrary, I am ready to receive and pour out my love like a feast before you, for you are the Worthy One. How I love you!

Have you experienced the type of joy that the psalmist describes in today's psalm?

Seasons of Joy

God has given us these seasons of joy, days that the God of Jacob decreed for us to celebrate and rejoice.

Psalm 81:4

God of Jacob, you are the God who provides in every season. I will not neglect your hand in the bountiful seasons of joy. What delight I find in the season of Christmas! I love to celebrate you, and I am overwhelmed with joy as I gather with loved ones throughout this time of year. May you be glorified as much in my joy as you are in my dependence on you.

Jesus, you are the reason I rejoice every day. Your coming opened a pathway to the Father, revealing what he is really like and offering us salvation through your death and resurrection. Your life is filled with wonderful wisdom and the ways of God. I celebrate the power of your whole person, Jesus, not just the way you arrived here as a baby. But that matters too. I celebrate you, Jesus, for you are my Savior and my God.

How can you celebrate Jesus in this season? In the tender areas where you may feel loss, where can you rejoice still?

Eternal Home

Lord, you have always been our eternal home,
our hiding place from generation to generation.

Psalm 90:1

This world is my home for a little while, but that is not the end for me. Lord, you are my eternal home, just as you have been for all who look to you throughout the ages. From generation to generation, you have remained our reason to hope, for you were God before the beginning. You will be God after this world fades away.

Your forever-kingdom is my true home. This won't change according to the rise and fall of nations, for you are King Eternal, the one who will reign throughout every age. You are perfect in wisdom, tempered in mercy, and complete in justice. You will never fail. When I feel like a stranger in this world, remind me that I have a permanent place with you. It is a place of peace, where I will rest. It is a place of light, where I will be free to roam in your glory. It is a place of joy, where I will rejoice with your people day and night. Thank you for the promise of this hope.

How has the Lord become your home?

Bright Hope

The Lord alone is our radiant hope and we trust in him
with all our hearts. His wraparound presence will strengthen us.
Psalm 33:20

Lord, you are my radiant hope. This is true not only when things are going to plan but even more powerfully when things aren't. I trust you with my whole heart. Trusting you is not wishful thinking. That does nothing, but you, oh Lord, are faithful to fulfill your promises. You are loyal in love, and that love is real and accessible in every moment.

When the darkness of this world settles, the radiance of your hope shines bright still, lighting up the darkness. You dispel my doubt in the power of your presence. You lift the fog of confusion with the burning rays of your truth. Thank you for all that you are and all that you do. I trust that you are as capable and strong as you have ever been to lead me and save me. What a glorious hope I have, for my hope is you!

How does hope lighten your load and clear your path? What does it mean to you that God is your hope?

Tower of Love

Higher than the highest heavens—that's how high your tender mercy extends! Greater than the grandeur of heaven above is the greatness of your loyal love, towering over all who fear you and bow down before you!

Psalm 103:11

Loving God, your tender mercy reaches further than my mind can even imagine. It is higher than the highest heavens, going into deep space and beyond our galaxy. Every atom is filled with this love, a living reflection of your power, wisdom, and creativity. Your loyal love towers over all who worship you. I worship you, my great God and King.

Reveal to me in even deeper ways the power of your mercy-kindness. I long to know you more. Draw me close to your heart as you broaden my understanding of your goodness. Meet me in the details of my day and overwhelm me with your thoughtfulness. I want to know you as my Creator and as my friend. Remind me of your nearness by giving me glimpses of your grace throughout my day. I will praise you for each one. Thank you.

What revelations of God's love have changed the way you think about him?

Completely Covered

*You've forgiven our many sins
and covered every one of them in your love.
Pause in his presence*
Psalm 85:2

Father, as I meditate on your Word today, I take time to pause in your presence. You don't just forgive my faults and then hold on to them to throw back at me at a later date. No, that is not how you work. Your forgiveness is complete. You never hold something against me that you have already forgiven. Thank you for the power of your mercy that completely covers me and releases me from my shame and guilt. You are more wonderful than I can describe; with each new experience of your love, that knowledge goes deeper.

"Farther than from a sunrise to a sunset—that's how far you've removed our guilt from us" (Psalm 103:12). There couldn't be better news than this. I am completely free from the guilt of my mistakes, of my past. I humble myself before you and offer anything that I know is creating compromise in my life. I want to honor you and walk in the liberty of your love. Here I am, Lord, covered in your kindness. Thank you.

Is there anything you know is forgiven yet you are still holding on to? Let it go today and let God's love completely cover it.

Famous One

God, there's no one like you;
there's no other god as famous as you.
You outshine all others,
and your miracles make it easy to know you.

Psalm 86:8

God, you are famous for your kindness. Who else can say this? Your miracles of mercy make it easy to know what you are like. How wonderful you are! Lord, where I have underestimated you, reveal just how great you are. Where I have brought you down to the level of my experience rather than trusting in your proven nature, expand my understanding of who you are.

You are faithful, Father, and I want others to know just how good you've been to me. When I see others struggling, help me to not just talk at them about your love. May I instead be compassionate and gracious, living out your love in practical ways that display just how kind and generous you are. May my yielded life be a testimony of your famous love and your miraculous mercy-kindness.

How has God outshined all others in your life?

Light That Breaks Through

His light broke through the darkness and he led us out in freedom
from death's dark shadow and snapped every one of our chains.
Psalm 107:14

Jesus, as I prepare my heart for Christmas, I remember that your birth was like a light breaking through the darkness of the world. The star of Bethlehem led the shepherds to where you were born, and it served as a sign of God's promise of redemption. You, Jesus, are the fullness of every promise.

You are the light that broke through the darkness and led us out in freedom from death's dark shadow. You, Jesus, snapped every one of our chains. You are the one. You are our liberating Savior. That light that broke through over two thousand years ago is the light that still brings breakthrough today. I look to you, my Savior and my Redeemer. Lead me out in your love, and I will tell everyone what you've done for me. Thank you.

How has Jesus changed your life? How has he brought
freedom to you?

He Has Saved Us

Everyone knows how God has saved us,
for he has displayed his justice throughout history.

Psalm 98:2

Lord God, today we celebrate you. Father, thank you for sending Jesus, your Son, to save us and show us the true nature of your love. Jesus, your name is famous on the earth, yet some still do not truly know you. As we honor your life, make room for more at your table of plenty. Welcome those who need a Savior and who have not known the power of your mercy. May your saving grace go far and wide until everyone knows the power of your salvation.

Jesus, I am so thankful that I can look to you. You put on flesh and bones; you know what it is like to go hungry and to be tired. You lived the whole human experience. Thank you for relating to me in my humanity. I trust that all I need I can find in you. Lord, you are worthy of my trust and my surrender. You have it.

Is there someone with whom you can share the hope of Jesus today?

Determined Heart

My heart, O God, is focused and determined.
Now I can sing my song with passionate praises!
Awake, O my soul, with the music of his splendor.

Psalm 108:1

My God, my heart is focused and determined. It is set on you. You are the Near One, my faithful friend and holy comfort. You wrap around me with the power of your presence, and you shower me with your mercy every time I turn my attention toward you. Every time I experience the affection of your heart, I become even more determined to love you more and to become like you.

I will pour out my praises on you, God, for you have lifted me from the dust of my troubles and set me on the solid rock of your kindness. You never fail to lead me into your goodness. How could I stay silent about how wonderful you are? Awake, my soul, with the music of his splendor! I join in with the song of creation and give you all the praise I can muster.

What is your heart focused on today? How can you praise God through it?

Relax and Rest

I can say to myself and to all, "Relax and rest, be confident and serene, for the Lord rewards fully those who simply trust in him."
Psalm 116:7

Holy Spirit, I know that I can rest in your wraparound presence. Surround me with your peace so I can really relax in you. You are my confidence and my serenity. I don't have to do a thing except trust you today. Even that, oh Lord, I cannot do without your grace. Help me to lean back into your loving arms and let my worries dissipate. You are my God, and you have me.

Thank you for the relief you give me in your constant care. You soothe and settle me in the peace of your presence. You recharge my soul and refresh my heart in the warm embrace of your love. I lay aside the problems of tomorrow and focus instead on your generous grace that meets me where I am. Help me to let go of the things I cannot change or control and to take this time to truly rest. No guilt. No fear. Just resting in your present peace. Thank you.

What do you need to let go of in order to truly rest and relax today?

Reliable Help

*Lord, it is so much better to trust in you to save me
than to put my confidence in someone else.*

Psalm 118:8

Lord, you meet me in my need and in my disappointment. There isn't a situation in which you leave me to work it out on my own. When others let me down, you know that pain. Jesus, you have walked through rejection and abandonment. You know the sting of betrayal better than anyone. May I never put on you what others have done to me. You are perfect in love. You are faithful to keep your commitments.

I know that I, too, let others down. Thank you for the grace of your mercy that covers our mistakes. May I keep my heart covered in compassion in all my relationships. And may the fullness of my trust, my highest hope, stay where it belongs—in you alone. You are a trustworthy help and a ready Savior. You won't ever leave me or forget your promises. Thank you.

*Do you let the disappointment of others change how you
view God? Even if you do, ask God to transform your view of
him today in the light of his truth.*

Good Paths

*I just want to obey all you ask of me. So teach me, Lord, for you
are my God. Your gracious Spirit is all I need, so lead me on good
paths that are pleasing to you, my one and only God!*

Psalm 143:10

Gracious God, I want to walk in your ways. I don't want to
just say that because it sounds nice and then give up when it is
harder to choose compassion over bitterness. Teach me, Lord,
to walk on the path of your love and to choose your ways of
peace, justice, and mercy. Spirit, I'm so grateful for your help.
You empower me in my inner being by revealing the nature of
God, his practical wisdom, and his kindness.

I follow your lead. Keep me on good paths that are pleas-
ing to you. Fill me to overflowing with your grace, oh God, and
I will have so much to give to others. You are my source, my
teacher, and my guide. Don't give up on me. Today, this very
moment, show me what it is you want me to do with my time
and attention, and I will do it. I love to grow in your Spirit and
to learn your ways. I am open, Lord.

In what specific way do you feel God leading you today?

Overflowing with Kindness

You're kind and tenderhearted to those who don't deserve it and very patient with people who fail you. Your love is like a flooding river overflowing its banks with kindness.

Psalm 145:8

Gracious Father, you're so very kind to us. Though you could grow impatient with our failures, you are tenderhearted and extremely tolerant of us. You see how many times I fall short of your ways, but like a good Father, you don't use that against me. You lovingly take your time to teach me. You correct me in kindness and encourage me in the clarity of your wisdom, showing me how I can choose better next time.

I have known your kindness, but it astounds me still. You are not easily offended. In your kindness, you see me just as I am, and you call me higher in your love. You never ridicule me or use my failure or weakness against me. You are faithful in mercy, and you are overwhelmingly tender with my vulnerabilities. I won't give up following you, for you are the best thing that has ever happened to me.

Have you ever experienced the disarming power of patience in someone whom you let down? What does that teach you about God?

He Keeps Us

There's no doubt about it: God holds our lives safely in his hands.
He's the one who keeps us faithfully following him.

Psalm 66:9

God, I have absolutely no doubt in my mind that you have me. You hold my life safely in your hands, and no one can cut it short. You know the number of my days, and I won't be afraid of what that number is. As I reflect on this last year, I see how you have kept me faithfully following you. Open my eyes to the myriad ways your mercy has met me.

You are so faithful, my God. As I look ahead to a new beginning, hope rises in my heart for the open book that we will write together. May it be filled with peace, the power of your presence, and love that overwhelms every fear. You are the one I follow, for you are good and you never, ever change. You are always overflowing in kindness and generous in grace. I trust you more than I trust anyone else. Transform me again in your love and your presence and give me eyes to see how faithfully you keep me close to your heart. Thank you for all that you have done and for all that you have yet to do. I love you.

How has God kept you this year?

About the Authors

Brian and Candice Simmons have been described as true pioneers in ministry. Their teaching and spiritual gifts have opened doors into several nations to bring the message of authentic awakening and revival to many. For many years, they have labored together to present Christ in his fullness wherever God sends them.

After a dramatic conversion to Christ in 1971, Brian and Candice answered the call of God to leave everything behind and become missionaries to unreached peoples. Taking their three children to the jungle tropical rain forest of Central America, they planted churches for many years with the Paya-Kuna people group.

After their ministry overseas, Brian and Candice returned to North America, where they planted numerous ministries, including a dynamic church in New England (US). They also established Passion & Fire Ministries, under which they travel full time as Bible teachers in service of local churches throughout the world.

Brian and Candice are co-authors of numerous books, Bible studies, and devotionals that help readers encounter God's heart and experience a deeper revelation of God as our Bridegroom-King, including *The Blessing*, *The Image Maker*, *The Sacred Journey*, *The Wilderness*, and *Throne Room Prayer*.

Brian is also the lead translator of The Passion Translation®. The Passion Translation (TPT) is a heart-level translation that uses Hebrew, Greek, and Aramaic manuscripts to express God's fiery heart of love to this generation, merging the emotion and life-changing truth of God's Word.

Brian and Candice have been married since 1971 and have three children as well as precious grandchildren and great-grandchildren. Their passion is to live as loving examples of a spiritual father and mother to this generation.